Creative Colour
Transparencies

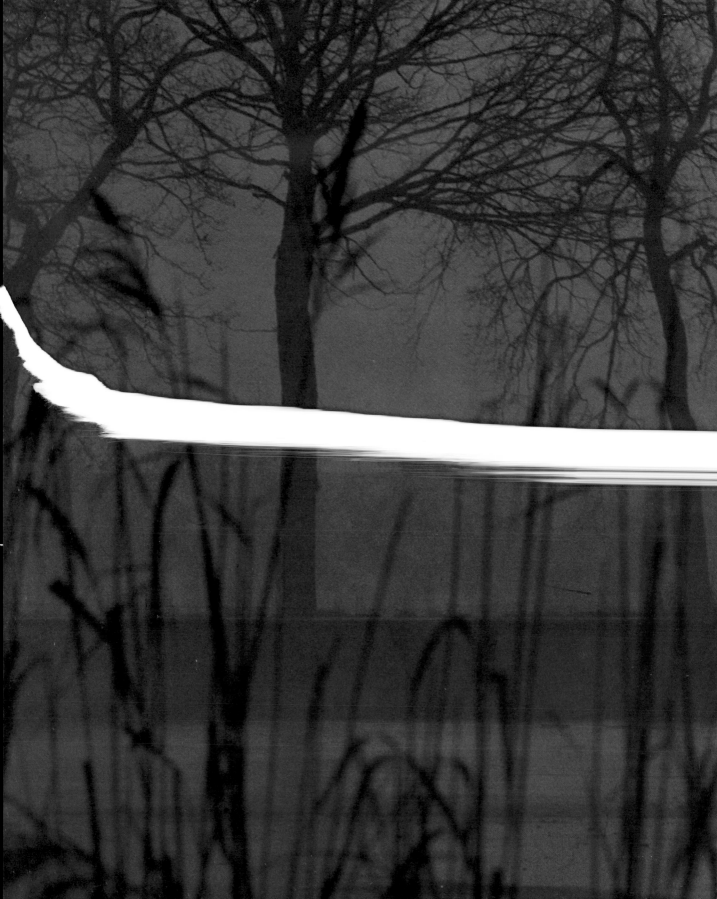

Creative Colour Transparencies

Wout Gilhuis

Fountain Press

Fountain Press

All the photos were taken by Wout Gilhuis using a Canon F1 and Canon lenses on Kodachrome film.

Technical assistance by Cees Foppele

Argus Books Ltd,
14 St James Road,
Watford,
Herts,
England

First Published 1980
ISBN 0 85242 711 5

© 1978 Uitgeversmaatschappij Focus-Elsevier BV., Amsterdam
English translation Argus Books Ltd, 1980

Printed in Spain by Graficromo S.A. – Cordoba

Contents

Preface

When judging competitions involving transparencies, as well as at lectures, I have often been struck by the fact that amateur photographers experiment to such a slight extent with their colour transparencies. When it comes to colour, people seemingly do not wish or like to deviate from well-trodden paths. They then talk decidedly disparagingly about "tricks". These "tricks" are referred to in the same breath as "techniques" in black-and-white photography!

There is of course an explanation for this. Over the years people have worked out so many "techniques" in the darkroom and become so conversant with them that they completely forget there are also techniques to be applied when taking a picture. A proper sense of proportion has been lost to some extent when it comes to colour photography, particularly in the case of transparencies.

The reason for this must not, of course, be sought solely with the amateur photographer. Manufacturers of optical aids persistently speak about "trick lenses", "trick filters" and the like. In my opinion, "supplementary lens attachments" would be a much better term for these accessories.

The most enthusiastic black-and-white photographer, from whom one was perhaps accustomed to expect magnificent photos as far as composition and printing were concerned, has very soon to profess his ignorance once he starts working with colour. He is still excessively influenced by the attitude that a picture which is not perfect from the point of view of composition is capable of improvement in the darkroom. There is perhaps something in this if colour negative film is used. If, however, the most modern direct-from-transparency processes are used, it is much better if the exposure itself is good so that tampering in the darkroom to obtain the correct image area becomes unnecessary. I am convinced that the direct-from-transparency process is the system of the future, not least because it makes few special demands on the darkroom. For years I used the transparency-internegative method for enlarging. However, I have now abandoned it and can assure you that direct enlarging on reversal paper is much more efficient.

This book is concerned mainly with techniques involved in taking pictures (for example working with all manner of optical aids, double exposures, sandwich transparencies, etc), resulting in transparencies which can be enlarged directly with no further steps. If a transparency has a normal density and colour balance, the initial print (i.e. the enlargement without extra filtering) should be good. Consequently in some cases filtering is superfluous.

When working with colour, the same methods apply as when using black-and-white. Consistent results are most rapidly obtained if one masters a specific method of working, always using the same materials and not deviating from it, at least in the beginning.

I use Kodachrome 25 and 64 of respectively 25 and 64 ASA (15 and 19 DIN) and Kodak Ektachrome High Speed of 160 ASA (23 DIN) for my photos, while I enlarge on Kodak Ektachrome 14 RC paper which I develop with Kodak chemicals. This does not imply criticism of other makes of film and paper. Far from it, but I stick to the material with which I have become familiar and I can obtain good results quickly and easily because of this standardization. The last chapter of this book is devoted to a few specific problems of enlarging using the direct-from-transparency method. It also deals with special printing systems, for example, making big enlargements with a few superimposed transparencies and corrections which seem necessary when using other types of film, etc.

You will not find any tables in this book. Its main purpose is to tell you how to obtain the desired effect when taking the picture itself.

This is something every amateur photographer can achieve with a little perseverance. Once you have the perfect transparency, enlarging it is a matter of secondary importance. There are plenty of books about the necessary technique, for example "Colour enlargements from transparencies" by Günter Spitzing and "Make your own colour enlargements" by Jan ven Welzen (Argus Books).

The starting-point of this book is consequently *working to fill the format* so that the correct image area is obtained right away. This means that attention has to be paid to composition. I do not claim to know everything and I merely wish to try to explain to you my method of working. This will perhaps help you to explore other ways of doing even more with your lenses and give your work an individual stamp. In other words, your camera will become an instrument for interpreting your feelings.

Some people say that nothing more can be done with a colour transparency film. They are forgetting that every amateur photographer is an individualist and is capable of manipulating the film. You can "manage" the film, starting with the exposure. If you stick absolutely to the instructions given by the manufacturer on the leaflet with the film then you are allowing yourself to be led by him.

A well-known photo critic once said to me: "It seems that popular cameras have only 1/125 second and the diaphragm settings f8 and f11." In other words, there has been a levelling here too!

If the technique is mastered, colour photography can lead to fascinating results. You should deviate occasionally from the "beautiful landscape". You will then avoid getting into a rut, a common phenomenon in amateur photography since it lacks ideas and imagination and, frequently, control of technique as well.

Just to give an example: in macrophotography one is told to stop down the aperture as far as possible to get the maximum possible depth of focus but I work deliberately with a full aperture and possibly also with intermediate rings. Because of the resultant lack of sharpness, the colours merge into one another and can appear to particularly good advantage.

Those who set to work in this way are moving in the direction of *impressionism* in photography and this is inherent in the creativity which lies at the root of the matter. This book will certainly also benefit those who prepare series of transparencies accompanied by sound (or to give them their modern name, *diaporamas*). I used to do a lot of this but stopped as soon as I noticed that I was beginning to make concessions to my photography, purely and simply to "complete" a series of transparencies. I am against turning mediocrity in photography to art for the sake of the combination of pictures and sound because I am primarily a photographer. Consequently, I hope that the makers of such series will benefit from this book so that they will also include in their work something other than exclusively "factual photography"; this by no means implying that I want to disparage this form of the art. If it is carried out well, it is an art in its own right. However, it is possible that if these people were to begin to apply the techniques described in this book they would notice a completely new dimension being added to their series. This can be specially fascinating when combined with sound.

Creativity is lurking in virtually every person, including you. It nevertheless has to be stimulated, and I hope to help you in this. Once you are occupied in a committed way in the proper sense of the word and deeply involved with your subject, you will notice that you are getting new ideas all the time. It is a matter of persevering and, if you are not at first successful, of starting again. And right away. Do not wait, since as soon as you put it in your diary it is a thing of the past. Creative photography is born by taking many photos because it is in this way that you automatically gain inspiration. If you leave off for two weeks, you will perhaps get three months behind and it is only persistence which succeeds!

The main thing to remember is that you must know the 'rules' of composition. I know very well that masterpieces have arisen by ignoring these rules, but those who did so had already mastered the rules completely and knew exactly what uncertainties could arise by deviating from them. Many contemporary photographers say they do not wish to be bound by 'rules' of composition. I,

too, have occasionally felt this, but on looking at my work in a quiet moment, it seemed to me that I had nevertheless adhered to them unconsciously in most cases. On the one hand perhaps, because they are practically subconscious but also because these rules are so good that the selected image area and final composition of the picture with which I was satisfied were in full agreement with them.

If you want to photograph creatively, then above all go your own way! Do not imitate anything or anybody because it won't teach you anything. Study a lot of literature, look at a lot of work by others and do not condemn it directly but try to work out the motivation of the creator. Ask yourself why he did as he did, and why you would perhaps have done it differently. It is not an easy path, sometimes full of disappointments but, if you follow it consistently, you will nevertheless arrive at your own recognizable style. Don't rely on the opinion of the members of your family; they are seldom unprejudiced. Above all, be circumspect if everyone praises you, or you will then rapidly lose your sense of self-criticism and that's the worst thing that can happen to a photographer. Dare to accept criticism, particularly well-founded criticism, but do be selective in what you do. You must also be able to set aside criticism and go your own way, but you must know how to defend your work! There is a high probability that people will then call you a rebel, but don't forget that this is often done by people who judge and condemn from out-of-date aesthetic standards.

When people started calling me a "fool in relation to colour", I first of all took it very much to heart. Later, I accepted it as a sign of recognition of my work.

The difficulties are not to be underestimated, but with a reasonable amount of perseverance they are certainly not insuperable. In this age of mediocrity and drabness in so many fields, it is a challenge and a relief, to have a hobby in which one can indulge one's feelings to the full. This is, after all, the great advantage the amateur photographer has. He is not bound to a brief like the professional.

Many who are already well on the way to a style of their own stop at a given moment and this is frequently the result of becoming stuck with a specific technique. They do not dare to proceed in a different direction for fear that their work will be valued at a lower level than the photos with which they already achieved positive successes. It is very important at that moment to find a different approach and be prepared to accept severe criticism. To start again in a new direction when one has got into a groove is in itself a victory and that results in more satisfaction than giving up the struggle. Admitting at a given moment that one is wrong is better than persisting in a point of view once adopted against one's better judgment.

Finally, the whole book has been based on the technique of making and processing colour transparencies. I am pointing this out specifically in order to avoid any confusion which could arise through a false interpretation of the data on exposures.

Wout Gilhuis

1. Landscapes

If an amateur photographer is thinking of purchasing specific lenses, he generally asks "how many times will that lens magnify" (if a telephoto lens is involved) or "how much more will I get in with that lens" (if a wide-angle lens is involved). These seem in themselves to be quite reasonable questions but they nevertheless show a lack of the most elementary knowledge of the possibilities of interchangeable optical equipment. When a camera is purchased the standard lens is always bought without question, even by people who are intending to do a lot of varied photography. Better advice would perhaps have caused them to acquire as their first purchase a camera body with, for example, a 35 mm and a 100 mm lens. With these they have a large number of creative photographic possibilities right from the start.

Mastering perspective

Too little attention is in fact paid to one of the most important aspects of photography, namely perspective. This is also related to the conscious choice of moderate wide-angle and telephoto lenses. This combination can, in landscape photography, be directly exploited creatively. I, unfortunately, learnt by bitter experience. I nevertheless had a photographic dealer who gave me very good advice and who, if I showed him my work, could criticize it constructively since he himself was also involved creatively in photography and passed this involvement on to his customers. I recently read in a photo magazine that in competitions 80% of the photos submitted were landscapes which were, for the most part completely devoid of any individual creative element. Landscapes in particular present many opportunities if people are familiar with the most elementary rules, such as a mastery of perspective, differential focus, etc. I don't find it difficult to understand why so many landscapes are photographed. Many people want to escape from the busy everyday world and to return to nature in their spare time. What a pity that the busy world from which they try to escape nevertheless recurs in a hasty and rash approach to photography, at least where colour is concerned.

Consumption of film

Another reason for poor results is the sparing use of colour film under the impression that transparencies are very expensive. This is an argument which is often used by photographers who at the same time do not shrink from using a whole pack of 30 cm × 40 cm paper for making one good experimental black-and-white enlargement.

Economizing on film is self-deception, certainly if one takes into account the cost of the apparatus and the time devoted to it. One piece of good advice is always to approach the subject from different angles. Give yourself a clear assignment. If need be, first go and look without a camera, because *learning to see* is most important if you want to achieve good results in photography. Robert Broere, a well-known Dutch photographer and an expert photo critic, once said: "Give me a square metre of nature and I'll make a series of photos I can talk about for a whole evening." He *can* do it – thus proving that the usual "I don't seem to be able to get it right" is the result of insufficient perseverance or a lack of vision. In the case of landscape photography it is, in my opinion, very often a lack of adequate self-criticism as well; this being so important for good results. Sometimes one is also confronted by the opinion "the gaudier the better" and that beautiful landscapes can only be photographed abroad. There is more beauty on one's own doorstep than many amateur photographers suspect. Seeing a good landscape and knowing how to reproduce it in the proper way will not of course happen by driving past it quickly on a Sunday morning. You will have to visit that scene regularly and, what's more, in all kinds of weather. You then automatically begin to see the typical features and the differences in colour under

various weather conditions. Do not go in groups because this seldom gives a good result. Trips with photo clubs are eminently suitable for social contacts but they seldom result in the taking of good photos, even if it is only because someone has taken his photos quickly and then forced the others on so that they will be ready as quickly as possible for the next subject. More often than not the next subject is a restaurant where time is devoted to discussing somewhat exotic and rarely used techniques!

Three dimensions

We must realize that what we see is tri-dimensional but we have to reproduce it in two dimensions, in other words flatly by means of a photo or transparency. If we master perspective, we can by using different lenses evoke any desired suggestion of depth and thereby suggest three dimensions on a flat plane. What in fact is perspective? It is the optical illusion that parallel lines converge in the distance and it can be seen clearly if you look along railway lines or stand between high blocks of flats and look up. It then seems as if all the lines are converging although we know that they are all nice and parallel. This phenomenon can be accentuated by using various focal length lenses with which we can, depending on our own intention, intensify or weaken the effect. Working in and out of focus and selective or differential focusing are also excellent means for suggesting depth and lead to a similar result. The fact that most people take such flat photos without any expression is generally the result of not having mastered these rules. Perspective is also a Cinderella among advanced amateur colour photographers, and yet colour lends itself very well to this treatment. The technique involved is described in virtually every book about photography. When I am conducting training courses I always show a series of transparencies in which mastery of perspective is shown to particular advantage. The first series was taken with lenses of 24 to 400mm. I always stayed in the same position and successively took photos of a car in front of a wood using these lenses, the image area becoming smaller and smaller, while there was not in principle any change in perspective. If I were to enlarge the photo taken with the 24 mm lens to the image area of that taken with the 400 mm lens, I would obtain exactly the same photo, although with a much coarser grain. If I were to be satisfied with grain and working solely in black-and-white, then I should, theoretically, have been satisfied with that 24 mm lens. (The basic principle is that I change the lens but do not choose another position.)

Things are different when working with colour. If it is not possible to get close, a different lens has to be chosen on each occasion. I often use a Canon zoom lens of 85 to 300mm in landscape photography and this enables me to change the image area very quickly indeed.

The second series of transparencies, taken with the same lenses, is completely different. It indicates what mastery of perspective really is. I selected a specific foreground (car) object and centred it in the viewfinder, using the 24mm lens. I then took a whole series of photos with all the other lenses already referred to. The only difference was that I now no longer remained in the same position, but moved further and further back so that the object always stayed the same size in the viewfinder. What happens now? We see the background coming further and further forward in relation to the subject in the foreground. In the case of the 400 mm lens shot, it seems as if the car is standing in the wood.

Wide-angle lens

The suggestion of depth which can be achieved is particularly fascinating. The shorter the focal length, the stronger the effect that can be obtained. The photo of the field of corn on p 16 shows a very large corn cob in the foreground that dominates

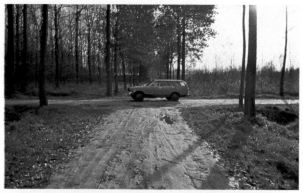

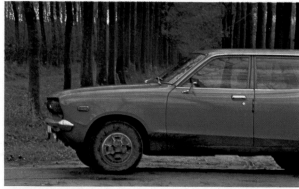

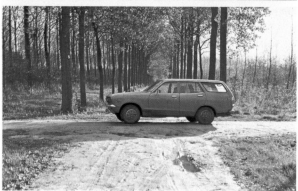

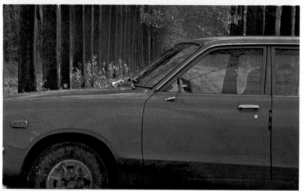

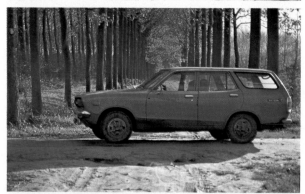

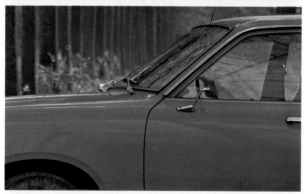

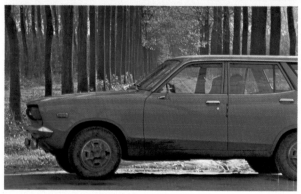

Lenses of 35 to 400 mm
(same position)
In this series of photos taken with lenses of focal lengths 35, 50, 100, 135, 200, 300 and 400 mm, the camera remained in one position. The relationship of the car to the background does not change.

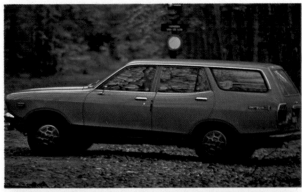

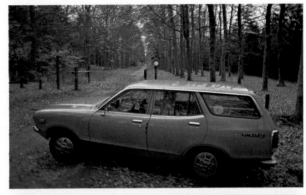

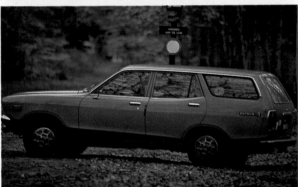

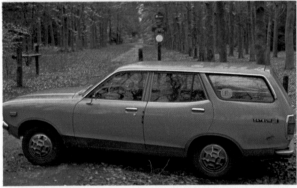

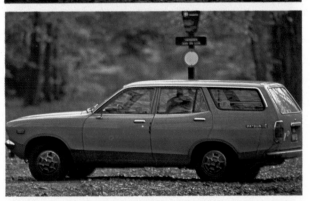

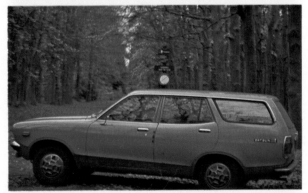

Lenses of 35 to 400mm
(different position in each case)
Here the camera position was moved
back for each photo in such a way that
the car was roughly the same size in
each picture. The relationship to the
background consequently changes in
each case.

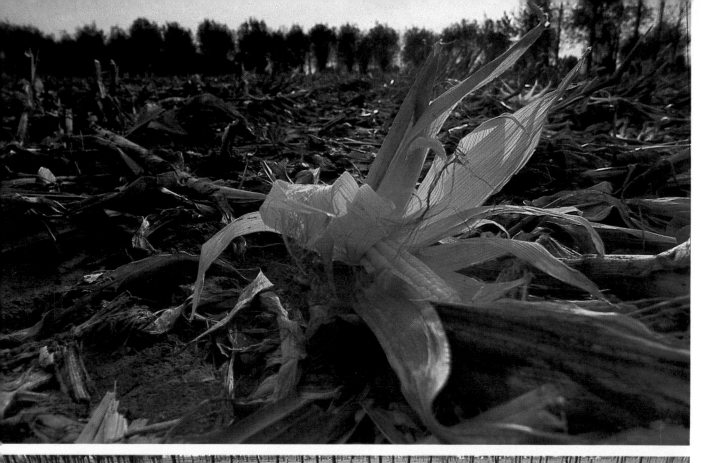
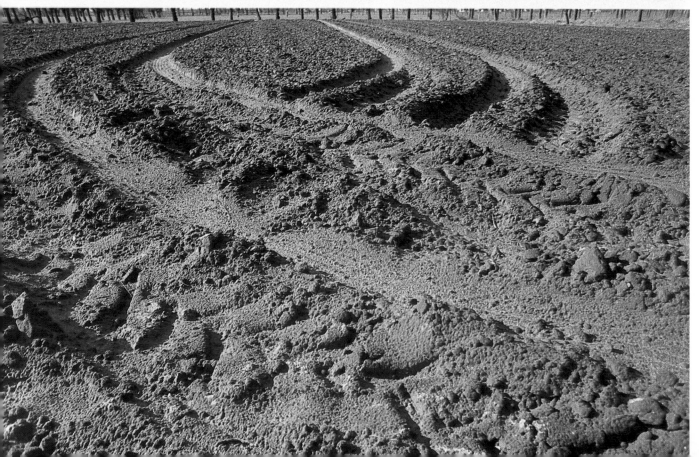

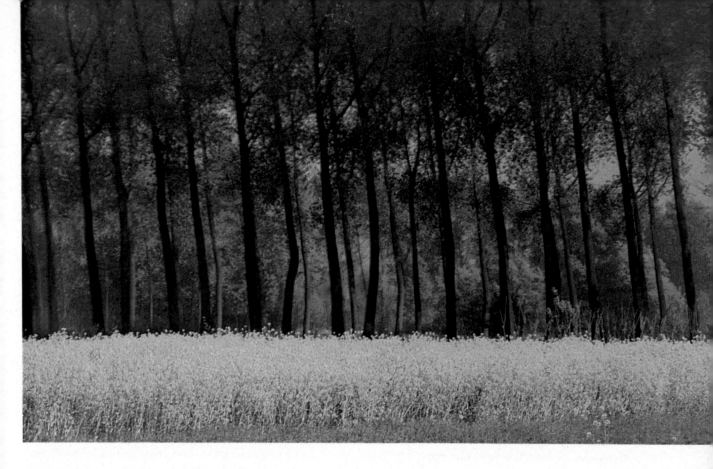

the whole landscape. This photo was taken with the camera from a worm's-eye view, i.e. as close as possible to the ground. The lower photo was taken a few weeks later after the field had been completely ploughed up and a tractor had left its marks. It was taken with the same wide-angle lens (24 mm), but with the camera tilting downwards, as a result of which the converging of the lines has become so marked that they finally almost meet. The impression of depth is further accentuated by including a small edge of the horizon. The field is not even 50 metres deep, but by deliberately manipulating the lens and shooting angle a greater suggestion of space has arisen.

In contrast to what many photographers maintain, a wide-angle lens can be used to excellent effect in landscapes, although the subjects have to be chosen carefully. I shall have more to say about this when dealing with special lenses such as the fish-eye where other factors are involved.

Telephoto lens

We achieve precisely the opposite effect by using a telephoto lens. The illustration on p 17 shows a field of rape-seed. By using a 300mm lens it has been brought into the picture in such a way that it seems to be adjacent to the trees. When I saw

the subject and observed it through the standard lens, there was a distance between the field of rape-seed and the trees which apparently could not be bridged. By choosing a focal length of 300mm and moving further back, I got the final effect which could not have been obtained with a standard lens. The zoom lens is particularly suitable in such circumstances because it replaces the need to change lenses. It is necessary to spend much time outdoors for this kind of photography and to visit the same subject repeatedly. This also applies to transparency photographs to be enlarged on RC 14 paper. It is still possible to make some changes in the darkroom, but the specific *moods* have to be established on the spot. Landscapes are always different, at all times of the day and in every season. The argument that something has already been photographed too often does not hold good. A tree for example can be photographed in a hundred different ways and it is always different if one only takes the trouble to look but, unfortunately, not everyone has sufficient imagination and perseverance. A fine example is given by the famous French impressionist painter Claude Monet. By diverting a brook in his garden he constructed a pond in which he planted all manner of aquatic plants and for nearly 30 years he painted it but not one painting was the same as the one which preceded it. An amateur photographer will perhaps say "yes, but I'm not a painter". That is true; but as a photographer you have, just as the painter has, a large number of technical aids for achieving the same objective. Just think of the differences in colour temperature at various times of the day and think of the effect of filters or the deliberate choice of the wrong film, etc.

Photography really has the same problem as that of the French Impressionists. How faithful has one to be to natural colours and what concessions have to be made to one's own feelings by interfering with them? In other words, does one always have to photograph what one sees or may one interpret it in one's own way by technical intervention?

It is clear that the perspective effect can be a great influence. That alone could be regarded as a decisive argument for purchasing the lenses referred to at the beginning of the chapter. They enable one, albeit to a limited extent, to interpret seemingly immutable objects in one's own way. The dullness and rigidity of a normal reproduction can be avoided by shifting relationships, depending on the importance of the elements in the picture.

What other lenses are there?

For those who want to go further, a good addition to the range of lenses mentioned so far would be the 24mm wide-angle lens and a 200mm telephoto lens. Those who already have a standard lens would do best to obtain first a 135mm and 24mm lens. Together they cover most landscape requirements.

A limited set of equipment, which nevertheless gives a good coverage would be a 28–50mm and an 80–200mm zoom lens. These lenses are often said to be too expensive, and they do in fact represent a big investment, but one gets an ideal combination with them. A fringe benefit is that everything can be packed into a relatively small bag without too much weight being involved. I shall be having more to say about the specific advantages of zoom lenses in the chapter on zoom techniques.

So far we have spoken about mastering perspective and the technique needed for it. We cannot, however, escape the fact that in spite of all the technical aids available, our own creative contribution is of the greatest importance. What is creativity? In my view, to be creative is to put something of yourself into your photos, but this is only possible if one is highly committed to one's subject and studies it in depth. All those who work creatively sometimes have lapses and this is normal. It is not good to move from one object to another. One does not then penetrate to the essence of either. If I can't get something right I go to a museum to look at the work of great painters or spend an afternoon looking through

photographic literature. I then frequently get so much inspiration that I can continue working smoothly. Ideas often come by being engaged on something. One thing leads to another and we keep on getting new ideas. Creativity also often arises by breaking all the 'rules'. It was years ago that Andreas Feininger set down in his books techniques and means for achieving creative photography. He described the means for portraying things as symbols. The photos of movement by Ernst Haas and the impressionistic photos of Francesco Hidalgo were also taken many years ago. There is nothing new under the sun except one's own interpretation of existing techniques or, in other words, one's own contribution. Just look, for example, at the landscape photos of people such as Ansel Adams or H. A. Murch, both of whom have a decidedly personal vision which could nevertheless only be built up by much practice, experimenting with existing data and extending them to form a style of their own. The creativity of the photographer is in fact limited solely by his own imaginative faculty and fantasy. It is important that he should, just like the criminal, always return to the scene of the action. This is putting it a bit strongly but it indicates that looking again and again at a specific object leads to fathoming the essence of it and the camera is merely the vehicle for expressing your thoughts and ideas. It is sometimes suggested that I should go against all the existing rules but I assume that those who say that do not read existing photographic literature properly but merely have the books as ornaments in their book-case without using them.

Differential focus

We now come to a technique which is particularly important in the case of colour, namely differential focus, with selective sharp focusing as its optimum application. A photographer I know once said "sharpness merely has a function in relation to unsharpness". This statement can also be put the other way round and it can be used to very good effect through its merging of colours, particularly in colour photography. One seldom sees photos in which the technique of selective sharp focusing has been exploited to the full. I admit this is easy to say, but it requires quite a lot of patience and perseverance to force yourself to get that far. I have noticed in the lessons I give that it is an almost impossible task for many people and that, particularly at the beginning, a method indicated by me for sharp-unsharp can lead to a lack of balance in photos. This is due merely to an incomplete mastery of the rules of composition or, at least, the inability to apply them adequately. People are frequently able to rattle them off but not to apply them practically, they forget them while revelling in colour.

The use of a tripod is also very important. I would give as a rule of thumb that the tripod must be a lot heavier than the combined weight of the camera and lens. This is of prime importance when using lenses of a long focal length, when it is also necessary to ensure that the combination of camera and lens is well balanced. It can even be necessary to use two tripods in the case of lenses with a focal length longer than, for example, 400mm or to screw the lens rather than the camera to the tripod.

A second indispensable aid is a long and flexible cable release. If you do not have this with you, then use the automatic release on the camera. It is not provided solely to let you get in the snap together with the rest of the family!

When working with differential focus the lens determines the effect. The longer the focal length and the higher the speed of the lens, the less is the depth of field at full aperture, particularly if you are working with somewhat long lenses such as 300mm and 400mm. The effect becomes stronger as the lens increases in focal length. It follows from this that with sharp focusing a lot of attention has to be paid to where you want the sharpness. By working with differential focus it is possible to produce very fine romantic impressions, for example, by photographing an orchard through blossoms. A lens with a long focal length is used for this and focused sharply

on to the orchard. The closer the blossoms are to the lens, the less in focus they will be. The greatest problem arises when the exposure has been measured and shutter speed set. The degree of unsharpness now has to be determined in connection with the desired effect. In most cases the shutter time will have to be adapted since, the more the iris is stopped down, the sharper the foreground will become. With photos of this type it is generally the intention that the blossoms will come out completely blurred although recognisable, so it will be necessary to work at full aperture or stop down one stop at the most. In order to know what the effect is like, the pre-view button for judging the depth of field will have to be used frequently. It is an important advantage in most reflex cameras that the effect can be seen in the viewfinder with the aid of that depth of field button. What appeared so beautifully out of focus in the viewfinder at full aperture can in fact, through stopping down, have become sharp. The lack of sharpness will also best occur largely at the bottom of the photo or evenly all round. Lack of sharpness merely in one corner often suggests lack of balance in the picture.

It will have become clear from what has been said that a tripod is almost indispensable with long focus lenses. With a hand-held camera the result is uncertain, however experienced one may be as a photographer.

So far I have spoken about lack of sharpness in the foreground, for which there had to be as little stopping down as possible. However, it can occur that the more recognizability produced by stopping down a little will give the necessary suggestion of depth to a photo taken with a telephoto lens. Everyone has to determine for himself what effect he wants and how he wishes to achieve it.

You will see four landscapes on the following pages. The upper photo shows a small island photographed in freezing weather. The lower photo shows the same subject, but with a total lack of sharpness in the foreground, resulting from focusing sharply on the tree and scarcely stopping down. There were frozen reed stems in front of the lens. If I had stopped down the reeds

would have been too sharp for my taste and the romantic impression completely destroyed.

In the upper photo on the next page the sharpness is not completely in the centre, but the picture in the middle is built up from an unsharp zone in the foreground, followed by sharp rape-seed plants and then unsharp trees in the background.

The lower example is a landscape with a strong effect of lines due to shadows of trees which were kept just outside the picture. The sharpness is here solely in the foreground but, in contrast to the preceding photos, the 300mm lens was stopped down so far that the lack of sharpness in the background nevertheless gave the desired impression.

If in photos of this type I have doubts about the result, in spite of the use of the pre-view button, I take three photos in succession, each with a different aperture, adjusting the exposure by altering the shutter speed. This is not the same as so-called bracketed exposures which give variations of negative density. I shall be reverting to this when talking about landscapes in the mist.

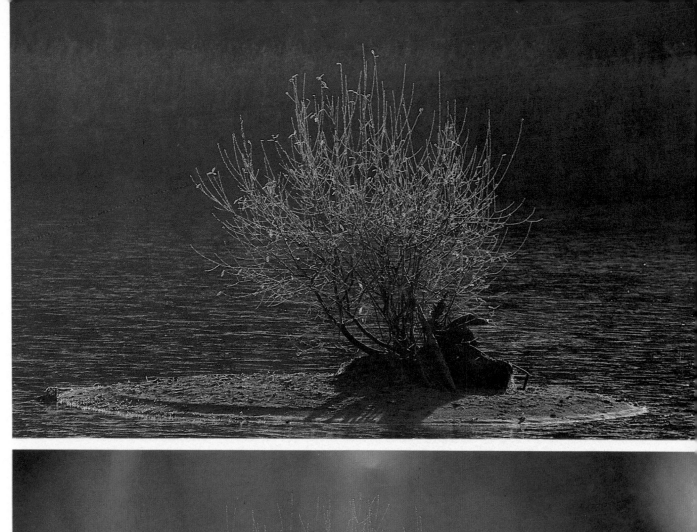

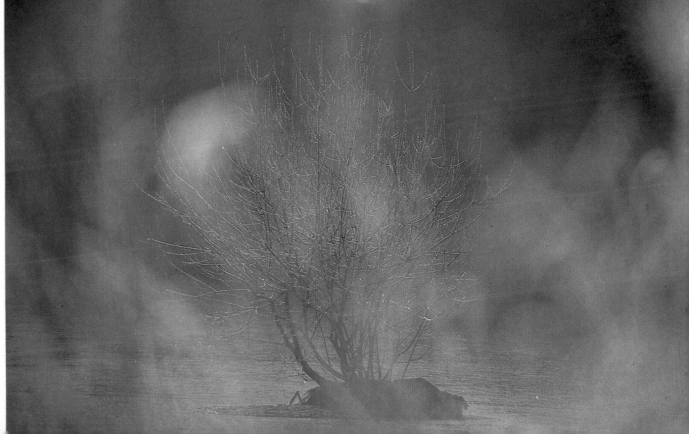

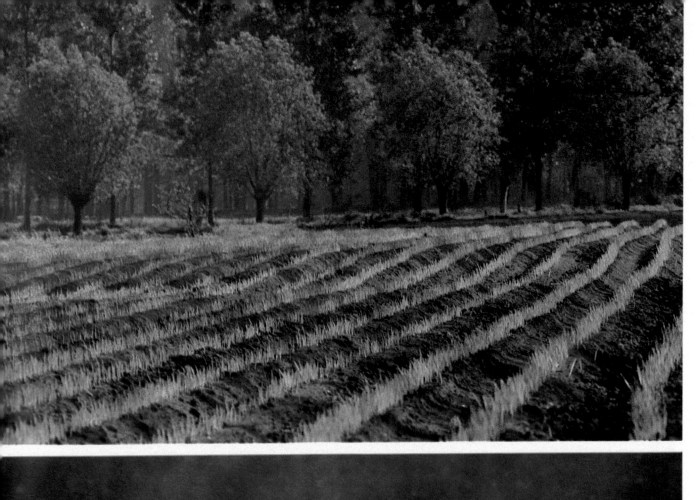

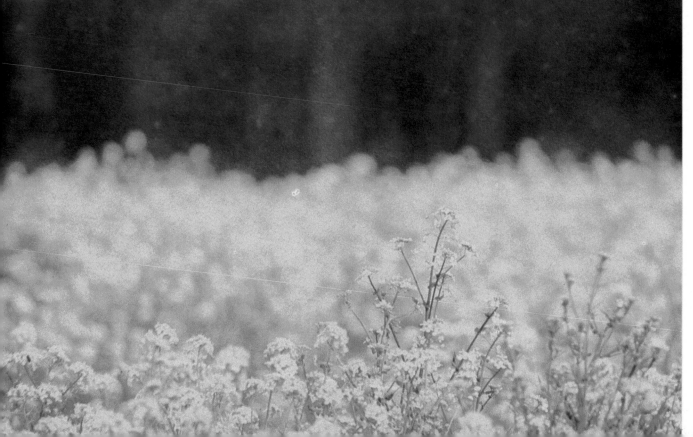

The standard lens

We have spoken about wide-angle and telephoto lenses in relation both to mastering perspective and differential focus but we did not consider the standard lens. In spite of my advice about the choice of lenses, I do not wish to overlook the standard lens which after all is the one most amateur photographers have. The standard lens could of course have been used for the techniques already described, but the effects when working with differential focus and the mastery of perspective are limited. Owners of a standard lens come into their own in the following technique, although the method which employs a full aperture and selective sharp focusing can also be used with all longer lenses, possibly up to 400mm or even 600mm. It involves using a converter.

I am sometimes asked in connection with buying accessories whether consideration should be given to purchasing a converter. I have nothing in principle against a good 2x converter but, in my opinion, the advantages do not outweigh the disadvantages, particularly for colour photography. Two diaphragm stops are lost and I find it a major difficulty with the slower colour reversal films. Furthermore, in my opinion, even the best converter affects the colour reproduction of a good lens so I think it is always better to save up for a second lens. The manufacturers of converters won't thank me for this remark but it is, in the final analysis, a question of results.*
To come back to the standard lens, I often hear amateurs boasting that they have bought a lens with a speed of f/1.4 or even of f/1.2. If I then ask why, I do not in most cases receive a sensible answer. Most of the time the diaphragm is used at f/5.6 or f/8; speed merely becomes a status symbol for many people. If someone really needed an f/1.2 lens in order to carry out quality work at full aperture, an aspherical lens would suffice. This is much more expensive, but does offer many advantages; for example, allowing one to operate

*Editor's note: this disadvantage has been completely overcome in the latest Adaptall Flat-Field converters.

with a full aperture when taking photos at night without any halation. If a normal f/1.2 lens is used it is necessary to stop down in order to obtain good results. When working with differential focus reasonable results can be obtained with normal standard lenses. This applies particularly to the technique to be described now by which we work with a full diaphragm opening, combined with extension tubes. I admit it is not customary in macrophotography to operate at full aperture when using extension tubes. There is necessarily a high degree of stopping down in that field so I am considering it in detail because magnificent compositions can be made at full aperture when the colours merge into one another.

Many photographers dare not work with a full aperture because they have read in test reports that the general picture quality and resolving power increases with further stopping down. This is true in principle, and it applies to almost every lens, but the resolving power with a full aperture is still more than adequate for the sort of photography I have in mind, although most very high-speed lenses will produce somewhat soft results at full aperture. This is, however, no drawback for my technique and it is consequently a matter of using creatively what someone else sees as a fault or shortcoming. Another frequently expressed view is that lenses with longer focal lengths are unsuitable. Nothing is further from the truth and they are, as a rule, more suitable. Those who wish to indulge in macrophotography with maximum sharpness must use a macro lens as a standard lens but using a lens with a longer focal length has advantages when photographing details at full aperture. If extension rings are used, it is possible to work a little further from the object, so that one does not, for example, knock the small leaf one wants to photograph. An important advantage of macrophotography with a full aperture is that it is often possible to manipulate freely without using a tripod. By not stopping down it is possible to make do with very short shutter times. If a tripod is not used it is of course essential to pay attention to composition. To give an idea of the possibilities, I shall explain in turn the various techniques for the five photos on the following pages. They

are all simple and can be carried out with any lens, provided one has a set of extension rings. The first photo with the blades of grass on which the light is just falling was taken with a standard lens and a $2\frac{1}{2}$ cm extension ring at full aperture. Pictures like this stand or fall by the sharpness of focus so care had to be taken that both blades of grass were lying in the same plane of sharpness. This photo also clearly demonstrates the 'rule' of composition that the highest light stands against a very dark background. I have already said that it is possible to work without a tripod, and it must be obvious why. It is often possible to make do with shutter speeds as fast as 1/1000 second at f/2.8, sometimes even making it necessary to use a neutral density filter.

The photo showing a lilac is once again surrounded completely by a lack of sharpness. It is, as it were, completely enclosed by it. Here I used a 300mm lens with a 5 cm extension ring at full aperture. The next photo, a leaf with raindrops, was taken with a 135mm lens and a $2\frac{1}{2}$ cm extension ring. This resulted in a small area in the lower left-hand corner that is sharp, while the rest of the photo relies entirely on the colour effect produced by the unsharp course of another leaf.

The photo below this, showing a branch projecting above the snow, was taken with a 400 mm lens without extension rings, but with selective sharp focusing. The second photo of the sun with reeds to be found on the first page of the book, always raises the question as to whether a very long focal length was used. It wasn't. The photo was taken with a 100 mm lens and a $2\frac{1}{2}$ cm extension ring. By focusing sharply on the reed panicle and including the sun in the picture, part of the reed stalk is sharp. The sun is reproduced very large since it is completely out of focus. If there had been any stopping down here, the sun would have formed unacceptable shapes, as in the case of the diaphragm shapes in the first photo. Photos of this type are not taken when the sun is high in the sky but with a low sun, preferably through a hazy sky. These photos all show that you can get very beautiful results with every lens, with or without extension rings, by selective sharp focusing.

Selective sharp focusing makes demands

When working with differential focus, whether with landscapes or details from them, there are a few very important points to remember. There must be no unacceptable high lights in the unsharp sections since they immediately give distracting light spots (unless one is aiming precisely at them, for example on water, so that they become an important or even dominating element). Branches on which there are a few raindrops or which are glistening in the sun can be particularly disturbing. They create a confusing effect particularly if they run across the picture. Special attention must be paid to this since the effect will be very much more pronounced on a transparency than it was through the viewfinder and, just as in black-and-white photography, the shadows come over much harder than they seemed at the time of taking the photo.

I sometimes add a soft-focus attachment if I want to obtain very soft colour impressions. This makes a welcome change when projecting a series. One can pass from a sharp picture to a soft one and vice versa and still remain artistically acceptable. It is obvious that colour harmony must not be forgotten and that it is best to work with soft colours and contrasts.

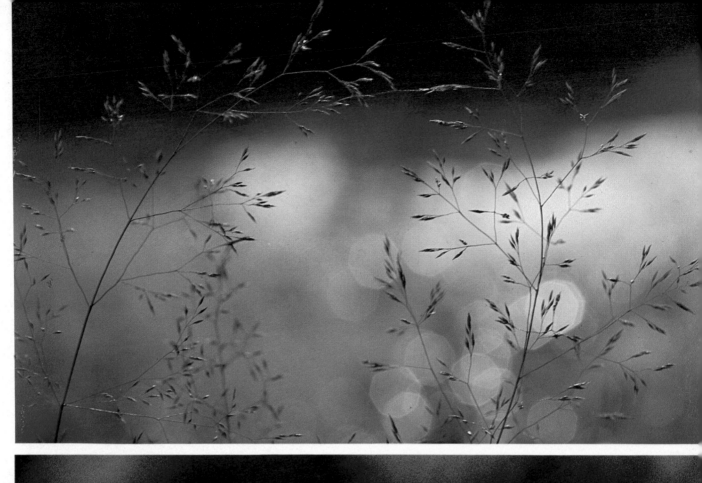
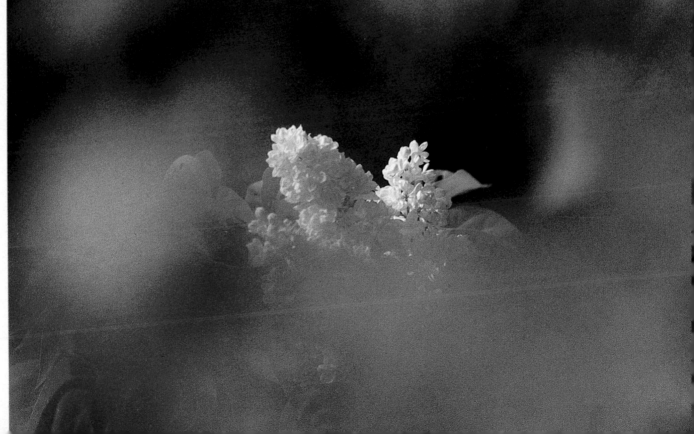

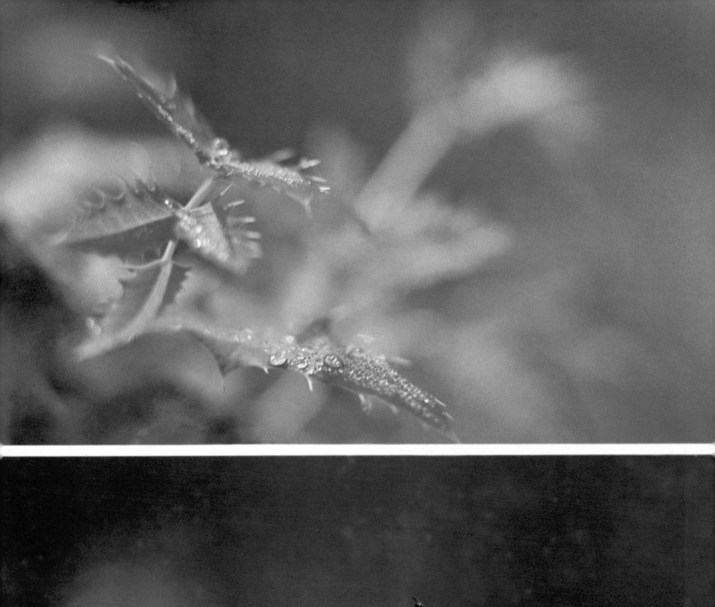
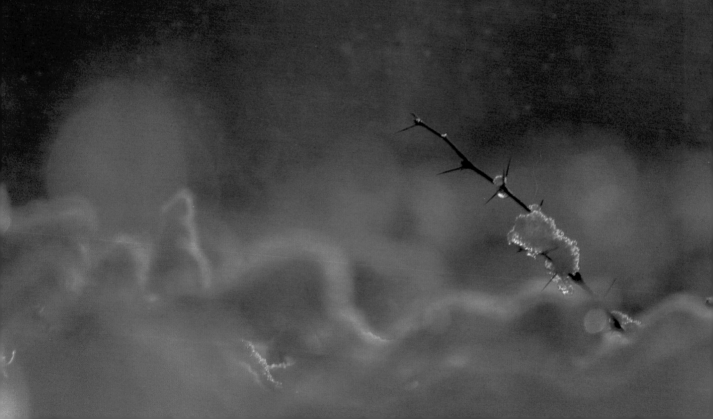

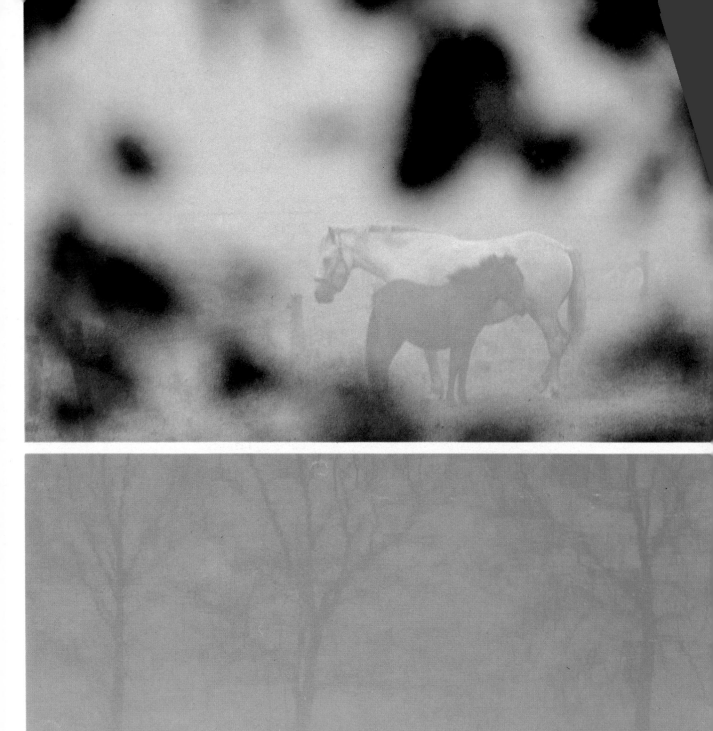

Landscapes with mist

A complaint frequently voiced by amateurs when photographing in mist is "my transparencies close up completely". One could say that the photos are literally absorbed in mist. The major fault committed here is incorrect interpretation of the meter reading and beginners would do well to read a book about the proper technique of exposure. What in fact happens in mist? The meter measures the whole, fairly light picture area and then indicates an improbably tight exposure. If this meter reading is used then a completely over-exposed transparency results. In order to master this problem, a series of exposures can be made. For example, 1/125 second at f/8, 1/125s at f/5.6, 1/125s at f/8, and 1/125s at f/11 when the meter read, for example 1/125s at f/22. When these transparencies are processed it will probably be seen that the transparency taken at 1/125s and f/8 shows the soft atmosphere observed when taking the photo.

I am often asked: "if the sun breaks through, giving a sparkle to the edges, do I then use a polarizing filter?" In most cases I would say no because usually a polarizing filter destroys part of the mood, and that's not what you want in this type of photography. This filter can be used to good effect in landscape photography in general, but be careful not to "filter the landscape to extinction". I mean by this that, if all the sparkles are eradicated completely, a deadly landscape results. The filter must be used very selectively when there is mist, and you must study the scene in the viewfinder where the effect can be judged. The same advice applies to snow scapes. If they are taken precisely according to the meter, they tend towards blue because of under exposure, while the sparkling nature of contre-jour light is lost completely. In spite of automation, adjustment is still essential for those who wish to arrive at their own interpretation when using a meter. Even with non-adjustable automatic exposure cameras it is possible to vary the exposure by changing the setting for the film speed.

With misty landscapes it is also sometimes an idea to use artificial light colour film, resulting in charming blue transparencies, particularly with over-exposure. As an illustration I have shown three photos taken in mist and fog. The photo on p.27, showing two horses with unsharp leaves in the foreground, was rendered very soft by the mist and was taken at full aperture. A soft-focus attachment was also used. When using such attachments you should not stop down further than f/5.6 or the effect will be lost.

The lower transparency on p.27 was taken of a lake in which trees were reflected, while the sun was just coming through the mist. It has revealed the soft, silvery ripples in the water and the trees are reflected as a soft tint in the water.

The upper photo on p.29 was taken using a super wide-angle lens in misty weather when the sun was just breaking through, although it was kept behind a tree. You can see here the distinct improvement in perspective, resulting from tilting the lens obliquely.

Fish-eye effects

The last two photos in this chapter were taken with a 15mm fish-eye lens at f/2.8. I am well aware that not everyone possesses such a lens and this is understandable since they are made for very specialized photography. But they can, in the hands of a creative photographer, result in very distinctive transparencies. A characteristic of fish-eye lenses is the extreme distortion they produce at the edges of the picture, but with no loss of proportion in the middle. If such a lens is used at an extreme angle, for example obliquely upwards, then the horizon is reproduced as a curve. This can be seen in the lower photo on p.29. The distance from the tree was three metres and the camera was held obliquely upwards, as a result of which the tree looks as if it were standing in a sort of valley. The sky is somewhat darker on one side than on the other, but that of course is because of the incidence of light at this extreme shooting angle. The photo on p.30 is a landscape in which the canal runs as a curving diagonal

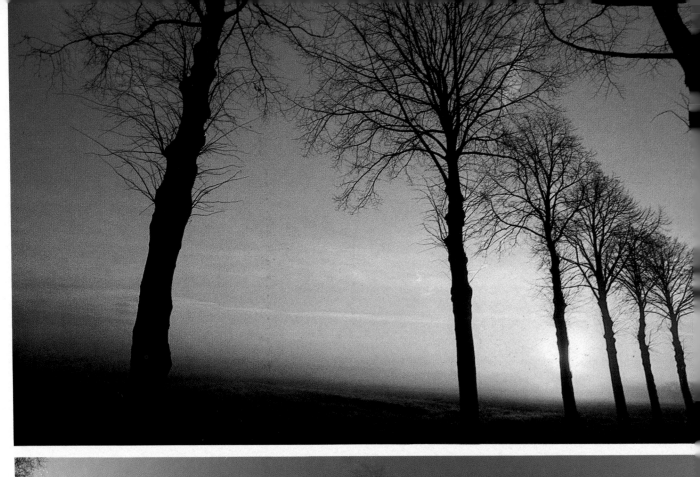

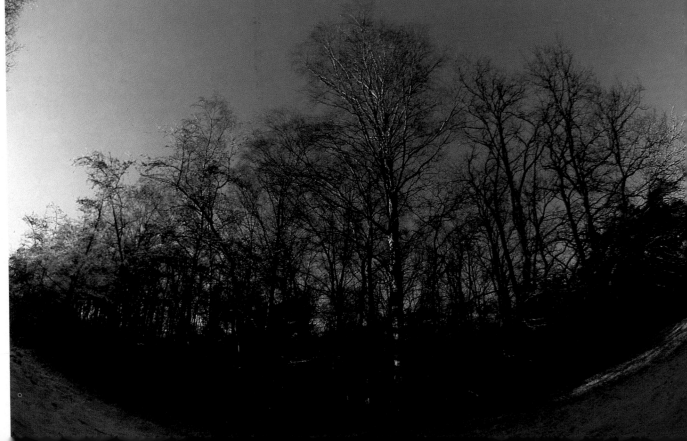

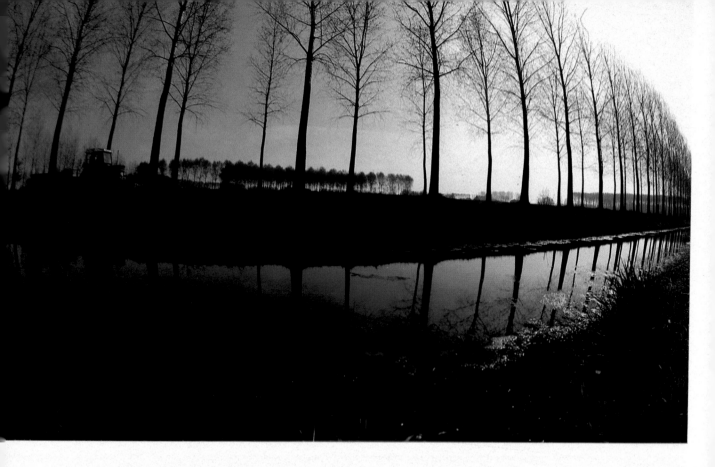

through the picture. Finding subjects for lenses of this type is difficult since good composition is essential with such extreme shooting angles.

There are fish-eye supplementary lens attach-ments which can be used in combination with another lens. They give a circular image within the picture area and do not cover the whole picture frame.

2. Impressions, reflections, double exposures

Is impressionism in photography acceptable? This is something one might well ask; at the same time considering whether colour lends itself better to it than black-and-white. Let us begin with the first question. Many amateurs who are completely free in their approach to photography still adhere to the belief that everything should be in focus from the foreground to the background. I believe we shall gradually have to get away from this view because people will never achieve a personal interpretation if they adhere rigidly to the sharpness syndrome. I am sure that impressionistic photography is not appreciated by everyone but, on the other hand, if everyone were to find everything beautiful in the same way that I do, I would do better to throw my camera on the scrap heap—there would be nothing more to discuss! I think it is possible to answer 'yes' to the question of whether or not colour is more suitable than black-and-white for impressionistic photography. It is certainly more difficult to arrive at an acceptable impression of one's own because of the extra dimension. This is evidenced by the endless production of transparencies which tell us nothing because the authors thought it was impossible to do anything with a transparency. For years the transparency has been a starting-point for my colour prints which I made initially via an inter-negative, but now in most cases do straight on to Kodak RC 14 paper. Very occasionally I still use internegatives if there is no alternative and I shall come back to this in detail in the final chapter. It is clear that it is more difficult to express oneself in colour, particularly if one is, for example, engaged in documentary photography. Colour quickly introduces something cheerful which is not always required but it is possible to adapt colour to this very difficult branch of photography where it makes a major contribution, without making it more cheerful, by adding an element which greatly increases the value of the impression. One must exercise self-criticism to an unprecedented degree before attempting anything in this direction. Criticism will at first not be inappropriate, rightly in my view, since the result has to appeal to others. Many people think that it is permissible in this sort of photography to ignore all the rules of composition and science of colour, but that is far from true. It is here that the rules reviled by so many modern photographers are most applicable. I am well aware that this might sound controversial but it is frequently possible to recognize in modern photography a clear influence of the doctrine of composition – often in the work of those who say they do not wish to be influenced by it. They omit in most cases to say that it has become a sixth sense for them! I have already alluded to this in the preface. Very much could still be said about the subject, but I should now like to return to the title of this chapter, or at least to a part of it.

Double exposing

Double exposing is making an impression by means of two shots on one transparency. This technique is dealt with fully in the chapter on zoom technique. It will be obvious that you have to plan such shots beforehand. Just taking two photos on top of one another has no purpose at all so you must select two or more appropriate subjects and utilize them to the full. In the example on p.33 you can see a row of trees which, by means of three exposures on one transparency, creates an increased impression of denseness in the wood. The camera was moved slightly after each separate exposure and a tripod is needed, otherwise you can't be sure of what is going to happen and that is not the intention. The result must be visualized beforehand. In order to obtain an acceptable density, there must be a shorter exposure than indicated by the meter when making multiple exposures. With a normal double exposure one stop smaller than the measured exposure time is used for each shot. With more shots on one transparency two stops smaller should be used in each case. It is possible to get variations by making the first shot very dark and the other much lighter exposure time, but this is a question of trial and error.

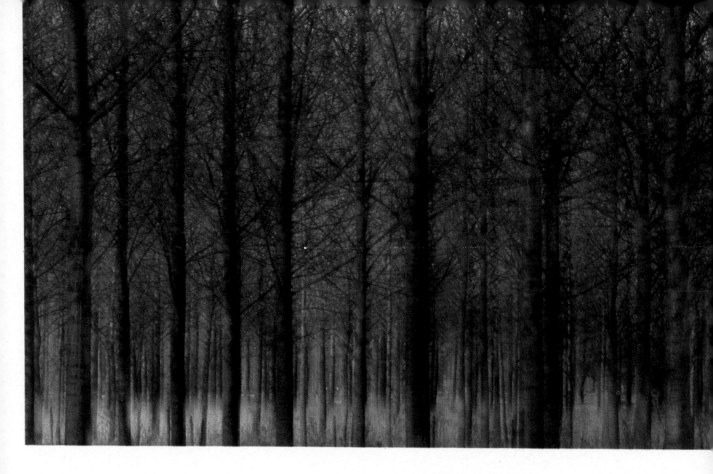

Sandwich techniques

Another method is to sandwich two transparencies together. This is in fact the opposite of the double exposure technique because two transparencies are mounted on top of one another, each having been taken separately. This means that each transparency has to be over-exposed by one stop in order to achieve an acceptable amount of light. If this is not done, then the picture becomes far too dark. It is necessary to take account of another important factor when sandwiching – that it is advisable to mount the transparencies with the emulsion sides against one another in order to avoid Newton's rings. Newton's rings occur through interference between the transmitted light rays and those partly reflected on surfaces in the layer of air so the distance between the surfaces must be very small, no more than a few wavelengths of the light. This can give rise to problems, especially when mounting because we have to ensure that the emulsion sides are in perfect contact. It should be taken into account when taking the transparencies. Since not all transparencies are specially taken for sandwich mounting, there will obviously be deviations from this rule. In such cases Newton's rings might occur, but they can often be avoided by mounting a piece of colourless transparent foil between the transparencies. Look at the example on p.34. It was made from two single shots of a fir tree, both over-exposed by one stop and then mounted together in one transparency mount, and shifted in relation to

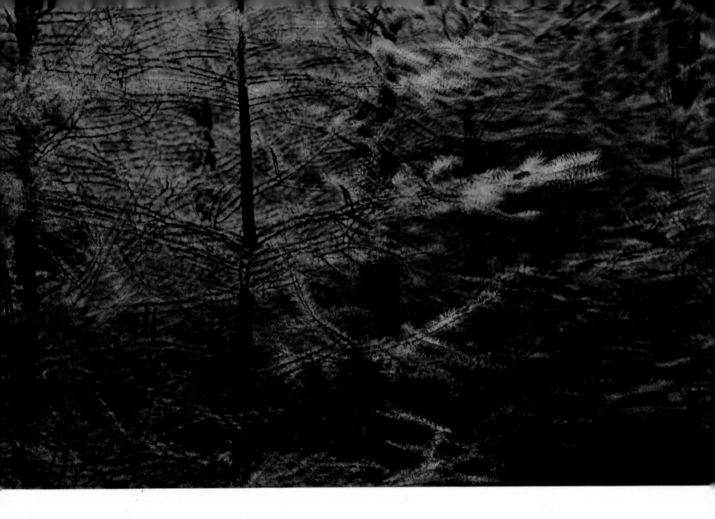

one another. This produced the whirling autumnal
effect. The transparencies have also been rotated
slightly. Both double exposing and the sandwich
method have to be practised with feeling and
understanding since one can easily produce
results for which the term 'kitsch' would be
flattering! If people want to indulge in this and
start looking for their old, over-exposed trans-
parencies, they are already on the wrong path;
there is no question of well-considered production
or of a personal creation, but only of a method
being degraded to a procrastinated receptacle
for rubbish which should long since have been
thrown away. I have no objection to people
first experimenting with old over-exposed trans-

parencies to see the effect of the colours, provid-
ing it's done in order to arrive at artistic end
products but such products seldom lead to accept-
able results. It could be that a person has an
idea; for example, a landscape behind which a
specific structure could be placed. If the land-
scape has already been taken, but there has been
no opportunity for taking the picture one wants
to put behind it, the landscape should be stored
with a note about what is to be done with it. It
is wise not to wait too long since otherwise it will
be forgotten but it can of course also happen
that the appropriate opportunity will not occur
until much later.

The photo on p.35 is an example of this. The

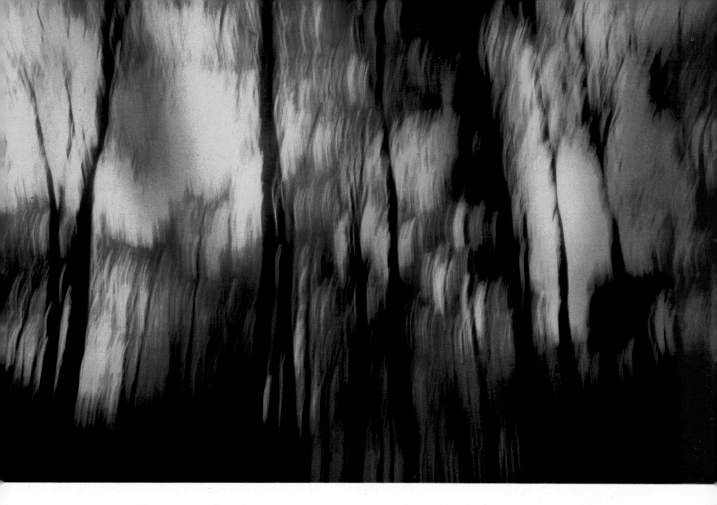

intention was to create an impression of autumn for which bare trees were necessary. They were taken with a wide-angle lens and the camera was moved during the exposure. I then experimented with all manner of unsharp backgrounds to try to obtain an impression of autumn but without success until I had the idea of photographing fallen leaves on the ground very much against the light and out of focus. The camera was also moved while taking this but the sandwich was not successful. I had not taken account of the technique used when taking the first shot. It had been taken with a wide-angle lens moved vertically upwards driving a 1/8 second exposure, resulting in somewhat crooked trees. The second shot with the autumn leaves taken against the light and out of focus should have been taken using the same technique to form a properly matching composition. When I had retaken it, I obtained a successful montage which was considerably stronger than the first photo which did not fit and it is clear that details can sometimes decide whether a specific technique has been successful or not. The result in this case is a very deviant autumnal photo which certainly doesn't resemble a straight shot. This does not mean that I could not appreciate a good documentary autumn photo, in focus from front to back, but in my opinion deviation widens the photographic possibilities enormously. It is quite

understandable that many amateurs should initially choose autumn for their colour shots. The range of autumnal colours is after all fascinating, but unless one is careful it can degenerate into revelling in colour – by no means a beginner's fault only. The old proverb of "moderation in all things" is applicable here.

Often the sandwich does not have sufficient contrast but it can be increased very simply by duplicating the transparency. This automatically results in greater contrast. Duplicating can be done using artificial light for which artificial light type colour film must be used, or using electronic flash for which daylight colour film is appropriate. I prefer to work with Ektachrome artificial light film and a special duplicating film is available commercially, but only in packs for large-scale users. It has a low contrast. If you want to duplicate with normal film without obtaining a higher contrast, it is possible to give the film a preliminary exposure of 1/1000th of the measured exposure time. When doing this attention must be paid to the fact that the sensitivity has increased slightly while the contrast is reduced. Very marked contrasts can be bridged by mounting a faint black-and-white unsharp negative behind the transparency and then duplicating. This is called "masking". It is essential when using this method that the negative is exactly behind the transparency and not moved at all, since otherwise a bas-relief effect occurs in the new transparency. Relief can be used as a creative technique by making a hard negative and mounting it slightly out of register with the original transparency. If duplicating is done afterwards, a higher contrast is obtained than by employing a mask. This method is, in my opinion, less suitable for landscape photography but I shall come back to it when discussing sport photography. I have already mentioned a very short preliminary exposure as a way of softening contrasts but it is also possible to give an after-exposure. I have said I preferred duplicating on artificial light colour film or on special duplicating film. If I were to work with electronic flash on daylight colour film, then I should always have to reckon with very short times, but with artificial light colour film I can employ more acceptable

times as a result of which, in my experience, the copies themselves become less hard. A duplicated sandwich transparency is sometimes called a double exposure, but for me it remains a duplicated sandwich transparency. This is in order not to create any confusion with the genuine double or multiple exposure which is produced directly. Duplicating transparencies can be made easily with a bellows extension and a 35mm slide copier and there are copiers available which incorporate a contrast control facility.

One method of obtaining very coarse grain in a transparency is to enlarge a small part of it but it is also possible to use a film which itself has a coarser grain – High Speed Ektachrome artificial light colour film for example. Illustrated here are a few sandwich transparencies which were not duplicated since the colour reproduction did not make duplicating necessary. On p.37 is a sandwich transparency of trees which were photographed in misty weather, leaving the background completely free for a personal interpretation of the sky. I waited until a suitable moment presented itself and then took a photo of the sky from a recumbent position. I then mounted the transparency vertically behind the transparency of the trees so that the striving-upwards effect of the trees was further accentuated. The example on p.38 is also a photo of trees, combined with a transparency of reflections on a surface of ice. This combination provided me with an impression of winter. This technique can not only be used in a landscape, but in innumerable other ways, possibly combined with various techniques involving movement and zooming. I am sometimes asked at lectures why I always disclose my techniques. The answer is simple. If I did not, then I should not need to come and talk. After all, a speaker is always invited so that you can learn something from him. There is, however, a danger in telling people exactly how you have done something. A friend of mine had made a magnificent transparency of a landscape on which he wanted to obtain a reticulation effect, i.e. a sort of crazed effect such as seen on oil paintings. He got the idea of putting the transparency in the kitchen oven and the result was staggering. Everyone praised it until he was asked how he had done it.

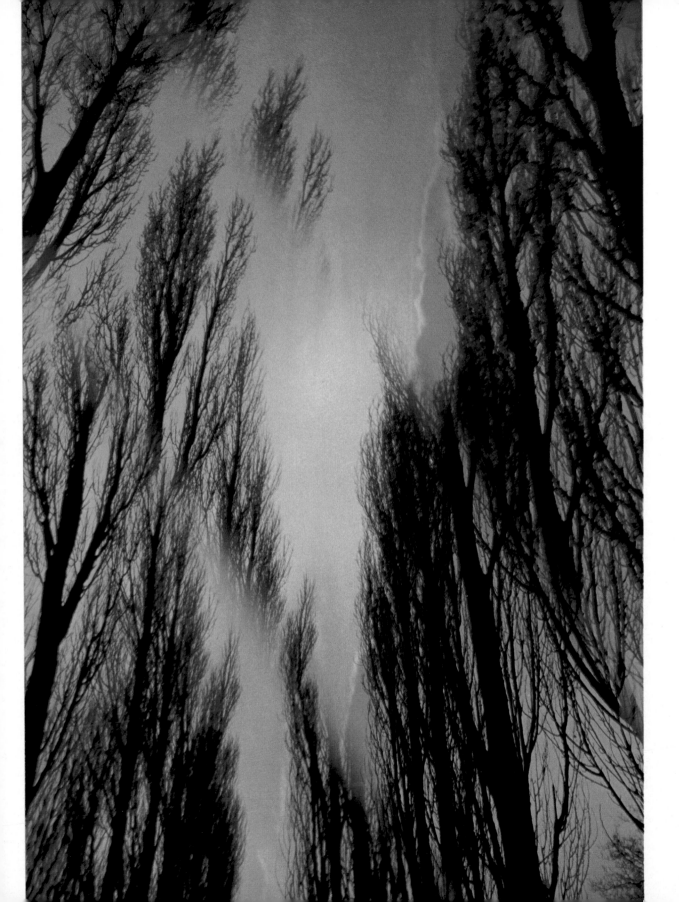

He revealed this in a completely honest way and then there were disapproving comments from the hall, mainly from people who do nothing but fiddle black-and-white photos in all possible ways in the darkroom. It can be concluded from this that what is regarded as perfectly normal in the case of black-and-white photography is often unacceptable in colour photography.

Reflections

Another method of achieving impressionistic photos is to use reflections on water, which is where they are often found, although it is also possible to take them in shop-windows, chromium hub-caps of cars and virtually all other shiny surfaces. When photographing reflections account should be taken of a basic rule (although as with all rules, there are of course exceptions) which is that you must at all times have the sun firmly at your back in order to get the most brilliant colour reproduction. Beautiful results are then obtained if the reflected object is lying in the sun and the water in which it is reflected is in the shade. As proof of this I deliberately

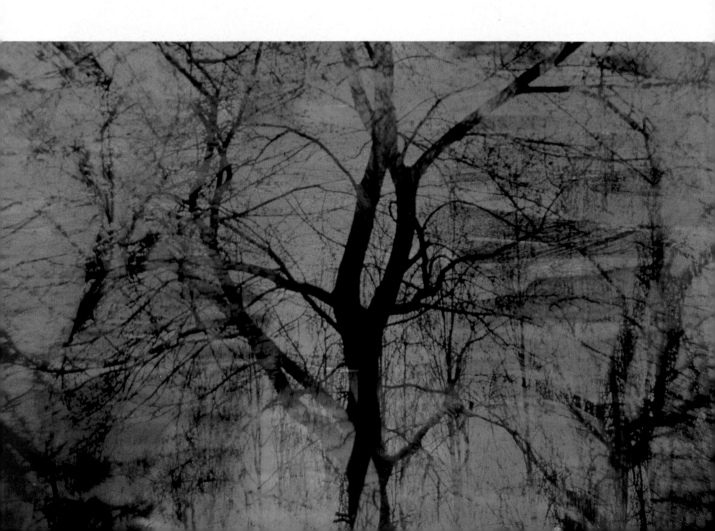

deviated from it in the first example on page 38. What you see is the reflection in water of a shed which is painted yellow. We see a colour composition of blue (of the water) and yellow and brown (of the shed). I photographed the shed, or at least its reflection, from the side and with the sun not right at my back but coming obliquely from the side. The result is that the side of the shed on which the sun was shining reflected its correct colour in the water and the part lying in the shade does not – it has a brownish hue. One is obviously also dependent on the way the water is moving. If there is a lot of wind, hardly anything can be seen because of the ripples. If there is no wind at all, the reproduction of the reflection is almost as sharp as that of the subject so it is best if the water is moving gently. It follows from this that,

if you want to depict the impressions fairly sharply, a shutter speed of at least 1/60th second or even 1/125th second has to be used, unless it is intended to let the colours merge. It is then possible to use longer times but a tripod is necessary. A lens with a longer focal length than standard is usually best for this type of photography. The determination of the composition is particularly difficult in the case of reflections. You have to look for the clock-work repetition of the pattern although it never repeats itself exactly. If there is hardly any wind, it is possible to produce ripples by throwing in a stone. In order, for example, to obtain a picturesque effect in the case of leaves reflected in water I sometimes throw in a handful of sand. This produces a very fine ripple. There are people who think that a

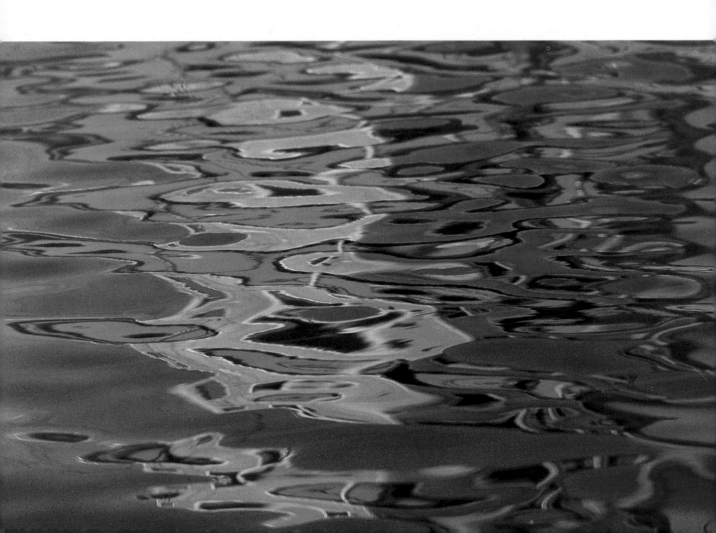

polarizing filter is necessary for taking reflections but nothing is further from the truth because the blue reflection of the sky would disappear and the water would take on a dirty green or grey tint. Yet, such a question is understandable since it is often said that the light contrast is reduced when using a polarizing filter resulting in the colour contrast being increased. Very brilliant colours often occur in reflections produced according to the rules given above and that probably accounts for the questions.

The photo on page 40 was taken when I came to a ditch above which a washing-line with coloured linens was stretched. There was no wind but after I had thrown a stone into the water, the coloured pattern reproduced here was formed. The upper photo on p.41 was taken in a café directly opposite which a barge was moored and this was reflected in the window. The window itself was covered with paintings of a Mondrian-like pattern. By focusing sharply on the reflection in the window, the paintings, were out of focus while the barge was sharp. An extremely short exposure time and a virtually full lens aperture were used in order to avoid getting any patterning in focus. It is precisely this lack of focus which ensures the atmosphere in the photo. Reflections can be found everywhere if you look hard enough.

The lower photo on page 41 was taken of a truck on a building-site after a heavy shower of rain, just as the sun was breaking through. It was taken from a very low viewpoint using a standard lens. The photo was turned upside down in the presentation, resulting in this unreal effect. Someone who is creative does not always need a whole set of lenses – he can manage with a standard lens although this sometimes involves

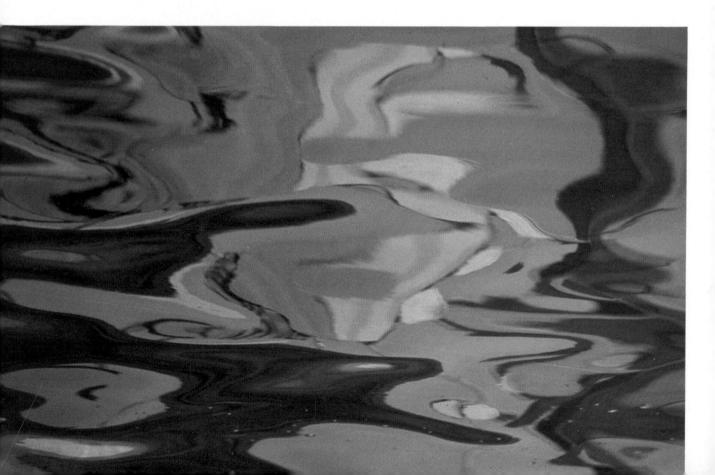

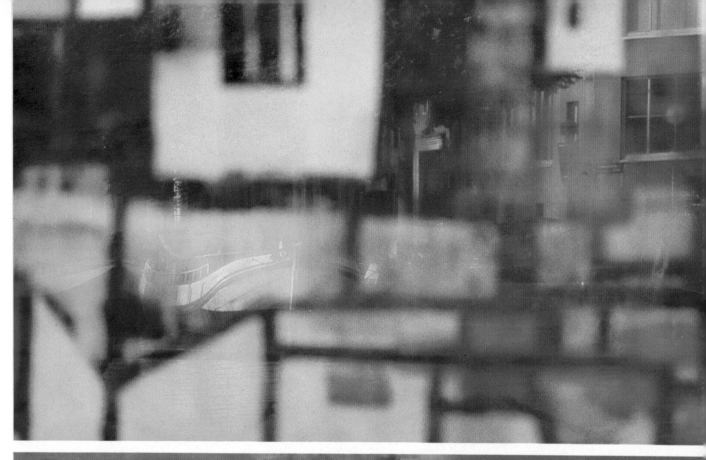

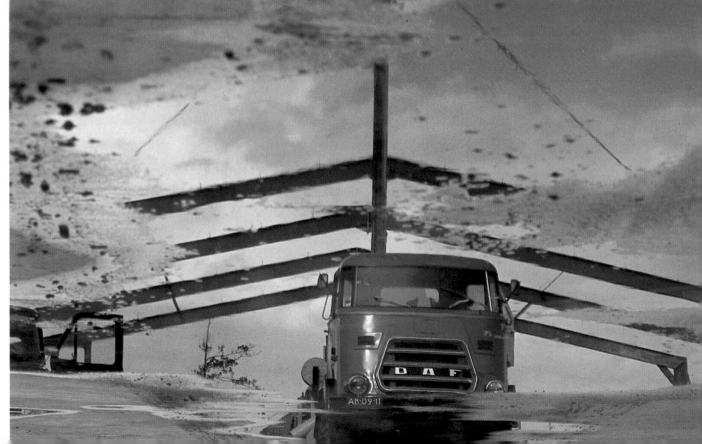

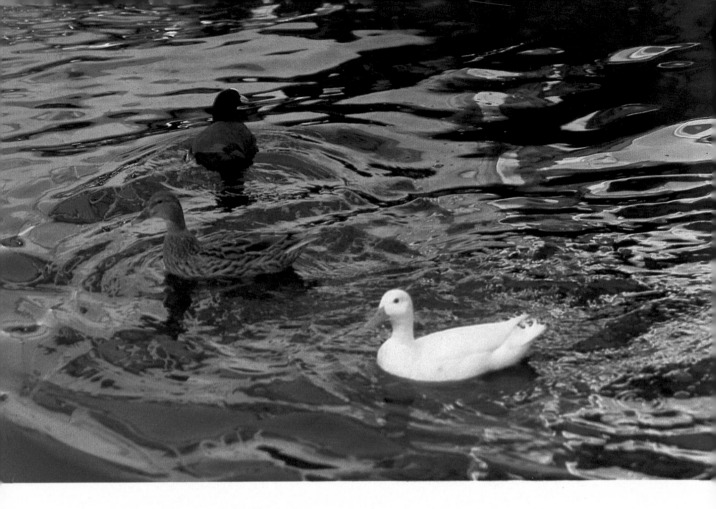

a little more effort; but the satisfaction is no less. Creativity has to be developed by "seeing" and not by purchasing a whole series of lenses.

I mentioned that, when taking reflections, care must be exercised to have the sun at one's back but when photographing reflections in objects which are close by, there is a danger that one appears in the picture oneself. This can be avoided by photographing the object from an oblique position. In such cases I frequently use a 135mm lens with an extension ring, particularly for example, when photographing reflections in car wheels.

People will at a given stage automatically arrive at the idea of using a reflection in water

as a décor for simple motifs such as, for example, a photo of swans or ducks in water, because it gives an extra dimension to a very ordinary subject. The advanced photographer probably looks down somewhat deprecatingly on an amateur colleague who is standing photographing ducks. Nonetheless, you can look forward to very creative effects from them if you are prepared to go through life with your eyes open and have the necessary patience. Look again at the photograph of ducks swimming in "gold". This reflection came from a very low sun on a summerhouse and the ducks were there to complete the ingredients for a good shot. The only problem in such a situation is how to get the ducks precisely

where you want them. The only solution is to wait with the camera at the ready, an hour if necessary! The first evening I was unsuccessful in spite of waiting for a long time. The next day I returned at almost the same time and after waiting for a while I got two ducks right in the middle of the reflection. At such a moment I make not one, but at least five photos using different exposure times. Such a photo is quickly dismissed as being a mere fluke but this is because the person judging it projects the situation too much on to his own train of thought. Many of my photographs result from concentrating for hours on the motif. If I am not successful on a given day, then I start again the next day.

Impressionism

When we speak about impressionism in photography, we can think of other ways of achieving it, for example moving the camera in the case of stationary objects. I shall be reverting to this in detail later in the book when discussing photographing moving objects, because this is one of my favourite pursuits. The photo on page 43 shows total blurring. The subject consisted of three sun-blinds which occupied an exactly diagonal position in the picture. It was really too static so I thought of moving the camera. But how did I get it in the correct spot in the picture from the point of view of composition,

and how did I keep the course of the lines straight? I solved the latter problem by using a tripod. That may sound like a contradiction – using a tripod when the camera was moved – but, the lines had to be straight so I put the camera on a tripod in order that it could not be moved horizontally. The only movement possible was in a vertical direction. The shutter was set at 1/30th second and, in order to select the moment at which the shutter had to be released, I moved the camera using a 300mm lens fairly quickly up and down over the subject. When I knew with a probability bordering on certainty the exact moment to release it, I took the picture and then made two more since I wanted to be certain of the result. The third photo was the best and that is the one shown here. The photo on p.44 reminds me of what Ernst Haas once said: "I spread the colours over the transparency just as the painter does with his colour." It is a composition in red, grey and yellow and there is nothing sharp at all in the picture, probably not to everyone's taste. I was out to take photos in the rain – something quite inexplicable to many people who are generally frightened of getting their cameras wet! When photographing sailing events for example, it's impossible to avoid the camera getting wet, and I must say I have never had any trouble afterwards. As a result of a good shower of rain my windscreen presented a totally blurred picture of the entrance to the station in front of which I was waiting. The outlines were blurred so I decided to continue observing the entrance to the station until there was an interesting colour composition. I deliberately set the camera a little out of focus and after waiting for quite a while,

the opportunity arose, and that's how this photo through the windscreen was taken. I then parked the car and started looking through shop-windows covered with rain in order to get impressions in which I wanted to show merely the window with the rain in focus, allowing the rest to become blurred in colour. Once again I used differential focus. This is the way in which the last photo in the chapter was taken. It shows that you don't have to stay at home when it is raining because it is a good time to take artistic photos.

Reverting to the subject of the wet camera, if it is possible the front lens must be protected with a lens hood. If the lens still gets wet, I clean it with a lens paper and sometimes a lens cleaner. We are frequently warned against this since the lens coating is said to be so soft that it would be damaged, but I haven't yet found this true. I reject the use of an ultra-violet filter for protecting the front lens since I do not want to add any extra reflecting planes to my accurately designed Canon lenses. I consequently regard this ultra-violet filter as completely superfluous since at times when it would be necessary according to the rules, a haze filter is more appropriate.

3. The zoom lens and its creative possibilities

When buying lenses we are faced with the choice of a zoom lens or a set of separate lenses. As I said in the first chapter the ideal combination for the amateur is initially a lens of 35mm focal length and a short telephoto lens of about 100mm. However, the position is the same in photography as in other hobbies – as technical skill increases, you need to move on to more advanced apparatus. I have already mentioned the value of a 200mm lens in this context. The position is just the same in amateur circles as with professional photographers. People begin to specialize in a given field of photography. Those who specialize in macrophotography will probably wish to acquire a macro lens with bellows and, possibly, extension rings or focusing bellows. On the other hand those who decide upon theatre and night shots will probably acquire a good large aperture aspherical for this. However, if you are devoting yourself to general photography, it is worth considering a zoom lens. The argument that these lenses are terribly expensive cuts no ice, although the zoom lenses of well-established camera manufacturers, are somewhat higher in price than the alternatives offered by specialized makers If one has a good make of camera with accompanying lenses and adds a lens of a different make to it, then it is usually visible in the colour reproduction. I discovered this by bitter experience. Once when I needed a lens with a long focal length and really could not spare the money for it, I also bought such a lens, but after the first few films it became clear that there were such major differences that I immediately exchanged it for a Canon 400mm lens. I don't mean to say that lenses not linked to a make of camera are bad but it does seem that the colour reproduction of a lens of another make is different.* I also found that I had to stop down one or even more stops to obtain an acceptable reproduction of contrast. It is necessary, particularly in the case of sport photography, to work with a full aperture, and when using slow colour films. Even though I use the new Kodak Ektachrome Professional 200 film, it is still often necessary to work with a full aperture, in spite of the fact that this film can be revalued upwards to a large extent without any appreciable difference in colour. This is a considerable improvement on the old Ektachrome High Speed Professional and I shall be reverting to this point in detail in the last chapter.

It is quite possible that in the course of time you will want to exchange your 100mm lens for a zoom lens, for example a 100–200mm, or a 80–200mm. As far as the purchase price is concerned, you must bear in mind that it is always lower than the cost of several lenses of the same quality with different focal lengths. A 80–200mm lens is, moreover, highly suitable for the techniques described in this chapter, mainly in combination with Kodachrome 25 especially if the lens can be stopped down to f/32, meaning that a neutral density filter is in most cases unnecessary. I regularly use 80–200mm and 85–300mm lenses. The latter is really the ideal for the sport photographer.

There are also shorter (wide-angle) zooms such as the 28–50mm and the 35–70mm lenses. These are ideal for the photographer working as a reporter and they both offer the opportunity for close-up working. Those who really want to work seriously with macro-photography would do better to purchase a macro lens.

It is often said that zoom lenses are worse than lenses with a fixed focal length. This is no longer true, at least not for lenses of the best makes. Likewise, the frequent complaint that a zoom lens cannot be used for shooting against the sun has to be relegated to the land of fables. I even use my 85–300mm in extreme contre jour and have never had trouble with reflections. A lens hood does have to be used, but that goes for every lens however good it may be, not only in sun but under all circumstances! A third complaint is the distortion zoom lenses are said to have. There is hardly any further question of this with branded lenses and the longer zoom lenses. However, you only get what you pay for and cheap zooms are a false economy.

I recently read in a German photographic

*Editor's note: this was written before the introduction of greatly improved lenses by independent manufacturers which match camera makers' lenses in every respect.

48

magazine a remark by a well-known photographer that he regarded the Canon AE-1 with two zoom lenses, namely the 28–50mm and the 80–200mm, as the ideal combination for the amateur photographer. This was not merely because of quality, but also compactness and at the same time because this combination covers almost the whole of the amateur's needs. A substantial photographic bag with a whole set of lenses in it–28, 50, 100, 135 and 200mm–cannot be carried in comfort. This is a thing of the past with the advent of zooms. I would advise those who are on the point of making a definitive purchase also to consider the creative aspects of the zoom lens. That is what this chapter is about. After reading I think it will not be long before you decide in favour of such an ideal piece of modern optical equipment. I mean this not only for the colour photographer, but also for the avid worker in black-and-white. Famous examples are the zoom lens portraits by well-known American photographers as well as the sport photos by the sports photographer Gerry Cranham who may well be called a trend-setter of modern zoom techniques in this field. The creative aspect has always been of decisive importance to me when purchasing lenses. In filming, including amateur filming, the zoom lens has long since become common currency and no self-respecting manufacturer would put an ordinary lens in a medium-class film camera. The zoom lens has unfortunately not yet become popular in still photography, although things have recently begun to change, partly through the influence of the professional photographer who has long since realized its advantages. Everyone knows the effect of zooming in on a shot with the movie camera. The fact that the same thing is also possible with the modern still camera and that one can obtain very artistic effects with it is still something of which only a few people are aware. They think the only advantage is that one can have many different focal lengths at one's disposal. What I regard as the most important aspect has received little attention. The effect of zooming with a still camera naturally produces a completely different result from that produced by a movie camera, although there are certain points of agreement. If a zoom

picture is shown at a lecture, one hears people say that it is a fluke, a trick, or a result of the technical ability of the optical industry. They completely disregard the fact that every technique, however difficult it may be, can be learnt with a little perseverance and as soon as one can pre-visualize the effect it is possible to use it creatively. Why should such a technique then be called a trick? The question is also often asked: "how many rolls did you shoot for it?" That question is just as unreasonable as asking a black-and-white photographer how many 10×8 in sheets he used for an enlargement! We find in every book on photography the advice not to be sparing with film material. That always holds good, but it is not true that the techniques described here necessarily swallow up extra film. It is true that, if I am not sure of the result, I take several photos but in my view that is quite normal. People must really regard transparencies just as the black-and-white photographer does his negatives. The ultimate aim is a photograph, and that is something quite different from turning out transparencies on a conveyor belt. They are impressions, each appearing for a very short time on the screen, which in turn fade away quickly and little remains in the memory. The result must be a photo which appeals. People sometimes say: "I hang it in the room for a month and if I still like it, I show it to others since I can then support it." Ger van de Berg wrote a very admirable sample of self-criticism about his own transparency archives in the monthly magazine "Foto". Of the 2000 he had taken and kept over the years, he kept back only 20 when he started enlarging them. The enlarging of transparencies on reversal paper added a totally new dimension to colour photography which caused him to think quite differently. I have already said that this book could be of benefit to those who make transparencies in series but this need not contradict what has just been said. It does confirm my plea for a better sort of photography in a series sequence so that they create, in combination with music, a stronger overall impression than is now the case. It often happens that people lose sight of their standards in a series, merely in order to complete it. A zoom lens is eminently

suitable for arriving at sophisticated format-filling pictures. I always advise working to fill a format and I am not alone in this. I am occasionally reproached – wrongly in my view – with the fact that I am an opponent of darkroom techniques but this is definitely not true. If one can clearly improve a good photo by specific actions in the darkroom, I don't in the least object to it. Nevertheless, it happens all too often that good photos are ruined in the darkroom. I find it even worse when people are engaged for days on end in technical tamperings with an enlargement which lacks interest and in which the degree of difficulty of the tampering purports to indicate the quality of the photo. With photos of this type you hear whole stories of how difficult it was to achieve but that doesn't impress me. If one sees a really good photo by a well-known photographer you will find below it merely:– "taken with such-and-such a camera with such-and-such a lens." You will not find there:– "climbed for an hour-and-a-half to find the correct position carrying about 30 kilos of equipment!"

Before we start on the technique of working with the zoom lens, we must first know what lenses are on the market, and I do not mean by this the makes, but the systems.

Zoom systems

There are two different systems. The first has an adjusting ring for the focal length which is also the adjusting ring for focusing. This ring slides lengthways over the lens and has the advantage that the focal length can be changed very quickly, although there is the danger that sharp focus can easily be lost when zooming in rapidly. For those who are accustomed to use their zoom lens quite calmly for the correct picture area, this is not a major disadvantage, but it is a problem for the techniques described in this chapter. Consequently, I prefer to use the system in which the adjusting rings for the focal length and sharp focusing are separate and do not run along the

length of the lens but, as with any other lens, rotate in the normal way. The separate ring system is, in my opinion, better mechanically and, according to experts, is also better optically. It is not that you can't use lenses of the first type for the techniques described here but I prefer those of the second type. I can well imagine, for example, that a newspaper photographer will prefer the first system and that there are people for whom there is no difference at all. The use of lenses based on the first system involves a greater chance that there will be a loss of focus and it consequently requires more practice than the use of lenses based on the second system.

Sharp focusing

The sharp focusing of a zoom lens should always take place at the maximum focal length. Focus then remains sharp when moving through the whole zoom range, unless the subject moves. The focus has then to be readjusted. It is because of this that I have qualms about the method of sharp focusing for the different types of lens.

Some photographers find it a disadvantage of zoom lenses that they have smaller maximum apertures. I have already pointed out in an earlier chapter that high speeds are rarely necessary, and if modern zoom lenses are considered the speed seems to be satisfactory. At least one 85–300mm zoom has, for example, a speed of f/4.5. This isn't bad for a 300mm lens.

Technique of zooming

The following are amongst the subjects to be considered in the technique of zooming:
1. normal use as a replacement for a number of lenses;

2. making double exposures of different focal lengths without changing the lens;
3. manipulation during long exposure times by adjustment of the zoom lens, both with stationary and moving subjects.

These three are the prelude to more advanced techniques such as, for example, those used in sports photography. Those who wish to achieve first class results will have to master them step by step.

We have already spoken about the use of films, and I admit that colour reversal film is not exactly cheap. There is a way of becoming familiar with these techniques without excessively high costs and that is to make tests with ordinary black-and-white negative film. The various blurrings could be studied and noted after I had developed the film and made enlargements.

Do not be afraid of the word "noted". I know that many people dislike it. Yet, if it is necessary anywhere, it is with these techniques, otherwise one ends up with what are nothing but flukes and many failures. Don't be satisfied if you get a good result with the very first film. This by no means ensures that you will be just as successful the next time. Only by a complete mastery of the technique is it possible to predict with a probability bordering on certainty what the result will be. Consequently, much effort is necessary, but the satisfaction gained from successful pictures is all the greater.

The neutral density filter

Since fairly long exposure times have to be used, a neutral density filter will be necessary in order to reduce the amount of light falling on the film. Most zoom photos with special effects are made with exposure times of longer than 1/30 second so a good firm tripod is necessary, as in many forms of photography. The neutral density filter must be of excellent quality so that it does not affect colours. It might be useful to buy a filter of the same make as the camera since that filter will be suitable for the lens. To use a filter of inferior quality on a first-class lens amounts to the same as using a cheap magnifying lens on a first-class enlarging apparatus. The expression that a chain is no stronger than its weakest link is known amongst sailors and it is relevant to a large extent in photography. There are a few special manufacturers of filters, for example B & W and Hoya, who not only have an excellent name in this field, but also have an extensive range. If, therefore, no neutral density filter is available from the maker of the camera, then it is possible to choose a filter from one of those manufacturers. It is always important to purchase a filter which fits on the largest lens one has. A large filter can always be used on lenses of a smaller diameter by using adaptor rings but it is not possible the other way round if there is much difference in size. This must also be borne in mind by people with only one lens but who intend to buy additional lenses in the future. If people first buy a small filter, they may have to spend more money for a second larger filter later. Kodak sells sets of filters with a holder which fits on virtually every lens and these fit into the lens hood. This solution is often used by professionals but it is also advisable for the amateur since it can involve an enormous cost saving. In addition, filters made from gelatin or plastic can be supplied where glass is too expensive. Many photographic dealers now have them in stock under the name of the Cokin system. I have devoted rather a lot of space to this because I am anxious to refute the argument that everything is so expensive. That certainly isn't true if one buys selectively. However, only a few amateur photographers do this, so it is not long before they say:– "that is too expensive for me!"

I can well imagine that not everyone will decide to purchase a zoom lens since there are always people who find the cost too high. That is not unrealistic. Many people have other hobbies apart from photography and have to adjust their budget accordingly but various alternatives for imitating the zoom technique can be considered. They will be discussed in the next chapter, which deals in detail with filters and their possible alternatives.

Motor drive or winder

A zoom lens is used primarily to obtain any desired focal length within the zoom range. The fact that this is possible without needing to change the lens is particularly convenient. One has merely to think of the newspaper photographer who can take both a survey and a close-up without any problems, something for which he had formerly to change lenses or work with two cameras. That is now a thing of the past. Not a second is lost; certainly not if the camera is also fitted with a motor drive. This is a comparatively new development and is of special interest, particularly to amateurs. It advances the film automatically and so attention remains concentrated on the action in the viewfinder since the camera need not be moved from the eye. For really fast working, for example in sports photography, a genuine motor drive which also fires the shutter will be indispensable if fractions of a second are involved. The winder only winds the film on but it is nevertheless, an attractive alternative for most amateur photographers. I also know of many professionals who use the winder, merely because of the possibility of remaining concentrated on the subject. What the industry still has in store for us in this field is not known. If things develop fast anywhere, then it is in photography, and it is a disadvantage that some people become so completely automatic that they lose sight of the fact that it is precisely by deviating from automatic functions that one can give a personal interpretation to the work.

The aids referred to are not an absolute must for the amateur photographer but the position is different for the professional because he has to capture precisely that right moment to make the picture saleable. For the amateur photographer it is a challenge to find that one moment without a motor drive or auto winder.

This is naturally possible and Henri Cartier Bresson has even been called the photographer of "the right moment". The sports photographers of a number of years ago were also able to capture the right moment without a motor drive or winder and it would seem from this that it is the photographer who matters, although he should be able to profit from the convenient aids which facilitate his work. They are, alas, film-swallowing devices unless they are used selectively and with common sense.

Double exposures

A second application of the zoom lens is for taking double exposures. The normal double exposure method was described in Chapter 2. It is considerably easier with a zoom lens because you don't have to change lenses. There is a button on most cameras which enables the shutter mechanism to be set, without at the same time transporting the film. For those who do not have such a camera, there is another method which can be used with virtually every camera, although it is somewhat more roundabout and also takes a bit of film. Those who start using the method described below must ensure they get their films back unmounted from the developing centre. In the case of Kodak films the corner of the bag in which they are sent off must consequently be cut off since otherwise a mistake will possibly be made in framing. It was stated in Chapter 2 that a shorter exposure must be used for each exposure and there is no harm in pointing this out again. The guidelines are: for an ordinary double exposure use one stop less and preferably take the first photo in front of a dark background or of a dark object. The procedure for transporting is as follows:
1. take the first shot;
2. turn rewind lever handle until resistance is felt;
3. depress the release button of the rewind mechanism at the bottom of the camera and keep it depressed;
4. hold re-wind lever *and* release button; then operate the advance lever. This cocks the shutter without the film being advanced.
The second shot can now be taken, possibly with a different focal length from the first. It is obvious that these procedures can be carried out more easily if the camera is on a tripod.

Difficulties can arise as soon as the second shot has been taken. When winding the lever for the next exposure, there is often a delay before the film is moved along. Part of the next exposure could then come over the double exposure and that is naturally not the intention. In order to avoid this, the next exposure is taken blind, i.e. with the hand in front of the lens or with the cap on. One frame of film is wasted in this way, but that is better than a ruined shot. This is why I advise against having the film mounted. Half a miniature exposure is wasted, but I cannot imagine this as a reason not to take a double exposure.

Zoom adjustment during exposure

Now we come to the application I see as being the most important for a zoom lens. In the method I am about to describe a good and heavy tripod is the first requirement and is something you cannot do without. Whereas it is possible in other forms of photography possibly to manage with alternatives to a tripod, it is really indispensable here. The method is in fact a variation on the double exposure, but being done with longer exposure times and without recocking the shutter. The zoom lens is manipulated while the shutter is open and it follows from this that the movement made by adjusting the focal length can be seen on the transparency.

For the example on p.54 I merely placed a set of glasses on a table in front of a black background. A few coloured spots were directed on to this, after which the exposure was measured. The light was too glaring so that the neutral density filter already mentioned had to be used in order to achieve the desired shutter time of ten seconds. After focusing had been carried out at the maximum focal length, the shutter was set at 'B' and the exposure began. After about five seconds of this the focal length was shifted to the maximum setting. This can take place by rotating the adjusting ring rapidly to and fro or rotating it

very slowly to the maximum distance. The effect remains the same. The result is that the glasses are visible in a sharp central area from which blurring begins. The broad strips of light arose by allowing the light from the lamps to fall so that they produced broad reflection marks on the glasses.

The photo on p.55 shows just one glass, but using a similar technique in which one exposes first, then rotates the focal length adjustment, as a result of which blurring occurs from the glass. Then the rotary movement is stopped after which the glass appears large in the picture. A large number of variations on the technique are possible. If the blurring is not desired from the first sharp central image, then the hand can simply be held in front of the lens, resulting in a double exposure of a large and a small glass. This technique can best be applied with photos taken in the evening, but it is not impossible under other circumstances.

In the case of photos taken in the evening, naturally with long exposure times, it can occur that the measuring range of the camera is inadequate, in which case a separate meter has to be used. If the exposure time has to be increased in order to carry out the various manipulations with the lens, a neutral density filter will have to be used. The necessary correction for the filter has of course to be allowed for in the exposure time.

The most beautiful evening shots are made at twilight and it's ideal if the strength of the evening light corresponds to that of the artificial light used. The most attractive combinations arise in this way. When using daylight colour films, the colour reproduction can, as a result of reciprocity failure, shift somewhat to yellow or yellowish green with long exposures. I attempt to solve this by using artificial light colour film in the evening twilight, although this film is more expensive than daylight colour film. An alternative is to use a KB 12 or KB 6 filter. In the first case the film is fully adapted to the colour temperature of artificial light and in the second, partly. The latter can produce extremely attractive results. Interesting effects can also be obtained when using daylight film, but then the

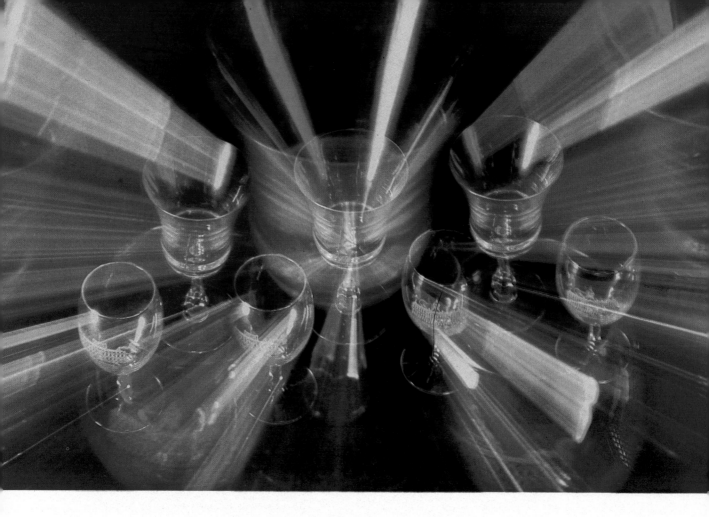

yellowish-green cast has to be fully eliminated – not easy. The Kodak set of filters already referred to, together with a lens cap, renders virtually any adaptation possible.

In the photo on p.57 of blocks of flats at dusk, daylight colour film with a KB 6 filter was used. In this way the film was partly adapted to the character of the light. The lens was set out of focus, as a result of which the outlines of the flats are not completely sharp and the high lights are changed into red spots. By first exposing for two seconds and then zooming out slowly, stripes have arisen from those unsharp spots which now give an impression of sharpness. So you will appreciate that there are many possibilities, even with a camera out of focus, and the only difficulty is finding good subjects.

Many people think the lens may not be touched again once the shutter is open and I get questions or remarks about this at almost every lecture so I shall try to remove this misapprehension. A camera must not, in principle, be touched during the exposure if one wants to take a dead sharp photograph. The tripod is normally used for this purpose but the position is different in zoom techniques. Here the lens has to be manipulated during the exposure and it is obvious that a very heavy tripod is the prime necessity. I use a heavy tripod with a universal pan head which can be adjusted in all directions.

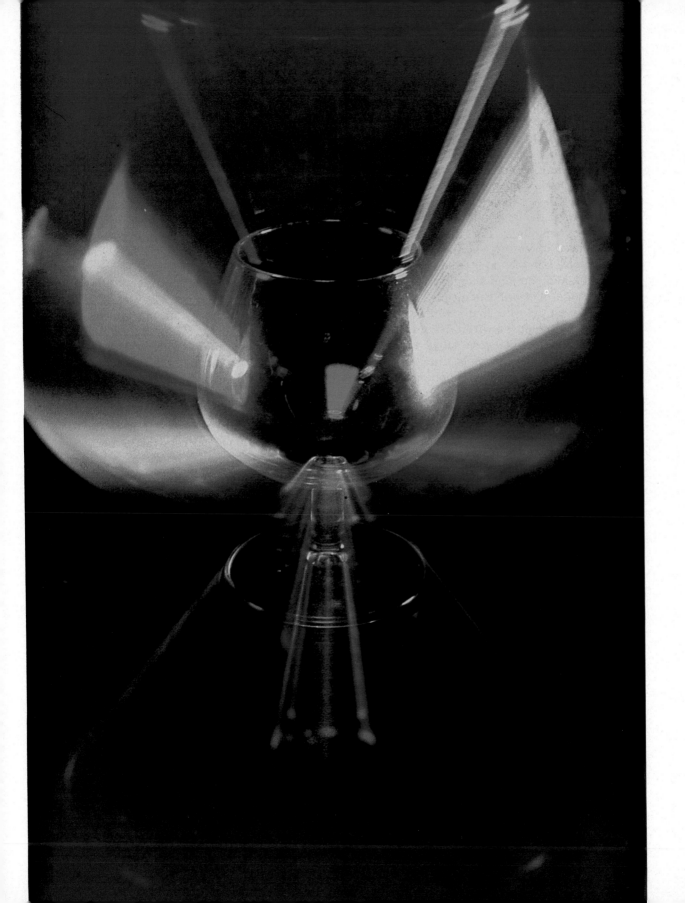

Try the following experiment. Put the camera on a tripod and take a photo with an exposure time of five seconds. Expose in the ordinary way for the first four seconds, but just before you close the shutter tap the lens slightly. This results in a slight vibration. What do we see on the film when it comes back from the developing centre? A sharp central image is there, but the vibration has also become visible around it. I shall be reverting to this in detail in Chapter 6. Giving a slight tap on the lens could even be regarded as a specific technique. For this the camera is again placed on the tripod and an exposure of, for example, 1/55 second is used. Just before the photo is taken you give a slight tap on the lens. Roughly the effect of a multiple exposure can then be seen on the final transparency. The images are reproduced several times as a result of the vibration. Not every subject is suited to this technique but it can be interesting when taking a photo in a busy shopping street, the action being further accentuated by the vibration.

But let us return to the zoom technique. It is essential that the first exercises be carried out properly in order to prevent problems later. The principle is really very simple. The shutter is pressed at the moment when the focal distance is altered. In other words, the exposure takes place while the adjusting ring for the focal distance is being moved. It is advisable at first to use long exposure times:– 1/30 second or longer. When you have to some extent mastered the technique, times of 1/60th and 1/125th second may be considered.

It is really very simple but it is nevertheless important that you know when to press the shutter release and how quickly the adjusting ring has to be rotated. If it is done at random, a good result will undoubtedly only be the result of a fluke.

People are often so fascinated by their first successful result that they think they have mastered the technique completely. If the next occasion does not produce equally good results, there is enormous disappointment. It has happened to me too. I had taken a photo which was particularly successful and full of pride I offered someone a similar photo. Naturally, I was unsuccessful on the second occasion and my disappointment was great. This book has largely come about because of my own failures. They made me run through every facet again and again and practise them. It is possible that everything was the result of flukes but I wanted to know why things turned out as they did. That could only be done through a detailed analysis of what happened and drawing conclusions from it. That then formed the basis for photos in which the results are calculated precisely beforehand. I have already written that I used black-and-white film to practise with and I should strongly advise you to do the same. Reversal colour film is expensive so it is better not to use it until you have mastered everything.

Now something about the effect you obtain with this technique. It is quite different from the previous techniques where blurring occurred from a central image which was on the whole sharp. Now it seems as if the centre of the image remains sharp if it lies precisely on the optical axis but this is only illusion. The phenomenon increases in intensity the farther the object to be photographed is from the camera. To begin with, we take subjects which are straight in front of the camera and make sure that the principal part of the subject can be seen precisely in the middle of the viewfinder. It is only under these conditions that the following tests can be successful but we shall also see later what happens if the camera is not precisely centred. That is yet another technique.

Photos of this type always show whether or not a tripod has been used. If it has, the course of the lines is completely straight. If it has not, we see a somewhat irregular course, often coupled with a lack of sharpness due to movement. This is explicable since no one can photograph sharply with a hand-held camera at times of 1/15 second or longer. It can have charm, but in that case it must have been deliberate and the result visualised beforehand. Let us choose orchids as a subject and we'll use a supplementary lens in order to get as close as possible. The use of extension rings is out of the question in zoom techniques since that would give a completely different effect, not a zoom effect but one giving a complete lack

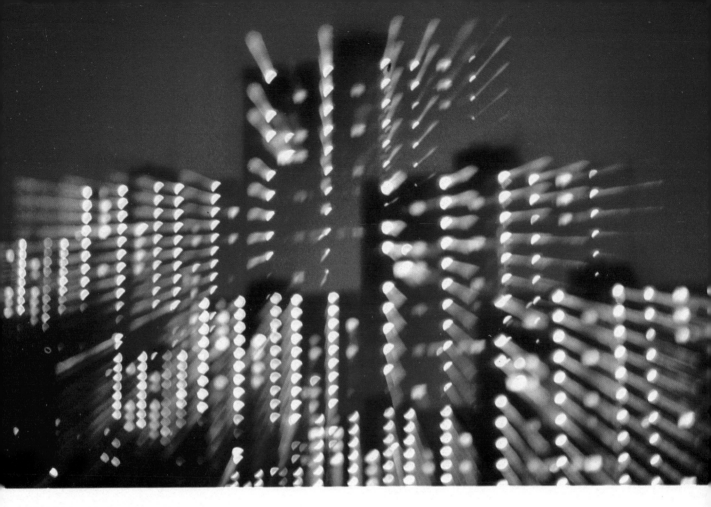

of sharpness. That is naturally not the intention. Supplementary lenses are now of good quality, particularly the two-lens supplementary optical devices sold, for example, by Canon and Tamron. They even give good results when working at a full aperture. Sharp focusing now has to be carried out and this we do at maximum focal length. We then pass through the whole zoom range. As the adjusting ring is rotated, the principal object within the image area becomes smaller and smaller. The rotary movement must be carried out slowly and it is a matter of determining at what focal length the shutter has to be released. In pictures of this type the composition is after all of decisive importance. Once it has been established at what setting the image is best, the shot can be taken. The trick is to rotate the adjusting ring and then make the exposure. The course of the lines is not visible in the viewfinder but, as a result of the tests described, we know what is going to happen. A frequent initial fault is that of stopping rotary movement just as the shutter is pressed. If this happens, the result is not a zoom effect, but a normal photograph with the chosen composition. When you have advanced further, it is easy to stop after exposure has taken place but it is better not to do that at the beginning. It does not matter whether one zooms from the maximum to minimum focal length or vice versa but it is important that there should be

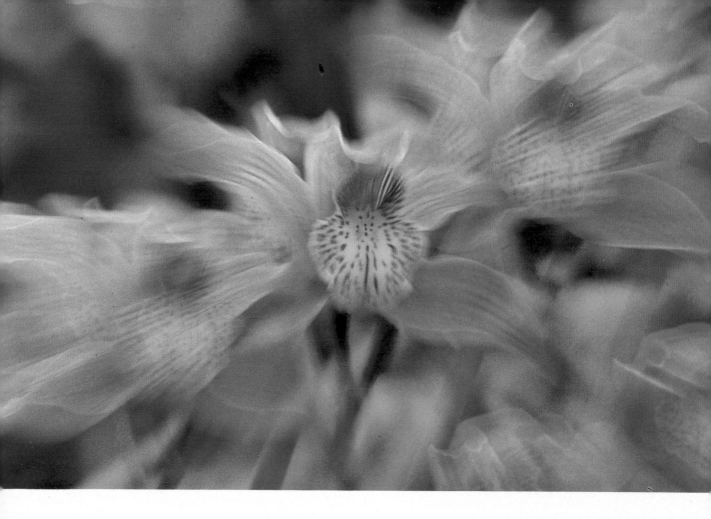

sharp focus at the maximum focal length. I have already mentioned the correct moment to press the shutter release. This is determined by running through the whole zoom range beforehand and making a choice. Account must be taken here, however, of the fact that it is necessary to release the shutter just before the desired focal length is reached because a fraction of a second elapses between the second when the brain registers that the right moment has been reached until it actually happens. When rifle shooting this is referred to as the firing delay and it varies with every person. I consequently strongly advise against looking in the viewfinder at the beginning, but look instead at the adjusting ring for the focal length. The release is pressed just before the desired focal length is reached. This does not present any problem if the camera is on a tripod. After all, everything has been adjusted beforehand. The position is obviously different if one is using a hand-held camera. It is then necessary to look in the viewfinder but the release has still to be pressed just before the desired setting has been reached.

After the camera is set up for the orchids, everything is ready, apart from determining the exposure which will in this case be 1/15 second. We now begin rotating the adjusting ring, bearing in mind the instructions already given. We do not rotate too quickly since that would result

in a total blurring so it is a matter of rotating smoothly and then releasing. After developing the film, an image can be seen in which the middle has seemingly become sharp and the rest is blurred. The faster the rotation the greater the blurring and the less recognizable the central image. It follows from this that with a shorter shutter time adjustment must be quicker or, with a longer time, slower. I cannot give any rules for this. It is important to practise it yourself and write down everything you do, so that you can check back. If you use a tripod, you will always get a reasonable impression of sharpness since the course of the lines is sharp.

A tripod was not used for the photo on p.60, the camera being held in the hand. This can be seen clearly since the zoom effect is not so sharply marked as in the photo with a tripod on page 58. The flowers were arranged so that the red flowers would come at the outside of the picture. An attractive feature of photographs of this type is that through the lack of sharpness due to movement, resulting from the long shutter time combined with the zoom effect, the colours merge into one another much more than if a tripod had been used. This intensifies the colour harmony and, if you like, the tension between the colours red and yellow. Practise a little before you start working with a handheld camera. Don't forget the flukes!

Finally, the photo on p.61, taken by this technique, gives an impression of birches in winter. The shutter time was 1/30 second and the rotary movement was carried out fairly quickly. This photo illustrates very clearly the phenomenon of optical illusion. The farther the object is from the camera, the more pronounced the effect of sharpness throughout the whole photo.

This is another of those subjects which people say are not so beautiful in winter but in fact the opposite is true. Winter and spring are particularly suited to photos of this type. In summer, when everything is a uniform green, the fine colour nuances seen in this photo cannot be obtained. I should like once again to point out that using a hand-held camera requires great skill. It is possible to obtain a completely wrong interpretation of the technique described if, by not applying the rule of shooting along the optical axis correctly, the sharp core of the image seems to lie in a completely different place from that expected.

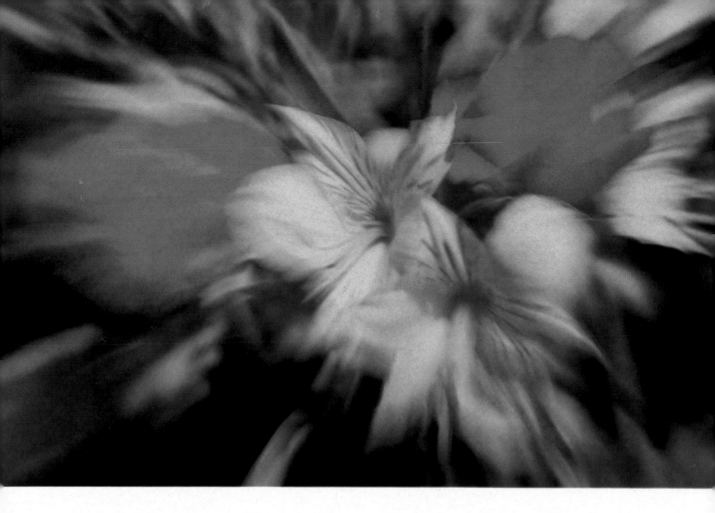

Zoomed portraits

The technique described can also be used for making portraits with a zoom effect. It is obviously necessary to use a model for this but I shall not deal here with finding a model. It is always possible to use a professional model, but no amateur photographer should have any trouble finding an amateur model from among his family or friends. Working with a model, professional or amateur, requires some preparation. If a professional model is involved, there will be little to say. In most cases she will quickly adapt to the circumstances and wishes of the photographer; after all that is her job. In the case of an amateur

model, care must be taken to get sufficient motivation. She also has to know just what the photographer wants and what result he wants to achieve. I work for the most part with a regular model who knows precisely what result I am aiming for. Working with a regular model promotes a good relationship between photographer and model. After all, it is not merely a question of making portraits, but also of taking pictures in which the model sometimes has to walk in order to obtain the zoom effects. We shall say more about this at the end of the chapter. Sometimes I approach someone in the street and ask her whether she will pose for me. That may perhaps seem impertinent and I can imagine that

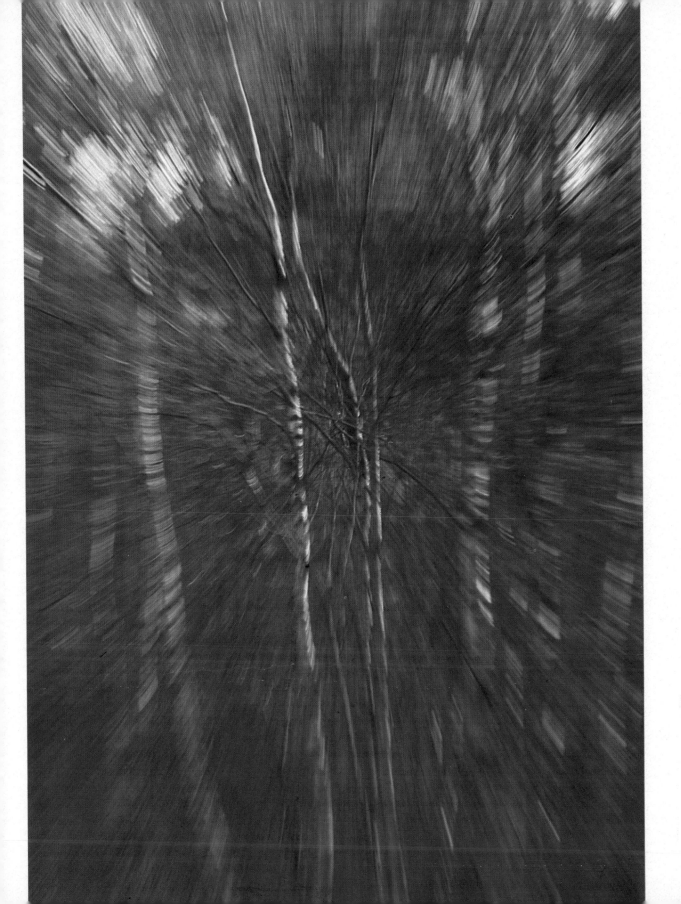

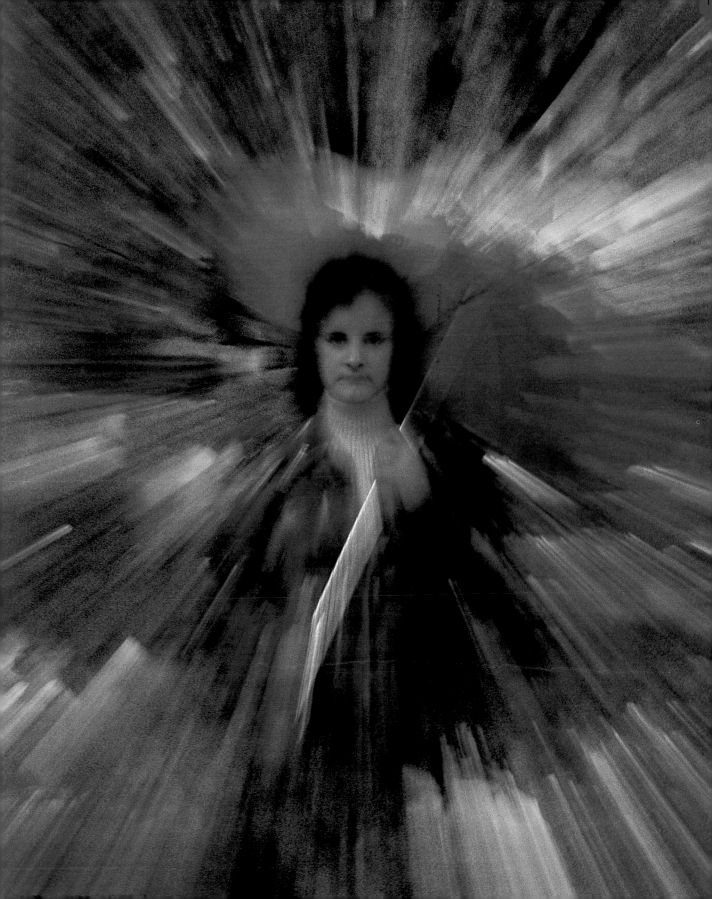

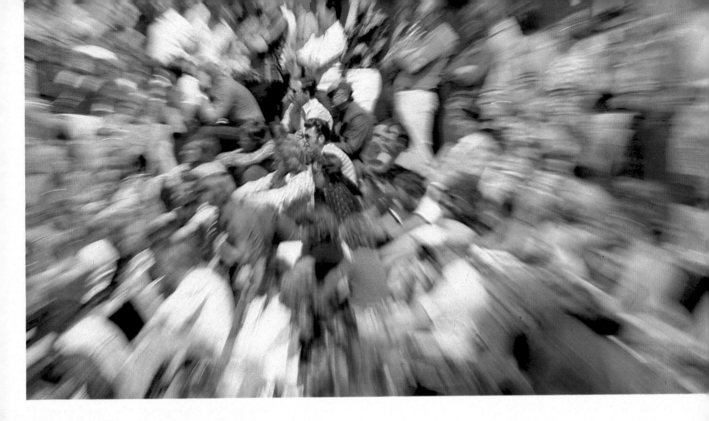

many people could not summon up the courage to do it. Nevertheless I know from experience that many women are flattered by such a request and pleased to cooperate, particularly if you can, (for example by showing a membership card of a photographic club) prove you are a serious amateur photographer.

Dealing with a model naturally demands tact on the photographer's part. He has to explain to her very patiently what he wants to do and if anything goes wrong, he must never lose his good humour, since that merely produces tensions which are very frustrating, both for the photographer and the model, particularly if they are otherwise complete strangers.

We begin with the placing of the model. We have to stage-manage everything and put it in its right place. For example, in the photo on p.62, the face had to be in the middle of the picture and the parasol, which constitutes a highly expressive

element, in the correct position within the picture area. In zoom photos it is recommended that the model looks into the lens since this results in the most expressive effect. The model was placed in this zoom photo so that maximum use could be made of the existing light and it was important that the light was spread as uniformly as possible through the trees in the background. Light in fact always plays a significant role in the zooming-out effect. The shutter time was 1/8 second, while the rotation of the adjusting ring was fairly slow. As described in the preceding pages, the whole zoom range is first passed through in order to determine the composition. You should have gained so much experience in the meantime that you can keep on looking through the viewfinder while the photo is being taken. This is important since you have to be able to have a good view of the model's pose. Any movement by the model during the shot can be disastrous because fairly

63

long shutter times are being used. A zoom portrait cannot be made all that quickly and the adjustment of the focus is a very important aspect. Don't do it too quickly, or there will be little left to recognize in the face. My advice is to use long shutter times and move the zoom adjustment slowly – you are leaving too much to chance when using short shutter times with corresponding rapid zoom movements.

Once we have mastered this technique properly, we can occasionally dispense with the tripod. Using the same technique we can sometimes also take something for which there was no special posing so it is perhaps useful, especially at the beginning, to use a chestpod. This is very useful in sports photography with a zoom lens, since one is limited too much to one place by a tripod.

The photo on p.63 was taken during a baseball competition at which the spectators were sitting in a circular stand. It is important for photos like this that the stand is full. As soon as there are empty places, the zoom effect becomes less spectacular. The man who is most clearly visible is completely engrossed in the game and he is sitting somewhat towards the top of the picture. I deviated in this shot from the principle of having the main motif in the middle of the image area. In this case the camera was directed obliquely on to the subject. Part of the top of the photo was cropped, resulting in an intensification of the impression. Other techniques can also be used for isolating a single figure from a large crowd and I shall be referring to them in subsequent chapters.

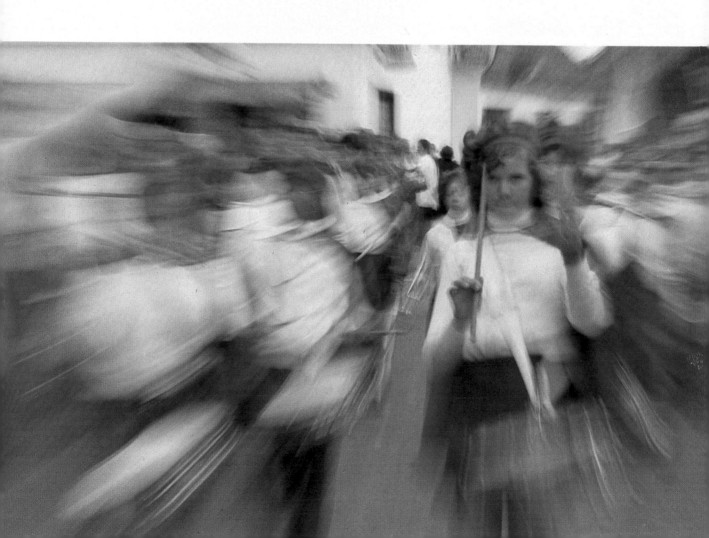

Moving models

So far we have worked with a single model and with someone who was sitting among the public. In both photos the camera was aimed at a fixed point and the person being photographed was not moving. In order to take photos of a model who is moving we have to set to work in a different way. We will begin with a subject in which both the model and the photographer move. It is important here that the distance between the photographer and the model should always remain the same or, in other words, that they are moving at the same speed. The portrait of the girl with the drumstick on p.64 could only be done by walking backwards in front of the band. In this picture, too, the sharpness is not exactly in the middle since I couldn't get exactly in front so it had to be photographed from an oblique angle. Here again, sharp focusing was naturally carried out at the maximum focal length. This is the reason why the distance between the photographer and model has to remain the same and it can be seen from the uneven course of the lines that the camera was held in the hand. What I wanted to reproduce sharply, namely the face of the girl with the drumstick who was walking in front of the band, has come out quite clearly.

It is not always necessary in impressions of this type to reproduce details completely sharp. In some cases a slight lack of sharpness can be very interesting when coupled with the zoom effect. It is also clear that there is some scope for tolerance since a small aperture is used in order

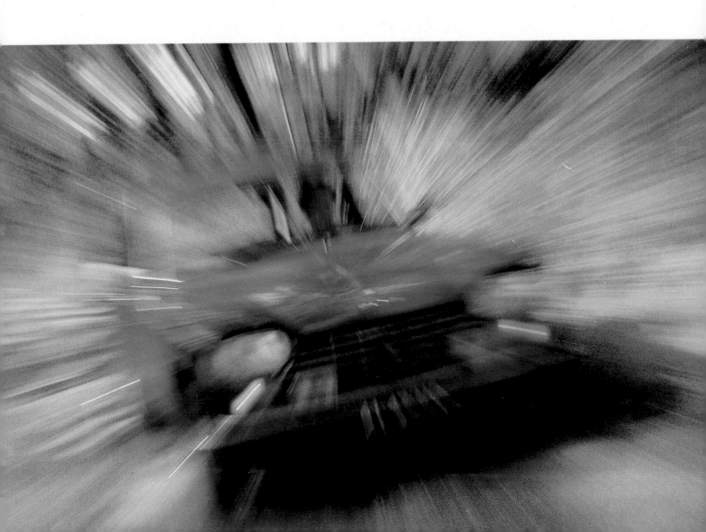

to arrive at a long shutter time and so there is a reasonable depth of focus. Photographs of this type often create a highly impressionistic mood.

Experience is a requirement for certain success with this type of photography. Don't imagine this is something which can be acquired in a few weeks. You will have to have a lot of perseverance. When you are successful you can, however, be very creative in your hobby and get a lot of satisfaction. Unfortunately, not everyone can appreciate pictures of this type and you will have to get used to that!

Successful photos cannot be made on an assembly line. I am describing all the techniques in great detail in this book, but I am well aware that by no means everyone will apply them. What I have written down here is the result of years of hard work during which I had to give up many other pleasures and I can imagine that not everyone is willing to do that for his hobby. Photography has nevertheless always been a challenge for me and a medium which has helped me to get through the lowest points in my life.

In the photos just discussed the sharp main motif was shifted to a section outside the centre of the image by using the camera from an oblique position. This is often unavoidable in zoom sports photography since it is rarely possible to get right in front of the subject. The last three photographs in this chapter consequently form an introduction to the technique in which the photographer stays still while the subject moves. This gives rise to special problems in relation to sharp focusing which consequently has to be obtained in a completely different way. These photos, too, were taken using a tripod.

The first photo (page 65) gives a suggestion of speed. There are various ways of suggesting speed photographically; for example, placing the motif obliquely within the image area. This suggestion of speed can be freely increased by zooming and in this shot the car was placed under the trees and the camera set up obliquely in front of it. The best time to take such a photo is in autumn when the colours merge beautifully because of the leaves on the ground. Although the car was stationary it looks in the photo as if it were storming out of the wood. There was no change

in this shot in the distance between the photographer and the subject and the manner of zooming is consequently not so important. It matters little whether you zoom from a minimum to a maximum focal length or vice versa although it would be important if the car were moving towards the photographer. In that case, zooming must definitely be from the maximum to the minimum focal length. The impression in the viewfinder then remains equally large, blurring somewhat but giving almost the same result as with the stationary car. It is once again important here that the shutter be released at just the right moment. I mean by this at the focal length chosen beforehand, in other words the focal length which gave the best image area when originally zooming through. As in every branch of photography, attention must also be paid to details. When the transparencies came back from the processors, I realised there was no driver in the car and that created an unreal impression so the photo had to be taken again.

I am often asked at lectures how many hands I really have but as you may expect, I have only two! As you have already learnt, sharp focusing is always done beforehand so that I have one hand free for the shutter release and the other for adjusting the focal length. All my attention can consequently be devoted to the proper manipulation of these two functions of the camera. It is also necessary to consider additional problems as, for example, in the case of the girl with the drumstick – care had to be taken to ensure that the distance between the camera and subject always remained the same.

The photos on pages 67 and 68 differ clearly from the previous example. In these, the photographer remained in the same position and the object moved towards him. This technique is fairly complicated and I shall, therefore, deal with it in detail before discussing the two photos. What is the essential difference? So far we have had a stationary subject and a likewise stationary photographer or the model and the photographer both moving at the same speed. In both cases there was sharp focusing beforehand at the maximum focal length so the problem of sharp focusing did not arise during shooting. The same thing

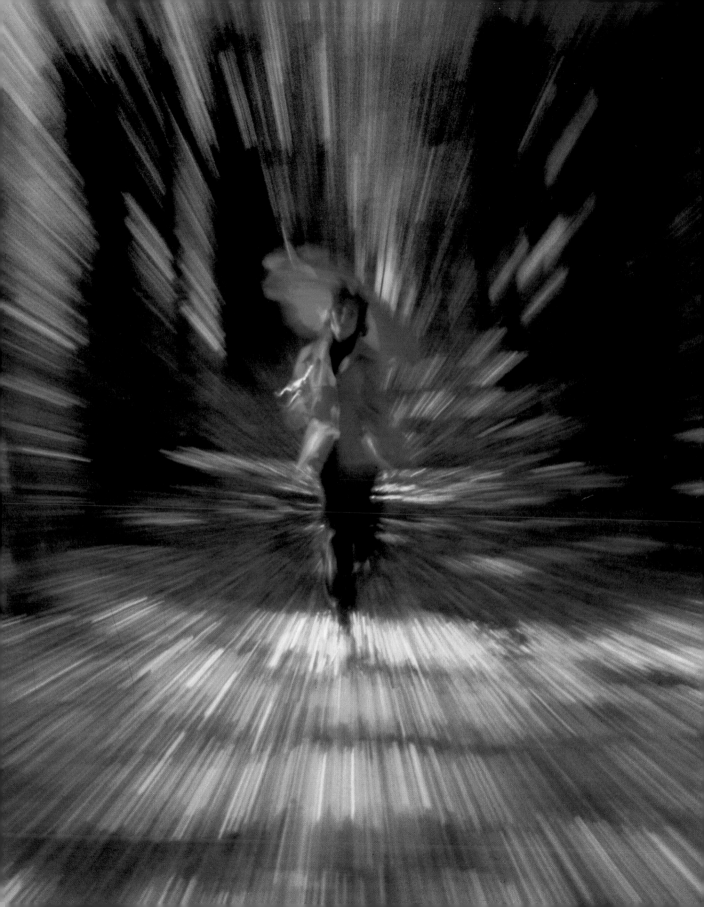

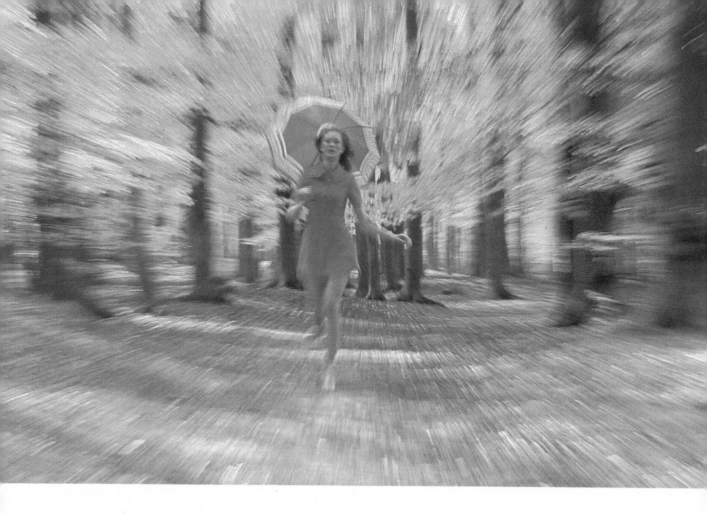

now has to take place with a subject moving in the direction of the camera and the image area and the sharpness now have to be determined before the shot is taken. This is done in the following way. The camera is set up in the wood and is directed with its zoom lens on the model who is about 30 metres (100 ft) away. She now begins to walk and you follow her in the viewfinder, at the same time rotating the adjusting ring for the focal length from its maximum to its minimum setting so that the model always remains visible at about the same size in the viewfinder. She walks in a straight line towards the camera and when she has arrived at the spot you consider best from the point of view of composition, you

tell her to stop. You then focus sharply at the maximum focal length. The model returns to her starting-point. Then she starts walking again and you follow her again with the setting of the focal length. When she reaches the point on which you focused sharply and where the composition was right you press the shutter release. The model continues walking and you continue to rotate the adjusting ring. You let the model stop just in front of the camera. This method can be called "walking into sharpness."

Accurate placing remains difficult but again, as a result of the high degree of stopping down necessary to obtain long shutter times, you obtain so much depth of focus that a difference

of half a metre (19 in) scarcely makes any difference. The model has to walk in a very straight line towards the camera since we operate according to the principle of remaining sharp in the middle of the optical axis. I have already said that working with a model places high demands on cooperation but, unfortunately, most photos of this type are unsuccessful the first time. A lot of practice is necessary and one must not hesitate occasionally to devote a whole film to it. We learn most from our mistakes, and the first good result comes sooner than you think if you operate according to the rules given here. When you have sufficient experience you can, of course, deviate from them and go your own way. That is, after all, the intention. There are already enough imitators in the world of photography and an individual interpretation is what matters.

Let us now return to the photos on pages 67 and 68. Both were taken using the technique described above, the subject moving towards the camera and the camera remaining at a fixed point. Parasols were used in both photos for composition and colour effect. The second photo was slightly over-exposed deliberately in order to accentuate the effect of spring.

In most of the techniques described in this chapter, lack of optical sharpness is not acceptable although this is not a firm rule for everything. Just look back at the photo of the flats on p.57 in which it is precisely the lack of optical sharpness which made the photo, and you will find further examples of this in the book. All these techniques have been described on the basis of zoom lenses with separate rings for focusing and focal length adjustment. After reading this chapter it will be clear to you why I am in favour of this separate system. I do not mean to say by this that the other system, in which both adjustments are combined in one ring, could not be used for this technique. I have myself taken many photos with the Canon f/5.6, 100–200mm zoom and it, too, worked perfectly. When using such a zoom

lens, however, care must be taken to ensure that sharp focus is not lost. The ring has to be moved completely straight. If it is twisted even a little during zooming, sharpness is lost.

So far in this book I have only spoken about techniques for taking colour. You could perhaps conclude from this that I have no appreciation of good black-and-white work. Nothing is further from the truth. Working with the zoom technique, in or out of focus, impressionistically or not, is certainly also possible in black-and-white photography. Putting it even more strongly, there are undoubtedly many situations in which the creative aspect is better expressed in black-and-white than in colour. Michael Gnade says in his book "Photography in Black-and-White" that he finds the term black-and-white far too narrow. It is, after all, precisely a matter of the broad, richly variegated grey area between the extremes of white and black by which much more expressiveness can often be conferred on certain photographic subjects than by all the colours in the world. I can confirm this completely and am aware that colour photography has marked limitations. I am, however, also convinced that if you want to achieve success in photography, you will have to specialize. This does not of course mean that both techniques cannot be used. I began with black-and-white and I consider that it formed the basis for my later work in colour. Every grey tint is a colour. That is a fact and the real basis of colour photography. I know photographers who work in colour one year and then change in the next to black-and-white work. A professional photographer has of course to work in both colour and black-and-white, and that is the most natural thing in the world for him. Both techniques are inseparably linked. Personally, I find black-and-white photography most powerful in photographs with a social content. These are very difficult to take in colour, since colour often gives them a cheerful aspect which is not in keeping with the subject.

4. Filters and supplementary lens attachments in colour photography

One of the most difficult aspects of colour photography is the use of supplementary lens attachments and filters. In my opinion, information in the instructions for use provided by manufacturers of filters is grossly inadequate. A great deal can be done with filters and supplementary lens attachments in combination with other techniques, but these combinations must be used in such a way that it is difficult or quite impossible to see what precisely has happened. Here, too, the position is such that practice gives rise to art. By using filters and supplementary lens attachments one can be experimental and creative but it arouses resistance from those who think that everything in a transparency must be in focus from front to back. Supplementary lens attachments and filters are highly suitable for use in creative colour photography, provided they are used properly and with a clear personal contribution. There may be a danger that your work will be regarded by others as kitsch but just bear in mind that what one person regards as kitsch is highly appreciated by another. You will have to learn to live with it! When using filters creatively, you will have to go your own way to a very great extent and often quite alone, but the individualist can achieve a lot if he perseveres.

The polarising filter

I would like to begin this chapter with a warning about polarising filters. It is not that they cannot be used and they are even indispensable to the colour photographer. To put it in popular terms they give an improved colour reproduction by reducing the contrast. It is nevertheless in this that the great danger lies. I have often seen cases in which a polarising filter was used inexpertly and it cannot really be considered at all with wide-angle lenses since only a part of the picture format is polarized. This gives rise to a very unnatural effect, i.e. part dark sky and part light. It is most effective with 90mm and longer

lenses. A common fault is the complete filtering out of all sparkles, particularly in landscapes and this gives a very unnatural effect. Those who wear glasses, for example, often look like people at a fair since their lenses are no longer visible, giving a very unnatural effect. This filter should be used very selectively. Before you take the photo ask yourself whether you are not filtering away too much. You can see exactly what is happening through the viewfinder so find the golden mean and proceed very selectively. It is one of the most valuable filters but also one of the most dangerous. It appears from a recent investigation that there is not so much difference in quality between the cheaper and more expensive types but I would nevertheless plead strongly for the more expensive types since the colour reproduction is better. There are hardly any differences in separating power.

Although much has already been written about filters, in this chapter I shall discuss a few creative aspects and applications with possible alternatives for those who find filters too expensive. At my training lessons I always advise purchasing the book by Emile Voogel and Peter Keyzer "200 Slide Tips" (Argus Books). This presents in telegraphese more information about colour photography than any other book I know. It should really have a permanent place in the bag of every amateur photographer so that he can consult it when in difficulty. I often use it for compiling lessons systematically before entering more deeply into the subject. Most of the filters I am now going to discuss are dealt with in this book. They are considered in greater detail in another book by the same authors, namely "200 Filter Tips" (Argus Books).

I do not intend to describe all filters and I shall restrict myself to a few types which I use creatively. I shall also give possible alternatives which frequently work even more effectively than the filter itself since one is not bound to a specific filter, but can devise all manner of variations. With a filter, one is naturally bound to its optical limitations.

Conversion filters

It is definitely not necessary for the average amateur photographer to have a complete set of conversion filters. They are seldom used and if you want to make full use of a complete set, then you will also have to acquire a colour temperature meter because the human eye adapts so quickly that one is soon filtering too much or too little. Some of these filters are nevertheless highly useful to the creative colour photographer since they convert daylight colour film into artificial light type, and vice versa. There are two types for this purpose, those which are tinted blue for artificial light shots on daylight film, and those which are tinted pink for artificial light film with daylight shots. A few filters can be used all the time. In my experience these are the KR $1\frac{1}{2}$ and 3 and the KB6 and 12. KB20 is rarely used and really serves for converting living-room light with a very low colour temperature into daylight and it naturally has a high exposure factor. If extremely short flash times are used on colour reversal film, then a KR$1\frac{1}{2}$ or KR3 filter can be used to good effect and I sometimes use one of these filters on dull days in order to obtain a somewhat more cheerful impression. The KB6 and KB12 filters will probably be used more frequently. It is not as a rule worth buying separate artificial light colour films, particularly for just a few photos in that lighting. With a KB6 or KB12 filter it is possible to adapt the colour temperature of daylight colour film to artificial light. In the

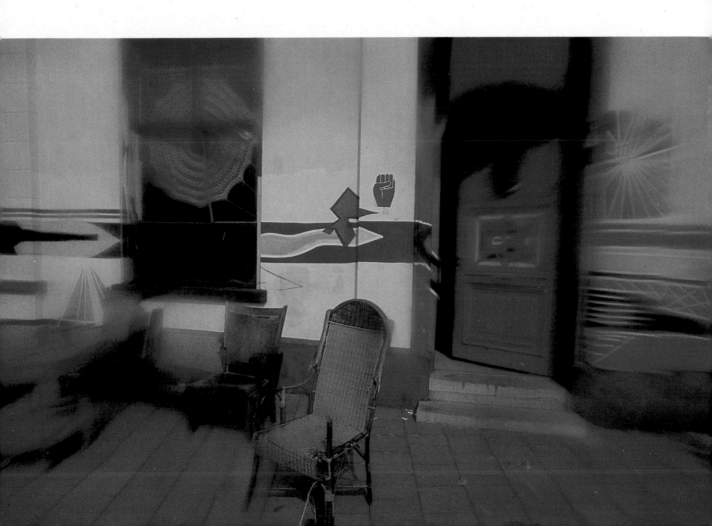

photo on p.73 a conversion filter was also used during the day, resulting in a bluish impression. It is convenient to use filters in the Kodak filter holder incorporated in a lens hood. This is particularly useful because of its virtually universal application. The Cokin system also uses a lens hood as a holder for a large variety of filters. Kodak does not provide its filters with any KR or KB code, but has a special numbering code.

Popular filters

The next type of filter I should like to discuss are the popular filters which are available in various colours:- red, yellow, green, purple, violet, to mention but a few. These filters alter the whole colour reproduction of the film. The first example on page 74 was taken with a red filter plus a neutral density filter to reduce the strength of the light. This produced a reddish sun and the transparency was combined with a second one of the birds in flight, giving the result shown. False romanticism? Perhaps, but you could also call it a personal interpretation.

It is not always necessary to buy the more expensive deep filters. Charming results can be

achieved with a filter which most amateur photographers own, namely a strong yellow filter. I took the photo on page 75 with one. In this way you can imitate a sunset by using a strong yellow or orange filter in the daytime, possibly combined with a lens of a fairly long focal length, and an out of focus foreground greatly enhances the effect.

When using filters in this way the photographer's own imagination is of decisive importance. It leads to different interpretations, since the use of filters alone does not usually result in sufficient originality. It is their combination with one or more of the techniques described in this book that leads to creative photos. It is very important to ensure that no kitsch effects result.

Prism attachments

The next aid I should like to consider is the five- or six-sided prism with a flat central field often wrongly called a prism lens or filter. In common with polarising filters these gadgets can be rotated in their mounts and this is one of their most attractive features. The effect is particularly fascinating initially, and many photos are taken with them but you must be careful nevertheless. These photos have virtually no value in themselves. The only result is that the image is reproduced five or six times and it will be appreciated the first time, but before long seen as a trick. That can be avoided by using the attachment very selectively and knowing what you're doing. It is frequently used in a haphazard way on television with no specific artistic effect. That is particularly disturbing and shows clearly that the user is really completely lacking in a personal creative contribution – something every amateur photographer must avoid. It is a pity that the makers of prism attachments usually provide insufficient information about the effects which can be obtained with them and about their proper use. This leads to the situation where many amateur photographers get back transparencies looking quite different from what they had expected. The choice of correct diaphragm is of major importance and this is frequently overlooked. In the case of reflex cameras with through-the-lens light measuring a time of, for example, 1/125 second is measured. The image is viewed at full aperture in the viewfinder because of the automatic diaphragm and, it is forgotten that the automatic exposure meter has perhaps chosen a diaphragm of f/8 or f/11. By stopping down a completely different image arises from that given at full aperture. A consequence of this is that the exposure time has to be adapted to the diaphragm used and that for evaluation it is always necessary to view it at the working aperture. The depth of focus pre-view button found on most SLR cameras can be used for this. It is important here that you judge the effect separately at each aperture and only then can you decide which gives the best effect.

It can happen that you will see circular images appearing at full aperture with the incident light at an oblique angle. These images have almost all the colours of the spectrum and arise through the refraction of light on the facets. They can be involved in the composition, but can also be avoided by stopping down to a very small aperture. Prism attachments can be combined in an ideal way with a zoom lens and I shall be dealing with this in the next chapter. A combination with the sandwich technique already described offers extra possibilities. The use of prism attachments with different lenses also provides considerable variety. When using wide-angle lenses with a focal length of less than 35mm, vignetting arises when a prism attachment is used but this can, however, be very well exploited creatively. I shall come back to it later in the chapter. The longer the focal length of the lens you are using, the more striking the effect since it can hardly be seen whether a prism has been used or whether it is a double exposure.

I have already advised that it is better to purchase filters to fit the largest lens one has, and to use tapering rings for the smaller diameters. That involves a major cost saving. Since the purchase of filters and supplementary lens attachments nevertheless remains expensive, one could

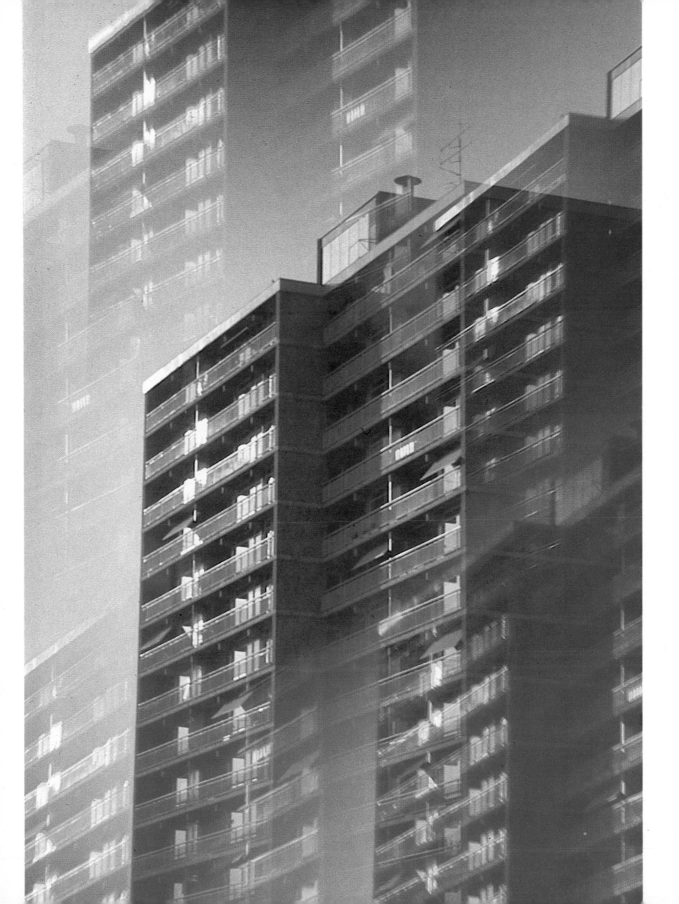

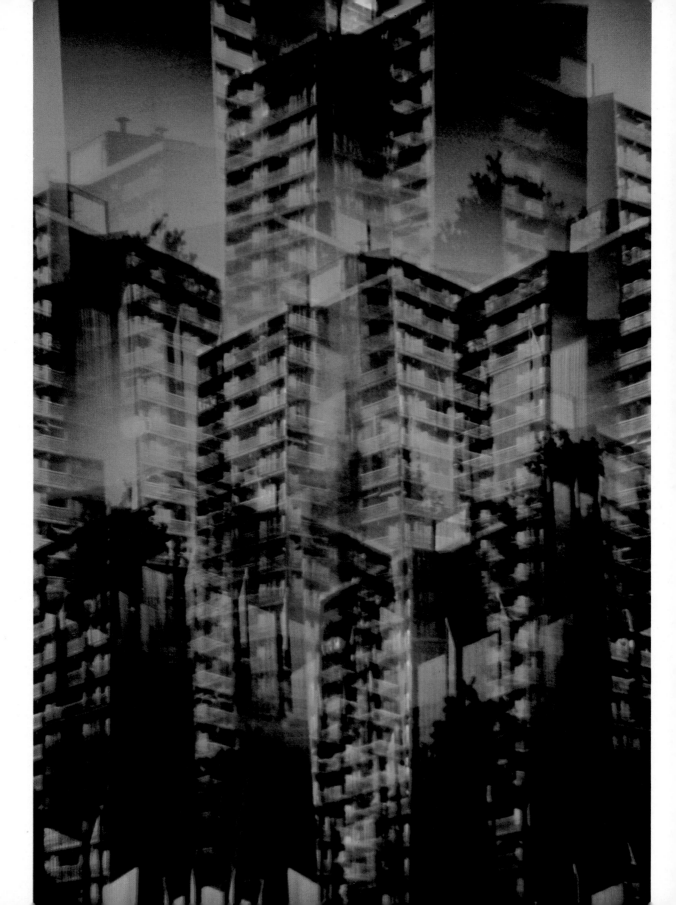

consider buying them jointly with a few friends
or amateur photographers. Much more can be
done in this direction in clubs. I am thinking,
for example, of the joint purchase of an expensive
zoom lens which can be hired to members. It is
after all the most normal thing in the world to
hire specialized equipment in the field of profes-
sional photography.

When working with prism attachments the
indispensable tripod will once again have to be
used. This is necessary if only in connection with
the well-considered choice of image area. Partic-
ularly in the case of subjects such as those in the
examples on pages 77–79; the result stands or
falls with the symmetry in the shots. As I have

already said the prism can be rotated in its mount
and the composition is determined in this way.
The aperture has then to be set for the correct
shape of the picture and for this one passes
through the whole aperture range. A choice can
be made but, for the beginner, it is better to take
a series of shots at different apertures. The expos-
ure time has to be altered in each case to match.
I stress this because often, especially at first,
people are so tensed up that they don't think of
altering the shutter speed. Under- or over-
exposure is the inevitable result.

The photo on page 77 is a shot of a few blocks
of flats in which the diaphragm was set at f/11
on a lens with a focal length of 200mm. At first

sight this resembles a double exposure, but on more accurate analysis of the picture we quickly recognize the typical features of the prism attachment. We see small sections of sky repeated between the flats. If the diaphragm images already referred to cannot be avoided in photos of this type, a different position must be chosen. Their use as a pictorial element was not possible in this case since the intention was to imitate a double exposure. The photo on page 78 was taken of the same flats, but at a different time of the day. I took two completely identical photos, each over-exposed by one stop, and the two transparencies were mounted together mirror inverted to form a sandwich. This impression stands or falls with symmetry. It was consequently necessary for the two transparencies to be identical since even a slight upsetting of this symmetry would give rise to a lack of balance. It will be seen as we advance that more and more techniques can be combined with one already described.

The photo on p.79 of the "burning" flats was also made using the sandwich technique. The first photo was taken with a five-facet prism attachment in very misty weather and I noted that something would have to be done to it later. In such cases I make a series of exposures with different times in order to be sure that, when developing my idea, I am not confronted with a situation in which the first transparency should have been somewhat lighter or darker. The most difficult part now arrived, namely taking a photo which would, in combination with the first transparency, suggest that the flats were on fire. Initially there seemed to be no solution so I put the transparency away and made a note in my diary that the idea must be worked on further. In this case the answer came very quickly. I had to take a few photos of glass. A bottle was standing there, and suddenly I saw through the bottom of the bottle a distortion of the red light which was directed on to the glasses. Immediately I thought of the transparency of the flats and I directed a spot light on to the bottom of the bottle. This did not produce the desired effect and the transparency became completely red so I made another transparency of the bottom of the bottle at a shutter speed of

1/4 second while I rotated the bottle. When the transparency had been developed the pattern turned out not to fit into the misty area between the flats so I made three further transparencies with different rotary movements. In the last the montage turned out to be right. The photo was taken with a 135mm lens on a miniature reflex combined with a prism attachment but completely different effects would have been obtained with the prism lens on a wide-angle lens.

Opinions about this photo always differ greatly. One person will call it kitsch while another finds it magnificent. Don't be disheartened if people criticise your work. Those who do are at least giving their honest opinion. It is much worse if people say they find it beautiful while behind your back they say it is kitsch. Unfortunately, this often happens with photography of this type. What one person finds beautiful, another finds ugly. Nevertheless, it's the challenge you have to accept.

Next we come to examples of the use of wide angle lenses and I want to let you see how I made direct use of vignetting. Many people think the picture on page 81 is a sandwich transparency, but it isn't. Once again I photographed the same flats, but on this occasion with the five-facetted prism in front of a 24mm lens. The distorted white shapes are of a sculpture in front of the flats. Since the camera with the prism on the lens was kept about a metre away and a small aperture was used, only three silhouettes of the flats are visible through the distorted sculpture. In this case in particular the rule applied that the total impression changed greatly with each aperture. In this instance I held the camera in my hand because I had to be very close to the sculpture and also had to shoot obliquely upwards from below. Any desired colour impression of this photograph can be made in the darkroom by working towards a monochrome colour and there has to be a high degree of filtering for this. Not every photo lends itself to this treatment but this one is particularly suitable. Using a hand-held camera is very difficult because the lens has to be rotated as well as the prism in order to obtain the desired impression and find the best composition.

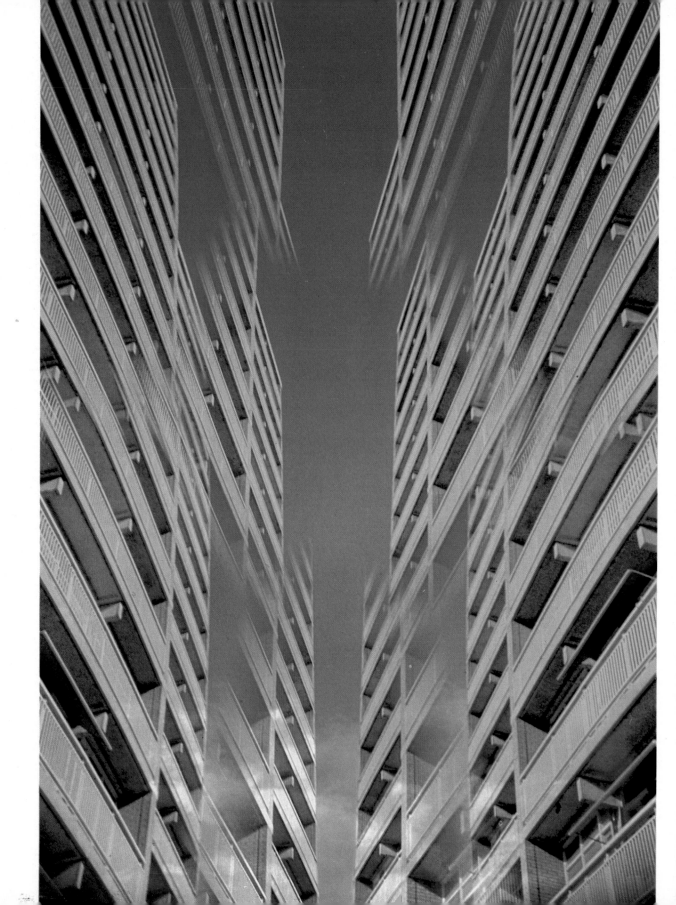

The techniques described here can be used for almost all other prism attachments. I shall therefore deal with the creative side of some of them but there is, in my view, little point in discussing the whole range. The choice is so great as to be scarcely surveyable and in addition, only a few people will be able to afford all of them. Various alternatives can be found for each one and often we can scarcely tell whether a trick attachment has been used, or whether there has been manipulation in the darkroom. As a rule, very little is done with it at the beginning but the longer one has it the more one thinks of ideas for using it. Initially, for example, I did not seem to be able to use a wide-angle lens, but suddenly I realized what could be done with it and since then it has become an indispensable element in my photography.

The photo on p.82 was taken with a prism attachment on a 24mm lens. It is, however, a combination of two transparencies, in other words a sandwich. It is really necessary to have a camera with interchangeable focusing screens for a photo of this type. In this case I used the screen in which the viewfinder image is divided into horizontally and vertically engraved lines. It can be used with all forms of photography in which composition is particularly important. (Another possibility is to use this screen in landscape photography so that the horizon can never slope in the picture – it would be seen straight-away against the lines in the viewfinder.) It was used in this case to take two identical photos of a block of flats, the two separate images being kept away from the middle of the ground glass. The transparencies were mounted with the emulsion sides together and this resulted in a penetrating impression of the striving upwards of such flats in our society. When taking these photos I had to concern myself with vignetting. Since this could not be used in the composition, I masked off a part of the transparency but masking is not necessary when enlarging on reversal paper since it is possible to enlarge from a part.

Masking is a particularly useful aid for the photographer who takes transparencies. It is nevertheless important that masking be carried out so that the picture still appears in the middle of the screen. Sometimes I see slides masked so that the rest of the picture appears to the left or right of the screen, and this in my opinion creates a very disturbing effect. I use the old-fashioned folding masks which used to be used for framing transparencies between two pieces of glass. It is best if the masks or masking tapes are gummed. Modern self-adhesive masks are less suitable since they do not always hold on the emulsion of the transparencies. Opaque black sticking tape is not recommended since it is seldom possible to mask perfectly straight with it and it creates a particularly careless impression if the border is not straight when projecting a transparency at high magnification.

Filters for colour effects

The filters I am now going to deal with influence merely a part of the picture. They were initially known as Cromo filters. They have in the meantime also been marketed by other manufacturers such as Cokin and we shall, for the sake of clarity, call them filters for colour effects. These filters can naturally be combined with other filters or supplementary lens attachments and enable the user to reproduce his own ideas and influence his pictures to the extent that they gain enormously in impact. The Cromo series consists of fourteen different filters in seven colours, each colour being in two densities, namely grey, blue, yellow, pink, violet, tobacco and emerald green. They can also be supplied in a form which fits into the Kodak filter holder of the Cokin multiple holder. Filters for colour effects can be obtained from B & W in two densities of grey, as well as in orange, violet, tobacco, yellowish green, green, blue, lilac and red. These filters can be used to obtain a special effect in a number of situations, for example in a sunset to intensify the effect by means of a red, pink or tobacco-coloured filter. It is naturally also possible to aim at a surrealistic effect by using a totally deviating colour. If one has only Cromo filters of the lightest type, they can be

intensified by adding a grey filter. This filter can also be useful in cases in which photography has to be carried out in a fairly bright light, but with a greyish sky having no clearly defined clouds. The grey filter can bring the background image into balance with the foreground. Specific scenes can be stressed because the filter operates selectively and another possibility is to obtain sunset effects on a bright day. Specific colours can be neutralized by using a filter in the complementary colour. Working with these filters nevertheless requires that the photographer be conversant with the behaviour of colour and his creativity also plays a decisive role so these filters have to be used very carefully.

A variation consists of two colours in one filter; for example, the lower half blue and the top half orange. Use of these filters involves quite a few problems since they affect the total colour palette, just as ordinary filters, but in two different colours simultaneously.

The photo on p.85 shows the combination of a Cromo filter with a prism attachment. When dealing with prisms I said that a specific feature is that parts of the sky run through in to the picture. In this photo the whole upper part has not only become darker, but blue, giving the impression that the flats with the cranes extend into the sky. The possibilities are great and I leave them to your imagination.

There are photographers who use, as an alternative to this filter, a piece of flat film. This is an alternative which you can make in the darkroom. It is of course essential that there be no dust around since dots in such a negative naturally produce very annoying effects. A variety of these negatives can be made and coloured, using the Tetenal multitoner set. In this way you can make your own set of colour filters on flat film, the Kodak or Cokin filter holder once again proving very useful. A really creative photographer is never at a loss. If he has no money for expensive aids, he makes them himself. I admit that the optical quality of such "filters" is inferior to that of those made by specific manufacturers, but they are a reasonable alternative with which good results can be obtained.

Spot attachments

The aids I want to describe now are at present very much in demand. They are the so-called spot attachments which are sometimes, quite wrongly, described as lenses or filters. Here the centre of the image always remains sharp while a lack of sharpness is created around it. The effect differs depending on whether a wide-angle or a telephoto lens is used. With wide-angle lenses it is necessary to stop down as much as possible in order to obtain a sharp image and with lenses of a longer focal length it is necessary to stop down less for a sharp central image. With ultra wide-angle lenses the spot attachment can once again give rise to a certain vignetting which can nevertheless here, as with prisms, be exploited creatively. The distance of the attachment from the lens, as well as the aperture, affects the amount of the picture rendered in soft focus.

An alternative can easily be made for this aid. An ultra-violet filter is taken and smeared on the whole of its outer edge with Vaseline, the centre remaining free. This provides a virtually complete imitation of the spot lens, but the alternative can even be used to better creative effect than the spot lens itself. It is possible with it to exert a partial influence and to leave clear what one wants to. In the genuine spot lens you are bound to the sharp centre which lies precisely in the middle of the picture area. The Vaseline filter was used in the photo on p.86, as a result of which the sharpness runs away to some extent in the corners. It is necessary to work carefully when using Vaseline. It must not be smeared on too thickly since then insufficient light is allowed through. A zoom effect can be imitated more or less by applying the Vaseline in strips from the centre, this being done normally with small rotary movements. The addition of dyes gives an extra dimension to the Vaseline lens. The photo on page 86 shows a mother and child on a merry-go-round. In a normal shot the main subject would be suppressed by the bright coloured and detailed surroundings. By using a spot lens the mother and child are completely isolated from their surroundings, resulting in a strong expression of their pleasure. It nevertheless remains clear where they

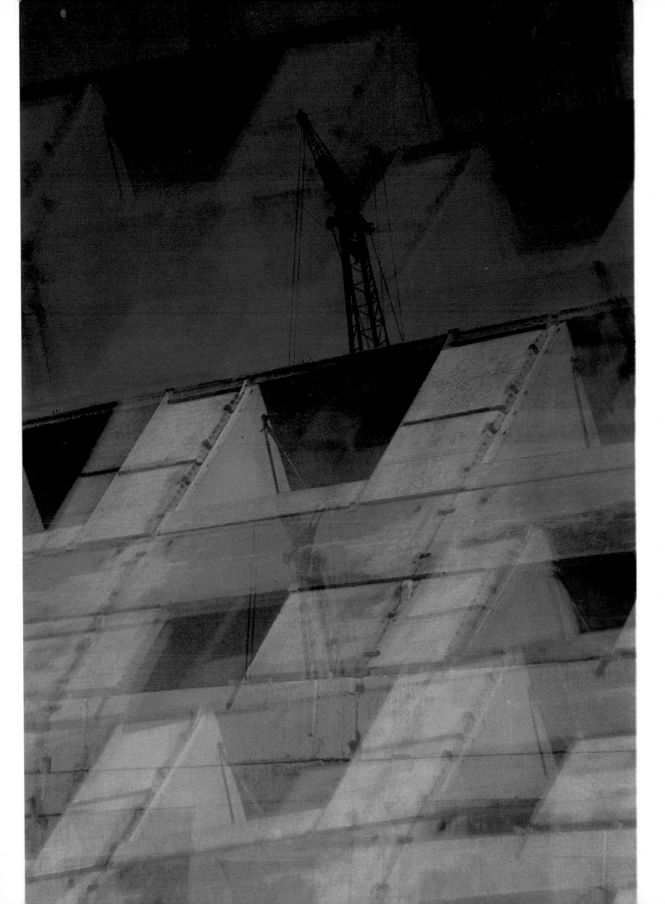

are and why they are so pleased. The spot lens also softens to some extent the always glaring colours associated with fairs which means that colour photos of them often create a banal impression. The lens had a focal length of 24mm which is highly suitable for this type of photography. Lenses with a longer focal length are not as suitable for combining with a spot lens. There is an exception to every rule, and so I should point out that magnificent portraits can be taken, for example, with a 135mm lens combined with a spot lens but too large an aperture can soften the whole picture instead of leaving the centre sharp.

The spot attachment is also suitable for reproducing specific moods, as illustrated in the two photos on p.87. The upper photo of a block of flats with shrubs in front of it shows an idealized reproduction. The lower photo represents a complete contrast, giving a clear impression of starkness and desertion, symbolizing, as it were, loneliness in a large community. This impression can be further intensified by enlarging, as you will see in the last chapter. It is sometimes said that one must never first show a transparency and then an enlargement from it. That may be true, but the original transparency can often be improved by enlarging it, at least if the technique has been mastered.

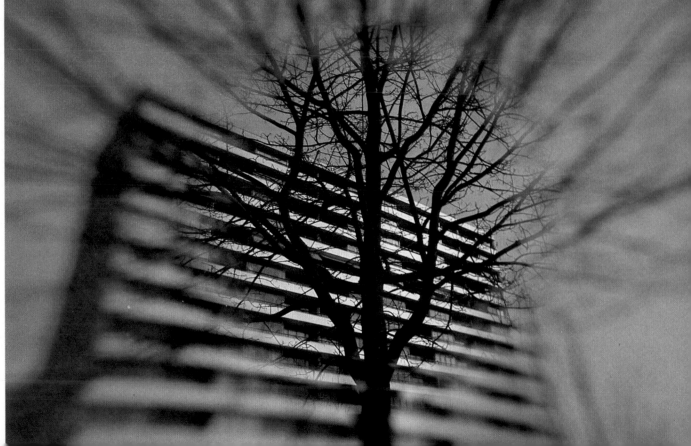

The starburst lens attachment

We now come to the so-called starburst lens attachment. You have no doubt occasionally seen photos taken at night in which the points of light have the effect of stars, or shots taken into the sun which likewise show a star formation. This need not have anything to do with the use of a starburst lens attachment. This effect can in fact be achieved by stopping down, for example to f/22 or even beyond. The point of light depicted then takes on a star-shaped pattern, caused by diffraction phenomena of the light passing through the blades of the diaphragm. The effect is stronger as the time of exposure is longer and also depends very much on the intensity of the light.

So-called starburst lens attachments were made in order to intensify the effect and imitate it at larger lens apertures. They can be obtained to give star effects with 4, 6 or 8 points and some consist of two contra-rotating glasses giving infinity variable stars. The position of the points can be regulated with them and all star effect attachments can be rotated so that their effect can be viewed. Star effect attachments generally have a softening influence. There is a reasonable alternative to starburst lens attachments, namely a piece of nylon stocking stretched tautly over the front of the lens. This can give star effects, but it also softens the image. A hole cut in the middle of the nylon will also convert it to a spot attachment.

The photo on page 88 shows a combination of various techniques which make use of starburst

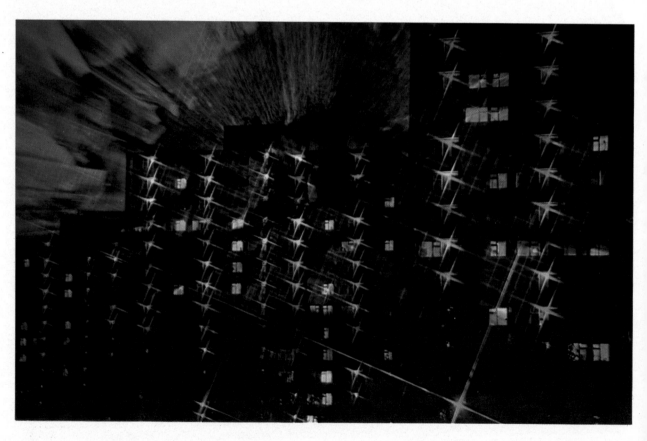

lens attachments. It shows flats photographed with such an attachment but when the transparency was finished I was not pleased with it because I wanted to make the flats seem more menacing. Consequently, I took a photo with a zoom lens of a piece of tin which was lying in the sun, using the method already described of zooming during exposure, so that the centre remained sharp. I mounted this transparency behind that of the flats, resulting in the photo shown here. One can see from the effect of the starburst lens attachment that the sources of light were not all that strong (just look at the windows). Only with strong high lights does one obtain a decided star formation. Another effect can be obtained by using the starburst attachment slightly out of focus. It makes the stars broader, and the photos more impressionistic. It is also possible to achieve very interesting results when shooting against the light on water. The number of possibilities is unlimited, especially if you start combining with other filters and/or techniques. Here are a few examples: a starburst attachment combined with a spot attachment or both together combined with a prism attachment. All these combinations can also be used with a zoom lens.

Diffraction filters

I should like finally to discuss a filter which gives a very spectacular effect, but which has to be used very selectively. It is called a diffraction filter and the name already tells you something about it. It can truly be called a filter because in fact it breaks down light into the colours of the spectrum. It also has a slight softening effect. Around bright objects or sources of light it gives outlines which show the colours of the spectrum. This effect increases as the light falling on the object becomes stronger. The filter can strengthen the image greatly, for example, when photographing a swan on water, surrounded by magnificent colours. The example you see on page 89 shows a block of flats with metal balconies on which the sun was shining strongly, giving bright shining planes which were highly luminous. Use of a prism increased the effect even more. The extent of stopping down here again affects the final result. In the last chapter you can see a photo of a block of flats photographed in the same way and then sandwiched. In this the effect is even better. A variation of this filter is the Galaxy which provides a circle of coloured lines around a bright light source.

I have already mentioned on various occasions the combined use of filters with a prism attachment. Take care that the filters are never damaged and make sure never to rotate a normal lens on a prism attachment. You can run the risk of damaging the filter because the middle section of the prism lens is somewhat higher than the other sections. There is a tendency to do this since the prism also has a screw mount. I have nevertheless experienced to my cost that no filters can be screwed into it so always first put the filter on the lens and then add the prism. This of course applies not only to the spectral filter, but to all filters. The spectral filter has a softening effect with pronounced outlines in black-and-white photography but, in colour, it shows the spectral colours around the subject. The photo on page 90 is based on this effect. It is a piece of sculpture, strongly illuminated, so outlines show around the subject, and where bright glaring light falls on it there is an extra strong refraction into the colours of the spectrum. The diffraction filter is ideal for use in combination with other filters or supplementary lens attachments. There are sundry variations on the market, but not all filters and supplementary lens attachments on the market can be featured in this book.

I hope you can create your own ideas from what has been discussed in this chapter and thus achieve completely original pictures.

5. Zoom lenses in combination with supplementary lens attachments

I have already pointed out that a combination of various shooting techniques can lead to unusual results. It also gives the photographer an opportunity to indulge his creativity when taking the shot. This greatly simplifies processing in the darkroom. The lenses which lend themselves best to a combination of sometimes three techniques simultaneously are, as you will understand, the zoom lenses. They can be combined in an ideal way with the supplementary lens attachments described in the previous chapter and, first of all, I shall describe the possibilities with a combination of a six-sided prism and a zoom lens. It is important with these combination techniques to try everything out beforehand and the amateur photographer has time for that because it is, after all, his hobby. He can also try again if he is not successful the first time. I think it is important that the amateur should set himself a specific task. It compels him to work purposefully, to concentrate on his subject and to get new ideas. There are some amateur photographers who want to do everything at once, but that of course is impossible. You must make a choice and then study the subject in depth. This not only gives much satisfaction, but also raises your potential to a higher level. By working just anyhow the result is likely to be merely mediocre. In my classes I always set assignments which treat a specific aspect of the material in the lessons. If they are worked out consistently, then one even sees good results from the most unlikely people, solely because they are now forced to concentrate on the subject. Before beginning a description of the combined technique, I should advise everyone to go through and practise the zoom techniques dealt with in Chapter 3.

The three photos on pages 95 and 96 were all taken from the same position and with the camera on a tripod. In all cases the same lens and supplementary lens attachment were used. The upper photo on p.95 was taken with a 135mm lens at f/8. In photos of this type the whole aperture range is first examined in order to determine which gives the most penetrating impression. In this shot the prism lens attachment was rotated during the exposure. That is more easily said than done. In the first place, there has to be long exposure time at the chosen aperture. This can only be achieved by using a neutral density filter. The most suitable film for techniques of this type is Kodachrome 25 which has a speed of 25ASA. It also has an extraordinarily high degree of brilliance which is specially important in such photos. The exposure time has to be about 1/8 second. The rotary movement of the prism lens attachment is not difficult to achieve since there is a small handle on the mount which facilitates its manipulation. The actual photo is taken as follows. First of all the rotary movement of the filter is started and the shutter release is pressed during it. The same applies here as in zoom techniques:- the faster the lens attachment is rotated, the greater is the blurring effect. It can be seen clearly in the upper photo that the rotating was done only very slowly and the outlines have remained visible in the region of blurring but different effects can be obtained, extending up to total blurring. However, in this example it was a matter of "spreading the colour" to some extent evenly over the transparency, as the well-known photographer Ernst Haas used to say. This technique can be used for virtually any subject, including photos of flowers which can be intensified enormously by the total isolation of a sharp centre within unsharp surrounds of the same colour. The viewer's attention is then immediately drawn to the centre and compared with the effects of 'Vaseline' filters the colours are reproduced more brilliantly. These two techniques can not really be compared since they each have a completely individual character. The technique described here can be used with virtually any prism lens attachment, including parallel prisms. Care has to be taken nevertheless with the parallel prism, since the lack of sharpness which arises through the movement is only on one side of the transparency. If rotation is carried out too far, merely total distortion results.

In the lower photo on p.95 the zoom technique was used as described in Chapter 3. Here, too, a sharp image remains in the centre and this technique can also be used in combination with lens attachments. The three photos illustrated on pages 95 and 96 each give a completely different result from the same subject. In each case the

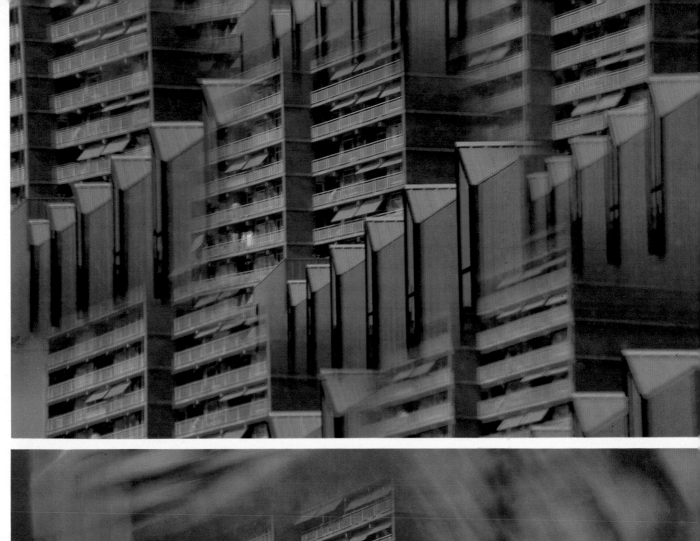
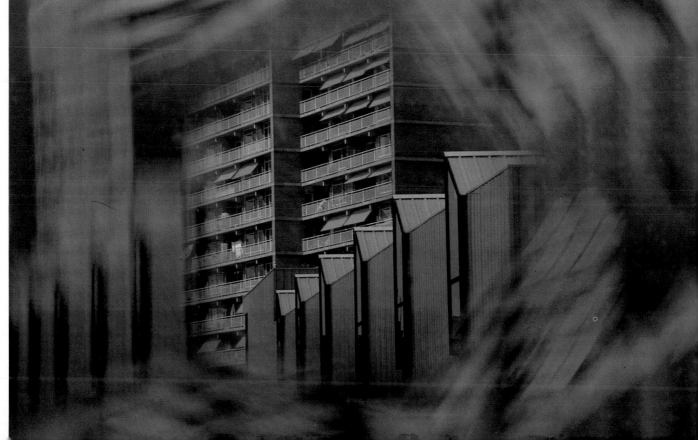

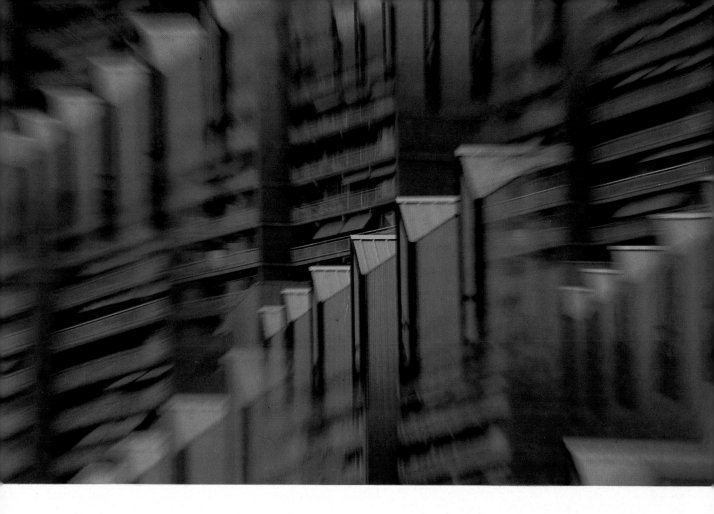

effect is considerably more interesting than a simple straight-on photo with a prism lens attachment. If transparencies made by one of the techniques just described are combined with another transparency using the sandwich technique, very unusual effects can once again result. It is not really possible to give rules for these, but only hints as to how they can be achieved.

The photo on p.97 shows the result of a combination of the zoom technique, prism lens attachment and sandwich technique. The photo of the flats with the birds was taken deliberately. A well-considered plan is particularly important for the success of such a combination. Artificial light colour film was used for all these shots,

although they could have been made on ordinary daylight colour film using a conversion filter (see Chapter 4) and they are extra blue since they were taken in evening twilight. The photo is the result of a treble sandwich. Two photos were taken using the zoom technique and from the same position, but they differ considerably. The third photo showed a group of pigeons against a lead-grey sky. The first zoom shot was taken with a prism attachment in front of the lens, adjusted on the flats. It was a time exposure of two seconds and the lens was zoomed out during the second second. The sharp streaks visible in the photo are the result of this. The second photo was likewise taken with a zoom lens and a prism attach-

96

ment. The camera was set out of focus, after which there was again an exposure for two seconds and the lens zoomed out during the last second. The unsharp larger streaks are the result of this. Both photos were mounted with emulsion sides together. Afterwards the photo of the birds was combined with them upside down, thus intensifying the unreal effect. Someone once said of this photo: "Look, even the birds are leaving those macabre masses of stone." It is often said that the colour red has a dangerous and threatening effect but it appears from this picture that the usually peaceful colour blue can also have a threatening effect in some cases, particularly in montages. With photos like this the difficulty lies

mainly in working out the idea in the first place. In order to arrive at a balanced whole I had, for example, to take the photo of the birds a number of times. It is sometimes said that technique predominates in this sort of photography, but I reject this emphatically. It is not purely a matter of the technique but a question of arriving at a preconceived aim with the aid of technique.

I am trying to show in this book that much can be achieved by a combination of different techniques, so obviously it is necessary to master each one. Just as a musician can only arrive at his own artistic interpretation after much practice, so the photographer must also practise if he wishes to work creatively. A great deal of

will-power is needed for this to overcome the many disappointments, especially when the greatest disillusion comes after thinking he has reached the appointed goal. Whoever wants to achieve something will have to get used to criticism, not all of which will be unfounded. Accept what you can use of it and leave the rest aside but also take account of the source of the criticism.

The photo on p.98 is also a combination of a zoom lens and a prism attachment. For this photo I visited the subject, the flats, evening after evening until the moment when the light was failing so that it satisfied the demands I had made for my chosen camera position. The late evening light had to fall precisely at the right angle on the flats in order to achieve the impression reproduced here. I used an aperture of f/8 with Kodachrome 25. A neutral density filter was necessary to master

the large light contrasts so that I could expose at 1/15 second. In this photo zooming was carried out during the exposure, and the position of the prism was changed. This resulted in the blurring effect of the blocks of flats bathed in the evening light. I would mention in passing that nearly all the photos of blocks of flats in this book were taken at the same place. It confirms that getting used to a subject leads to the maximum effects, and that a successful photo is frequently the result of working for many days or evenings. It is naturally not intended that the photos in this book should be copied exactly. After reading the descriptions of the techniques used you will automatically get your own ideas for subjects which you must then start working out. It is also possible to learn to master the various aspects of the technique step by step. The results

shown here are those of years of hard work, listening to good criticism, discussions with artistically trained people, etc. These latter need not be photographers, but can also be painters, draughtsmen or the like and they often have very enlightening opinions on photography. It has seldom happened that these people have refused to criticize my work. This has often led them to ask my opinion of their own work and very enlightening discussions have arisen from such situations.

The photo on p.99 was made using a number of techniques. The lens used was a 28 to 50mm zoom lens. There was no zooming employed but a tripod was used. The short range zoom lens was necessary in order to manipulate the focal length so that, in combination with a five-sided prism, the desired ray of light should fall between the buildings. Apart from the zoom lens and the prism

lens attachment, a three-colour filter was used. Such filters are expensive and used only rarely so they can be replaced by a piece of glass, for example an ultra-violet filter, on to which various pieces of coloured filter gelatin have been stuck. Here the zoom lens, a prism lens attachment and a three-colour filter were used for the first shot. It was then sandwiched with the transparency of the birds, resulting in an almost surrealist effect. The normal colour reproduction was of course changed radically by using the three-colour filter.

The photo is the result of several hours' work. In the first place I had to wait for the correct fall of light, no problem for me. Once I have such a subject I wait as long as necessary to take the shot. Were I not to do so, the idea for the photo would be quickly forgotten.

The completely unnatural colours will put

many people off but others will perhaps admire them. As I have explained various techniques were combined here and a large number of variations is possible. For example, one can think of a combination of a prism lens attachment and a three-colour filter, possibly combined with a Vaseline filter. If you want to make a three-colour filter yourself, this must be done very accurately, since the pieces of foil have to meet exactly. If you aren't careful, there will be an incursion of white light through the open chinks. If it is impossible to mount the separate colours close to one another, then it is advisable to allow them to overlap slightly. You are not committed to specific colours and you can make your own choice. The two-colour filter referred to earlier in the book can be made in the same way. It is obvious that the separating power is reduced to some extent by these manipulations so a lot of stopping down

may be necessary but it is definitely a good alternative for those who find the genuine filter too expensive. It is scarcely worth while to purchase expensive filters to use once or twice, and then no more. The position is quite different for the professional photographer. He can use these filters repeatedly for various commissions, and it may even be worth buying them for a single commission.

Alternative methods

What I am now going to describe is intended for those who do not have the opportunity to acquire a fairly expensive zoom lens. When discussing

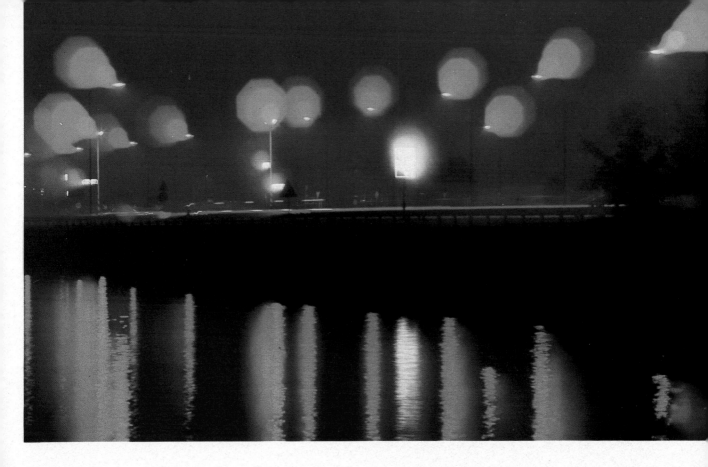

Vaseline filters I pointed out that they can frequently be exploited to better creative effect than, for example, a centre spot lens, but this does not apply when imitating the zoom technique. There are a number of restrictions attached to this, but by practice and endless experiment it is possible to achieve results which experts have difficulty in distinguishing from genuine zoom photos. The first method is once again based on the Vaseline filter, smeared according to the pattern you want and with the centre left free. This filter has its greatest effect when used on a wide-angle lens. This does not mean that there would be no result with another lens, but the wide-angle lens is the most suitable because of its large shooting angle.

The example on p.100 shows a white building taken with a 24mm lens and a Vaseline filter.

A fairly large part of the filter had been left clean. (I shall be saying something about an alternative zooming method with a Vaseline filter in the chapter on sports photography.) The filter can be smeared in various ways: the first method is with gentle rotary movements, not applying the Vaseline too thickly; the second method is to make streaks from the middle to the outside. Both methods approach the zoom effect, but each in a different way.

It is obvious that many mistakes will be made with such aids, particularly at the beginning and you certainly won't be successful every time. Nevertheless it is important that you do not give up, but persist energetically. We all make mistakes, even the most experienced of us. You all know the saying: *"those who work make mistakes; those who do little work make few mistakes; I*

101

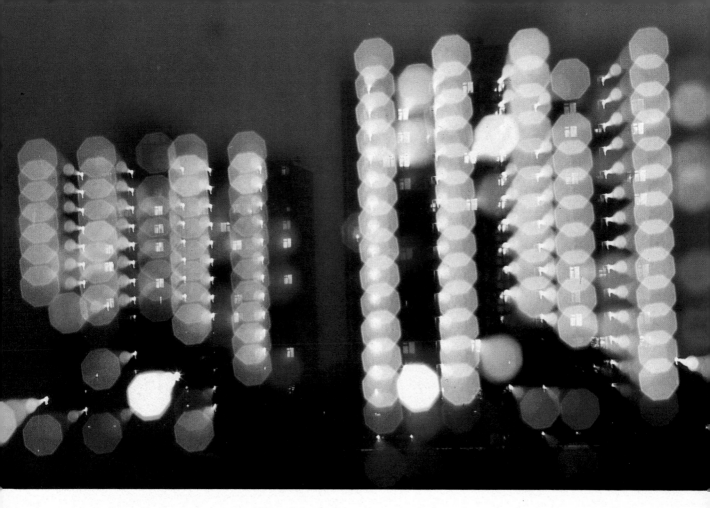

know people who do not make any mistakes".
You can be comforted by the fact that there are
many people who have an expensive set of camera
equipment merely as status symbols. They "do
not make any mistakes"; they go on continually
about technique, but do nothing themselves.
You need take no notice of the criticism of such
"amateur photographers". They are lacking in
any appreciation for the work of others.

Ordinary lenses were used for the "zoom"
photos on pages 101 and 102. I have already said
that there are a few limitations when using
ordinary lenses as zoom lenses but they must be
mentioned nevertheless. Here, too, the technique
is based on the use of long shutter times, longer
than one second so it is obvious that a tripod

must be used. This technique is essentially very
simple and it is based on the adjustment of the
lens from sharp to unsharp during the exposure.
The photo on page 101 shows a busy road and it
was made with a 13 mm lens. After measuring the
exposure time, the shutter speed was estimated at
8 seconds. Maximum stopping down is usually
necessary for such times, possibly using a neutral
density filter. For the first four seconds the ex-
posure was normal; then the lens was gradually
turned to the unsharp position. One can see in
the result that there was a very small aperture
because the shape of the diaphragm is visible.
To avoid this it would be necessary to work with
a larger lens aperture.

Photos of this type are very effective in evening

twilight. The street lighting had just come on and generally created a fabulous effect through its contrast against the deep blue sky. Daylight colour film without a conversion filter was used for this picture.

It is of course possible in photos of this type to use a combination of techniques. Interesting, for example, is the use of a three-facet prism combined with the technique just referred to. A combination with a Vaseline filter or spot attachment is also worth trying. The number of variations is unlimited but basic technique is and remains the decisive factor for success.

The photo on p.102 shows a few blocks of flats, once again in evening twilight. A KB6 filter was used on this occasion to avoid the lights looking too yellow. (This is a matter of taste about which I do not wish to argue.) In this case, too, the lens was turned out of focus in distinct stages. A sharp image is seen once again within the out of focus images due to the "zooming". This is not a true zoom photo, but one in which there was a turning out of focus while exposing with a normal lens.

Evening twilight was used in the last two pictures. This is not always necessary since, for example in rainy weather, it is possible in the evening in a city to make use of the lights and their reflections in the wet road. Magnificent photos can result from double exposures, time exposures in which the lens is turned out of focus or by double exposures the first shot of which is in focus and the second not, etc. Another good way of imitating a zoom photo is to take a shot from a moving car. Times of 1/30 or 1/15 second have to be used for this and the car must be moving fast. A small part in the middle then remains sharp, while the edges are completely blurred. It is important to have a steady hand but it does not matter if the middle is not completely sharp provided the impression is beautiful. Charming results can be obtained, in autumn when the car is driven along a lane with many trees but good pictures can also be obtained in a city.

One can argue whether photographs of this type have any value. The answer depends on various factors. It is very difficult to pre-visualise the result, but I don't think that is always necessary. What is important is whether the photo is expressive in itself and the photographer may well achieve this.

Perspective correction lenses

Lenses (in most cases of the wide-angle type) with which it is possible to correct verticals like the Canon, TS lens (Tilt and Shift) are available. Since there will be few amateurs owning such very specialized lenses, I shall not consider them in detail but I should like to refer to one use for such lenses. They can be adjusted during time exposures to achieve unusual effects which are nothing to do with the zoom effects, but have a character all of their own.

To conclude this chapter, I must give a general tip which does not belong here particularly, but which I do not want to omit. It concerns keeping films. Whatever film is being used, the best place to keep it is in the refrigerator. It is also not a good idea to leave a film in the camera for too long because the latent image is particularly sensitive to temperature influences. This applies to all makes and types of reversal film. There are sometimes complaints about a colour shadow shown by a film. It turns out in most cases after a few questions that during a journey to Spain the film was lying on the back shelf of the car (in the sun!). It is essential that all films be kept cool. This can be achieved to some extent on a journey by keeping the films between the clothes in your case.

6. Movement in photography

Not so long ago it was inconceivable to show photos in which lack of sharpness caused by movement was evident. It was regarded as a grave fault on the part of the photographer and was therefore unacceptable but times have changed.

An important part of this chapter is devoted precisely to the use of lack of sharpness caused by movement for impressionistic colour photography. There are of course more methods for photographing moving objects. The one most frequently used is undoubtedly "freezing" the subject by using an extremely short shutter time. This is also the best method in sports photography for obtaining purely documentary photos but those which show movement have more artistic and aesthetic value.

A second method, which is also attractive is the recording of the movement in a number of photos taken in rapid succession so that the action is presented as a story sequence. For this technique sports photographers frequently use the motor drive which can be fitted to some cameras. A winder can be supplied for certain cameras as a cheaper alternative. Those using such aids can concentrate on the subject without needing to move the camera from the eye. I find this an even more important advantage than the possibility of being able to take a number of pictures in rapid succession.

Working with a motor drive or winder also requires experience and mastery of the camera. Many people think "if only I had a motor drive, then all would be well". This is a great mistake! It is important that the focusing be controlled all the time and the correct image area has to be maintained. It is a myth that if someone shoots enough film with the motor drive he will come home with the print of his life.

I use a motor drive for many forms of photography, but in most cases I have it set at "single shot". I use it in the first place so that I can concentrate completely on the subject. The motor drive enables me, for example, to photograph a race finish at precisely the right moment, but I still focus sharply beforehand on a specific point and then let the subject come into sharp focus. Even when the motor drive is on "continuous", I seldom take more than three shots in succession, often only just one. After all, one can always see the correct moment approaching, particularly if one has some experience. The winder is slower in use than the genuine motor drive, because it does not fire the shutter as well as advancing the film but it is still a reasonable alternative.

In the photography of movement, handling of the camera is of essential importance. There are amateur photographers who hold the camera body with both hands even though there is a 135mm (or even longer) lens on it and they will not obtain sharp shots, even at very short speeds.

I hold the camera body firmly in one hand while I support the bottom of the lens with the other. I press my left arm firmly against my body and press the camera against my forehead with my right arm. My body is bent forward with my legs apart. If one adopts this stance consistently, it is possible after a lot of practice to shoot with a hand-held camera at speeds as slow as 1/60th second, particularly if you seek extra support from a wall or lamp-post. A motor drive increases the weight of the camera and adds to the stability of the combination, so increasing the chance of sharp photos. A tripod cannot often be used in sports photography but a good alternative is a chestpod.

If you want to take sharp sports photos, fast film is essential. Kodak and Agfa now make films as fast as 400 ASA and these can even be increased by forced development, but for photography to show movement and to avoid the use of a neutral density filter I use Kodachrome 25. There are of course cases where a tripod can be used, for example at race-tracks where the subject always returns to the same point so that it is possible to focus sharply on it. One is then considerably less mobile, but even so I should advise everyone to do this where possible.

The suggestion of speed

Another way to photograph movement is to design the picture in such a way that there is a suggestion of speed. I should like to refer you back to Chapter 3 in which I gave an example of a car placed obliquely in the picture and taken by the zoom technique which resulted in an illusion of movement.

It is, for example, possible to photograph a racing car perfectly sharply at car races in this way by placing it obliquely in the picture. You should consider whether to show the suggested movement in the direction of looking, i.e. from left to right, or in the opposite direction. I occasionally allow the movement to take place against the direction of looking because this, in my opinion, heightens the tension.

Sharp reproduction

In order to achieve sharp reproduction, it is important to know what shutter speeds to use. This depends very much on the angle at which the moving object is being photographed. A subject which is coming straight towards the camera can probably be taken at 1/125 second. If the angle at which the subject is moving is larger, then a faster shutter speed time has to be used. A racing car which can be perfectly sharp from the front with a telephoto lens at 1/125 second will, with a movement at right angles to the camera, probably not be sharp even at 1/1000 second unless the "panning" method is employed. The distance to the object also plays a part; – the shorter the distance, the higher the relative speed of the object and the faster the shutter speed required.

Lack of sharpness due to movement

I wrote at the beginning of this chapter that lack of sharpness caused by camera or subject movement was previously regarded as a fault. This "fault" nevertheless can be deliberately featured aesthetically by using a longer shutter time to capture a large number of overlapping images which together constitute a blurring effect.

This technique can be applied in many ways:–
1. Using a long shutter time, which can vary from 1/30 second to several seconds;
2. Panning the camera, to keep the subject sharp but the background blurred;
3. Panning the camera more rapidly than the movement of the object;
4. Panning the camera more slowly than the speed of the object;
5. Deliberately moving the camera up and down during a long shutter time;
6. Giving the lens a tap just before exposure involving a fairly long shutter time;
7. Panning the camera with an extra long shutter time so that both the background and the object become unsharp;
8. Using the zoom technique;
9. Using a zoom technique with moving objects combined with long shutter times;
10. Letting a detail move in a zoom technique while taking a static object, for example a parasol, (page 44) this detail then playing an extra part in the movement;
11. Suggesting movement at the printing stage by shifting the paper during exposure (much used in black-and-white, but not to be recommended in colour without a lot of experience);
12. Panning the camera with the subject and altering the focal length of the zoom lens during that panning.

Some of these techniques have already been mentioned earlier in the book; others will be described here.

Panning

The word panning was used a few times in the previous section. It is a technique which certainly needs some practice. In my opinion, those possessing a rangefinder camera have an advantage here, particularly when using long shutter times because one can continue to follow the object at the right place in the viewfinder, even during the moment the exposure is made. This is not the case with reflex cameras since the mirror closes during the exposure and blacks out the viewfinder image.

Consequently you have to have a lot of practice before this technique produces good results. The problems also increase with long focal length lenses.

Panning the camera with shutter times of 1/1000 second is not so difficult. The shutter is open for an extremely short time only. If longer times are used however, for example 1/8 second, problems arise. The problem is not so great in the case of objects which are not moving quickly but if it is a question of taking an impressionistic picture of a speedboat or a racing-car at top speed, the necessary practice must precede a good result. This practising need not necessarily take place with a film in the camera. You can easily practise with an empty camera, in order to get used to keeping the camera in the same place when taking the shot and ensuring that the object remains properly in the picture, particularly when using long shutter times. The body should swing from the hips and follow through after exposure, just like a golfer. Once this technique has been mastered it is possible to pass on to using black-and-white negative film and the amount of blur can be judged after developing it. You can also see whether the subject has remained properly in the picture from the point of view of composition. This latter is difficult when using a motor drive or winder: there is a tendency to follow the movement too quickly when taking several successive shots and this results in the main object getting in the corner or too near the edge. Those who master this technique completely can then move on to objects which are moving quickly. Blurring in the background which has to suggest movement depends to a large extent on the speed of the object and the shutter time selected. A racing-car at high speed will, for example, be reproduced against a reasonably blurred background on panning at 1/125 second. The longer the shutter time, the stronger the blurring in the background. In the case of dog races, for example, the background very soon becomes blurred at 1/60 second as a result of the often short shooting distance. A person who is running fast and who is not all that close to the camera can be taken at 1/8 second. Not too much sharpness then remains in the picture, but that can be an attractive aspect when movement of limbs appears against the blurred or streaked background.

You will see from the photos reproduced in this chapter that background plays an important part in photography involving movement. The background has to have a strong supporting character. It does not strengthen the impact to photograph a rapidly moving object in front of a concrete wall! It is even detrimental to the photo. In athletics, an ideal background is formed by the public dressed in colourful clothing.

The most suitable lenses for photography of this type are those with the longer focal lengths from 135mm to 400mm but as the focal length becomes longer, the difficulties increase. They are harder to keep in focus during panning. This is compensated by the fact that the results are certainly more interesting because all the colours merge into one another through the typical telephoto effect.

Sports photography

When I refer to sports photography here, I do not mean the reportage shots taken by a newspaper photographer. That type of photography cannot be practised by most amateurs because they cannot position themselves at the most important sports events where the best photos can be taken. I am concerned with artistic sports

photography and I mean by that the photographic impression. The winner is not important here, but portraying of tension and the expression on the faces is the object. You do not need to be concerned with top sport for this either, nor are you bound to the shooting positions occupied by press photographers. I have taken spectacular photos at places where there was no other photographer. It certainly is important to know something about the sport you want to photograph and going to look beforehand is particularly important, so that you learn to anticipate the action highlights. Don't begin with three or four kinds of sport at the same time :- tackle one and work on it systematically.

In order not to hinder the sportsmen a first requirement is a lens of a long focal length. Once again I very much like using a good 85 to 300mm zoom here. If this is too short, I use the Canon FD 400mm, f/4.5 an ideal lens for sports photography, partly because it is particularly light as a result of the use of floating elements. Thanks to its speed a shutter time of 1/1000 second can generally be used with a full aperture, even with Kodachrome 64 film. Bright light conditions are necessary for this. If the light conditions are bad, I prefer to use the 200ASA Kodak Professional film, although its grain is somewhat coarser. I can even take sports photos in the rain with it.

Zoom effects can be obtained with almost every sport, and I have found cycle racing particularly spectacular. You will see various examples in this book.

I have already said that particularly expressive shots can be taken of the spectators at sports events showing their reaction to the action. This can record exciting moments. Think, for example, of the exuberant mood in a stadium when supporters are applauding a goal or similar achievements. Those who want to be successful here will have to use a lens of a long focal length. This enables them to photograph unnoticed, which is important since many people lose their spontaneity as soon as they notice they are being photographed.

One of the problems here is in handling a camera with a long focus lens on it. Often it is not possible to use a tripod so it is necessary to use a chestpod, a shoulder support or a monopod. You will have to practise regularly at holding the camera still, but even then you cannot expect to come home with 36 successful photos on every film, every time. If only that were so! I have already emphasized that it is always a good idea to take several photos in order to have a better opportunity of getting a good result. You may even have to go back on another occasion.

I shall now describe all the ways of reproducing movement beginning with the studies of movement I made when my interest in this type of photography was just beginning to be aroused.

We see in the upper photo on p.110 that the rider is reproduced fairly sharply, while the background and foreground are somewhat blurred. The shutter time was 1/60 second. By using a long focus lens the background seems to be closer than it was in reality. The bike was moving at about 60 miles per hour and as a result of the relatively long shutter speed the foreground and background are well blurred. The photo was taken from a very low viewpoint the long grass in the foreground helping to heighten the impression of speed. The camera was panned with the subject. The difficulty is always that the subject has to remain in the correct position in the picture area and the direction of movement in this photo is deliberately opposed to the normal direction of viewing from left to right because, in my opinion, this expresses the speed better. The photo was taken on a path leading to the place where the races were held and afterwards it was crowded with motor cyclists on their way home.

Two techniques were in fact used in this photo, namely panning and the choice of a shutter speed to freeze the subject. If slower shutter speeds are used, more impressionistic photos result. I shall revert to this later.

The lower photo on p.110 was taken in quite a different way. Here, too, speed is reproduced, but in the opposite way. It was taken with a very long exposure and the camera was on a tripod on the roof of a car park so that the white arrows on the road surface were well in the picture. It was then a question of waiting until two cars came at the same time into the picture area to suggest the

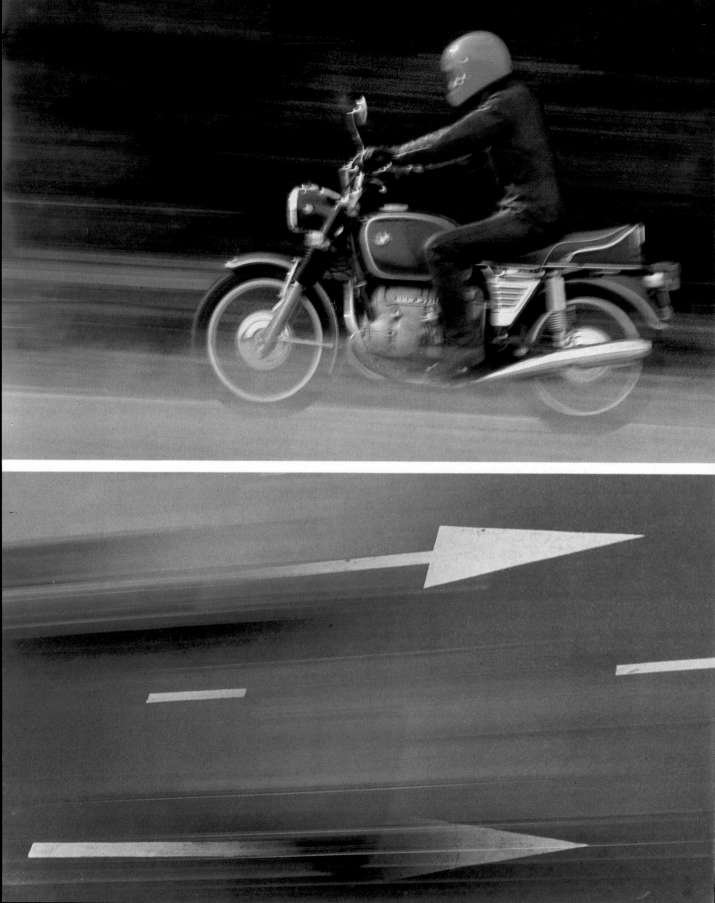

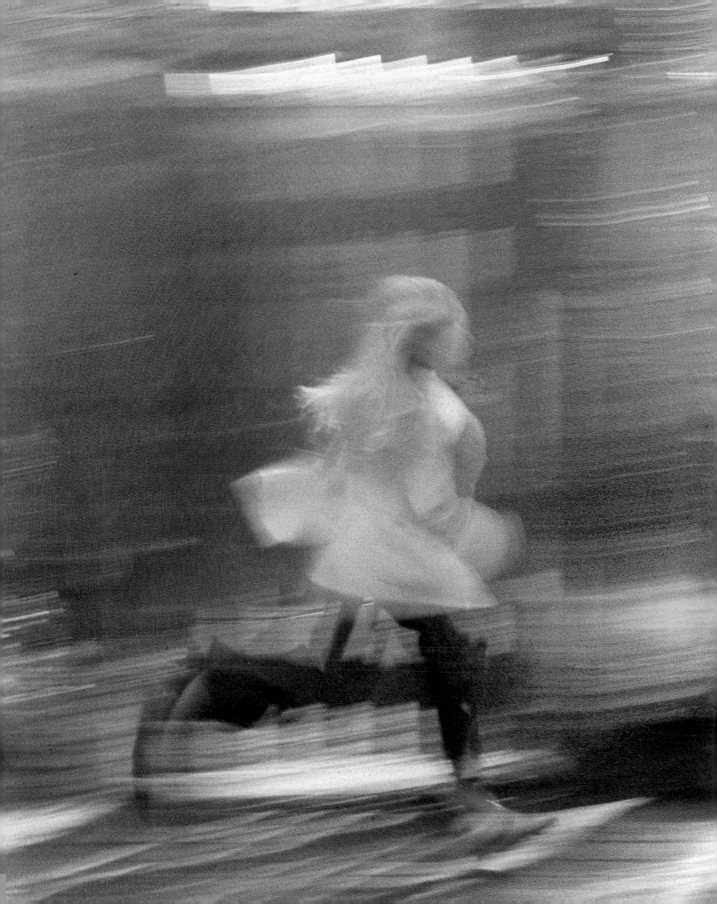

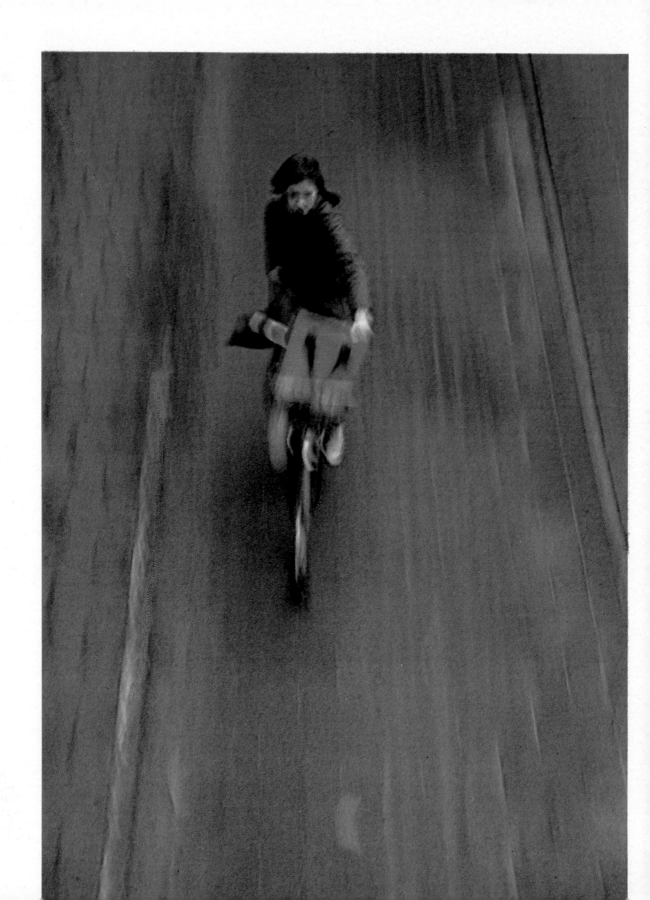

desired speed. The lines were just past a set of traffic lights so that the cars had not yet attained a high speed. The shutter was therefore set at 1/15th second. I intended to get the cars very blurred and going to the right in the picture. Obviously with this type of subject it is necessary to make a number of exposures to have a reasonable chance of one of them being successful.

The photo on p.111 shows the panning technique using a slow shutter speed resulting in unsharp blurring of the background and its character is particularly important here. The girl used to run past my house at about the same time every day and a fence in the background let the light through in the form of strips. This was of decisive importance in the composition and panning was also very important. Naturally the principal object must never be stuck towards the side of the photo or even run out of the picture. The shutter time was 1/4 second so it would have been easy for the girl to be in the wrong place in the composition. It is not for nothing that I am once again stressing that practice in the technique of panning the camera is more important than you think. The photo on page 112 of the girl on a cycle was taken with an exposure of 1/4 second while I was standing on a viaduct and the camera was panned vertically resulting in both the road and the girl being reproduced in unsharp. Here, too, the girl is at a strong point in the composition. Panning was here from top to bottom since I was shooting from a high view point and the girl was cycling directly underneath me.

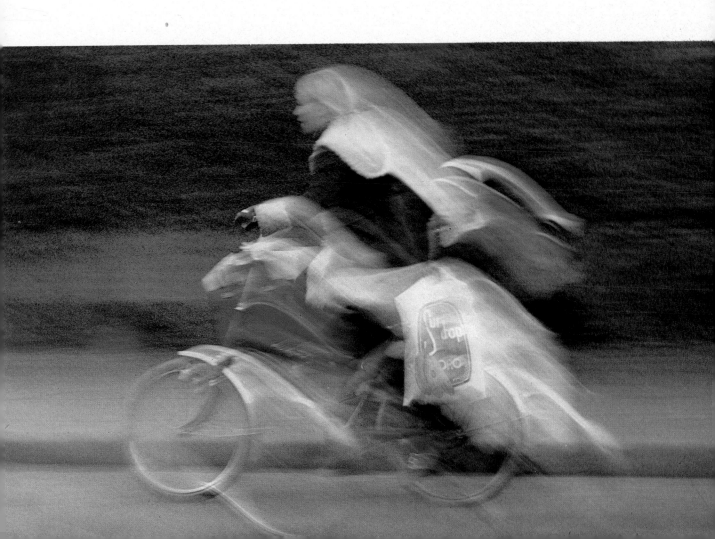

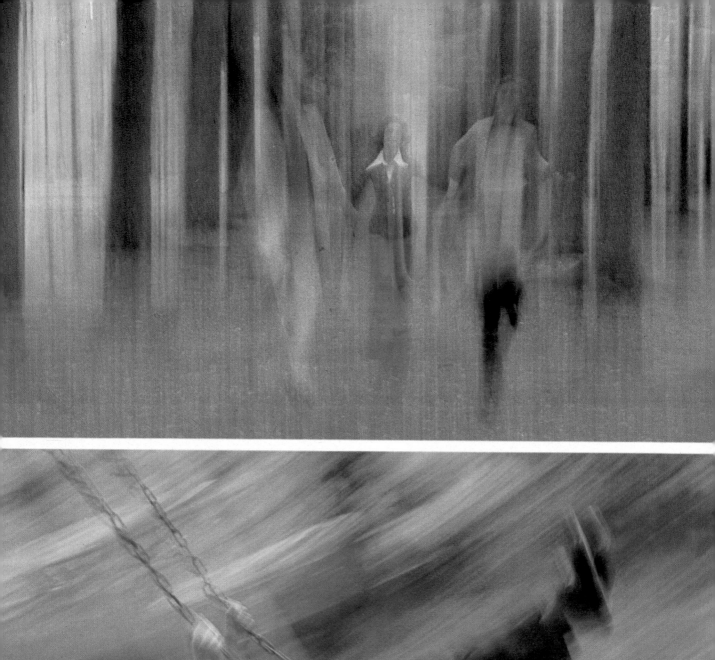
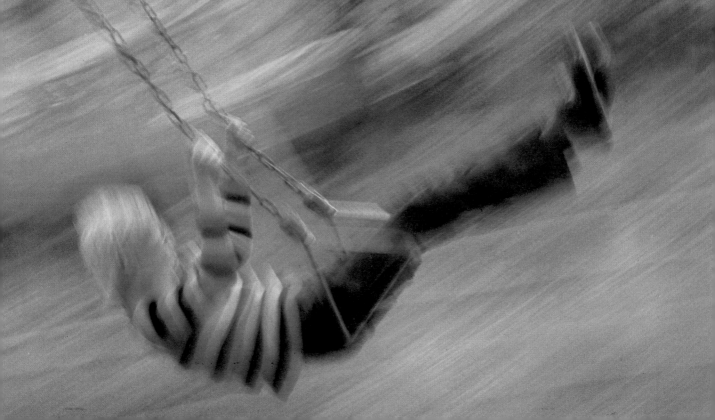

When taking the photo on page 113, I tried a different way of reproducing movement. The camera was moved against the direction of movement of the subject with a short-exposure. You can almost see from the photo what has happened. With this technique attention must be paid to correct placing in the viewfinder even more than when panning the camera. The shutter time was 1/30 second. The movement (in an opposite direction) was very fast and this technique is difficult until you have mastered normal panning.

I have already mentioned that panning need not always take place in a horizontal direction, as can be seen in the photo of the boy on the swing on p.114. The camera was panned in the direction of movement, and the shutter at 1/8 second was released at the point when the boy was at the end of the movement of the swing. Only a part of the chain has remained more or less sharp where it was kept still by the movement of the hands, while the body was still moving. The long shutter time took care of the rest. I probably need not tell you that this picture is one of the best from a whole series taken of this subject.

The upper photo on p.114, three hikers in a wood, was taken in yet another way. Here the camera was moved up and down during the exposure. It is not important whether the camera is moved down and up or vice versa. What is important is the correct moment of releasing the shutter. The shutter speed also affects the result. The shorter the shutter speed, the more rapidly the camera can be moved up and down. Those starting with this technique can best practise by moving the camera slowly from top to bottom and using a shutter time of 1/15 second. Bear in mind when establishing the moment when the shutter is to be released that there is a delay

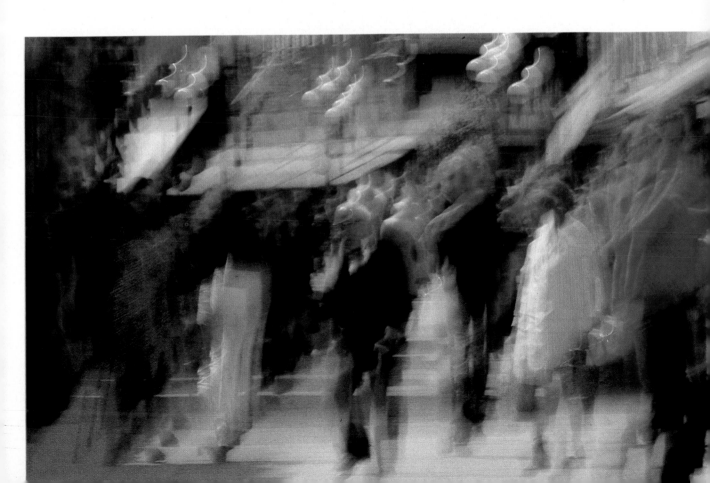

between the moment your action begins and that at which the shutter actually opens. This fact can be exploited when photographing different sports. Just think for a moment of the apparently wooden movements of walkers. You can accentuate this even more by the technique described but do not exaggerate, since that would result in total blurring and nothing being recognizable. The technique was used in this picture while the subjects were moving towards the camera. It can also be used while panning, the camera up and down so that the images are reproduced in a certain rhythm. Such photos are exercises for the fingers and they can possibly be exploited later in sports photography. Those who take such practice shots will learn exactly what is happening and what effect is being obtained and this applies to many techniques described in this book. They cannot be used everyday, but those who know

them can employ them virtually without thinking in situations where they can be applied to good effect.

The picture on p.115 was produced by making the camera vibrate as described on p.58. The lens had a fairly long focal length.

The focal length does not matter so much, but a rather long focus lens does result in a somewhat more pronounced effect. The lack of sharpness was caused here by vibration during an exposure of 1/15 or 1/30 second. This, too, is a technique which can be used fairly rarely in practice. A sharply focused late evening shot in which the lens is given a slight tap just before the shutter is closed has just a "touch" more than most other evening photographs.

Although we have devoted a whole chapter to the use of the zoom lens, you will find yet another zoom photo on p.117. Perhaps you can work out

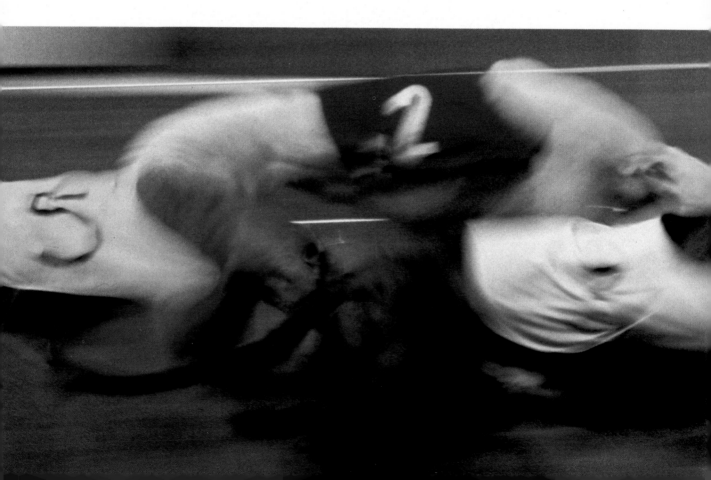

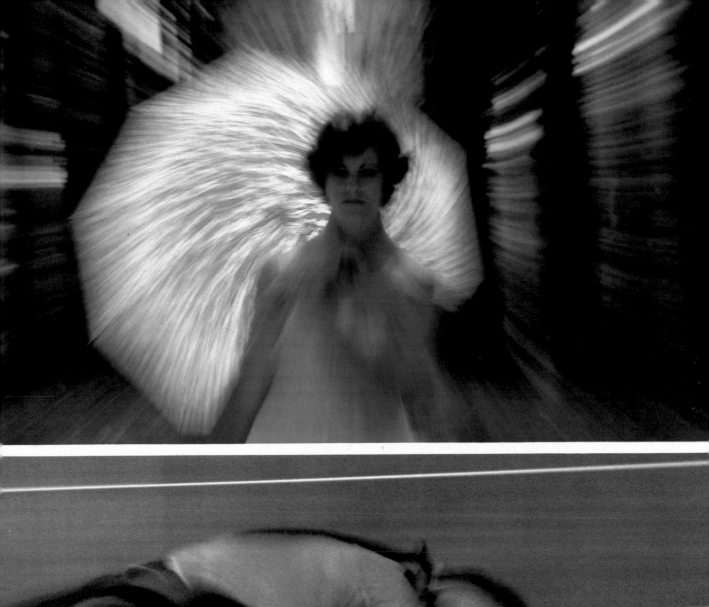
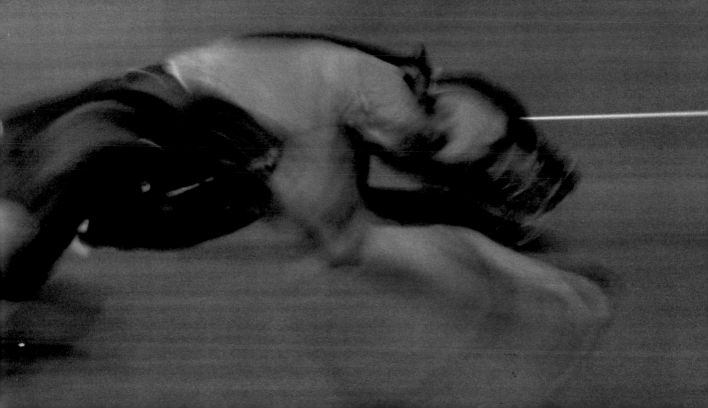

for yourself what manipulations were carried out during the shot. You will see that in the photo on the cover the parasol is reproduced in totally blurred form but in this photo the zoom streaks are not parallel to those of the parasol. This effect came about by changing the focal length during the exposure time. The parasol was also rotated rapidly, thus adding an extra dimension to an otherwise ordinary zoom photo. Another application of this technique can be found, for example, at a fair with its rotating attractions. This rotation, opposed to the zoom movement, adds an extra element. Those who know what the effect is can apply this technique in full confidence and experiments of your own will also provide the necessary experience. I keep on stressing this. You will not learn merely by reading: you can acquire theoretical knowledge about the possibilities, but there is a great difference between theory and practice.

It is also a mistake to begin experimenting before you have mastered the basic techniques. This seems unnecessary advice, but I think a

specific result only makes sense if you know how it came about and not when it arose by chance. It is only when you can depart consciously from specific fixed principles that these experiments acquire significance.

Applications in sports photography

I am now going to deal with the application of the movement techniques described in the first part of this chapter on sports photography. It must not be concluded that these techniques cannot also be used for other forms of photography. Sports photography has only been chosen because it is coupled with movement but we are concerned solely with an artistic interpretation of the action. In greyhound racing it is possible for a photographer to get close to the activities so that,

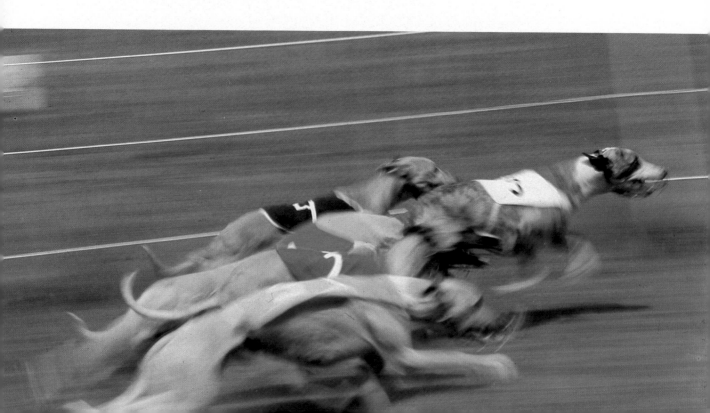

particularly at the starting line, lenses with a fairly short focal length can be used. A zoom lens can of course do valuable service, but it is not essential. A 135mm lens offers sufficient possibilities. Since the dogs pass quickly at a fairly short distance from the camera, the relative speed in relation to that of the camera is very high. In order to obtain blurring, as in the illustration on p.118, a shutter time of 1/60 second is necessary. For a sharp reproduction 1/1000th second would certainly be necessary but those who want to try that will have to master the technique of panning perfectly; otherwise they will never be successful.

Care must be taken that the movement is flowing, and that the legs are reproduced in an elegant way. It is impossible at these high speeds to guarantee a good result so you must not be frightened of devoting a whole film to the subject. Those who consider they can achieve in a single shot a result such as that reproduced on p.116 and p.117 are over-confident. Only with a lot of experience can you take photos with cool calculation and it is false economy to run the risk of failure. As a rule those who work in black-and-white bracket their exposures and colour workers should do the same. I believe one good photo a month is better than a whole collection of transparencies with which nothing can be done but to put them in a slide series with sound. This implies at the same time a plea for better photography in series presentations. This is not meant to be a disparaging remark to those devoted to this aspect of the hobby, but I hope it will give rise to reflection.

Water sport photos

Fast water sports in particular lend themselves to exciting pictures. You can see on p.120 a photo of a water skier which was taken from a speedboat lying along the path. There are often special tracks for water skiing, which are used regularly,

and where the camera can be set up on a tripod by the edge. You then focus sharply on a buoy, after which you wait for the water skier to run into the zone of sharpness. This was not possible in this case and I had to work with a 400mm lens, which was used at full aperture with Kodak High Speed Ektachrome film. The film was exposed at 400ASA and forced developed. A short shutter speed was necessary in order to achieve the desired effect. The orange buoys form an element which cannot be discounted in the composition. The picture was taken with a hand-held camera and a long focus lens from a rocking boat. I held the camera steady in the way I have already described, while I sought support on the boat's cabin top.

The photos on pages 120 and 121, of speedboats are both completely different. One is perfectly sharp, the other blurred. Nonetheless, both satisfy the requirement of giving expression to the concept of speed, each in a different way. In my view the second photo beats the first in the portrayal of speed.

In the photo on p.120 the concept of speed is indicated to a substantial extent by the bend the boat is taking and the resultant stern wave and these factors ensure that the photo expresses something while the contre jour lighting also contributes to the overall mood. There are always different factors which contribute to the success of a photograph.

Shooting against the light is something I like to do because it ensures depth and sparkle in the photo. It also adds to the illusion of depth. Taken on Kodachrome 25.

The photo on p.121 arose in a different way and it also involved many further problems. The course was marked off by three orange buoys which I wanted to include in the composition and I also wanted to have a second speedboat moving in an opposite direction in the picture, to heighten the impression of speed. I also wanted the photo to give an impressionist view of the sport and this photo is the result of working hard for a whole afternoon. The first thing I did was to find out at what moment the shutter had to be released in order to get the two buoys in the picture with the speedboat just between them. I chose an expos-

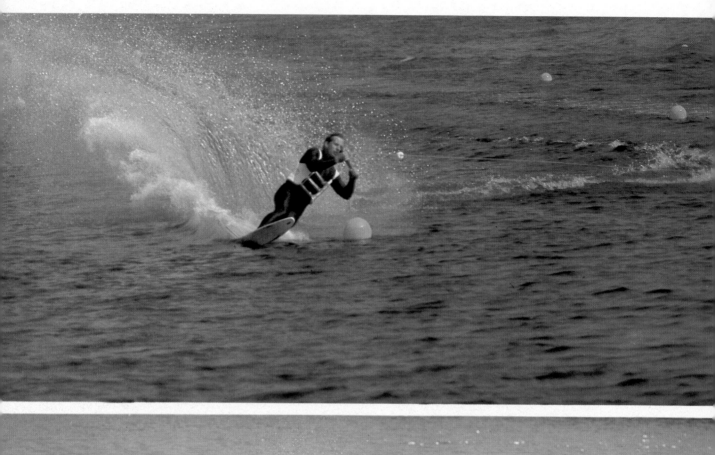

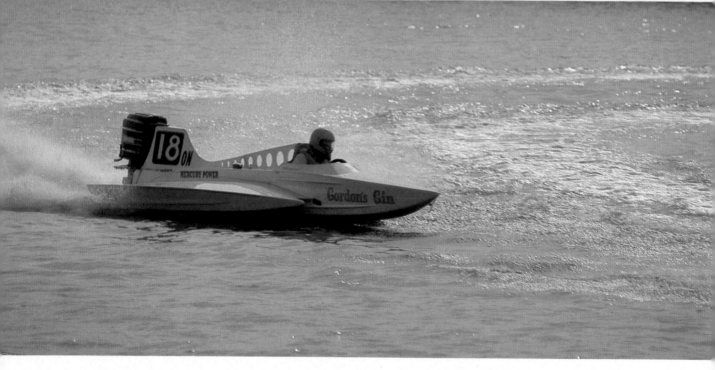

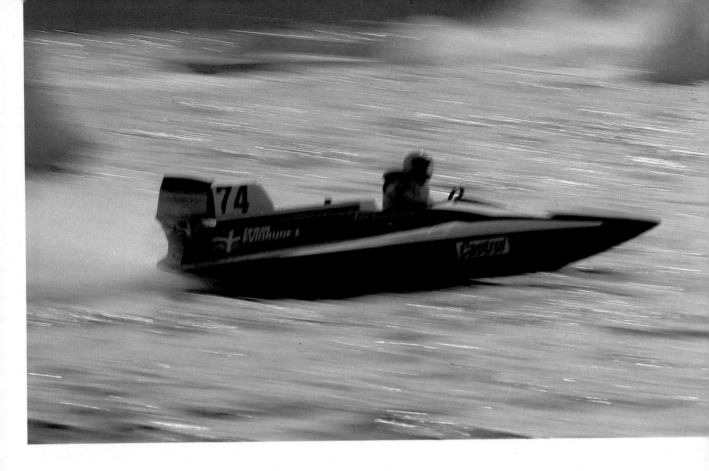

ure time of 1/30 second. It was now a matter of getting a second speedboat moving in the opposite direction in the picture as well. As you will realise, this did not happen on the first try, otherwise it would not have taken a whole afternoon! In one shot the second boat was in the wrong position in the picture, in another the buoys were but after much trial and effort the picture was obtained. During a lecture it was called a fluke by one of the listeners, in spite of the explanation I gave about how it had been obtained. Everyone has a right to his own opinion, but I consider that if, after many failures, one finally gets a picture as it was planned beforehand it should not be called a fluke. That is to under-estimate the photographer's intentions. It certainly has in common with a fluke that it took quite a lot of film!

Taking good photos of sailing competitions usually presents many problems. They are never really successful if taken from the shore, so you have to sail with somebody. I have found that someone is prepared to take me along on almost every competition but I should point out that those who offer a photo as compensation should of course keep their promise.

The upper photo on p.123 was taken of an event in the Spanker class. I used a long focus lens and we sailed out just in front of the field. The boats had to pass through a fairly narrow passage in order to get as favourable a position as possible and that gave rise to the massive "armada" of spinnakers sailing in the direction of the camera. It is almost always necessary in this sport to use a long focus lens, otherwise one gets too close to the yachts and hinders them

in their manoeuvres. The shutter speed was 1/1000 second. The speedboat in which I was standing with my back to the direction of travel was bobbing up and down violently and in such cases one has to take a number of shots. Here I used the motor drive in order to be sure not to miss this unique moment. It seldom happens that such a concentration of spinnakers can be seen when sailing before the wind like this.

When photographing from a boat good co-operation between the photographer and pilot is very important. The latter has to know what the photographer wants and give him the opportunity to achieve it by getting into the right position which is naturally not always directly in front of the subject. In the lower photo on p.123 the boat I was in was obliquely in front of the catamaran. Since we were travelling at the same speed, the angle at which I had to photograph remained the same. The distance from the subject did not change either so that, after focusing, the one difficulty was to try to remain standing upright and to hold the camera with its long lens still. A short series of shots with the motor drive is a reasonable guarantee of obtaining a good result. Here, too, the shutter speed was 1/1000 second.

The photograph on pages 124/125 proves an exception to the rule, namely that photos of sailing competitions can be made only from a boat.

This photo, in fact, was taken from the shore. A bit of luck is important in most cases, since the circumstances on the shore may then perhaps be optimal, but those on the water itself still much greater. This photo clearly reproduces an impression. The technique used has already been described (the photo of the girl cycling on p.112), although this is a slight variation on it. The camera was rotated during the exposure, being drawn in against the direction of movement, and this gave the whirling impression so dominant in this shot. The greatest difficulty in photos of this type is the placing in the frame. If the important elements are in the wrong place, the effect is substantially reduced.

This sailing shot clearly contrasts with the other two. It shows that in this sport, the photographer's imagination can also lead to interesting impressions. One can use techniques other than that described here, the zoom technique for example and I shall return to this later. I know that some people cannot appreciate such photos and say that they exceed the limit of what should be allowed. I do not of course agree with this. Such a limit is determined solely by the photographer's fantasy and power of imagination, and he should always summon up the courage to show his products to others. This is basically why people take photos and those who put away their results without showing them to others would do better to stop. Put up with the criticism and benefit from it as much as you can.

While dealing with sports photography, I should like to refer to the possibilities sports offer for photographing the facial expressions of participants. I have included three such examples. Obviously the fact must be in sharp focus and not blurred because it is, after all, a matter of capturing that one moment of top achievement. In the upper photo on page 126 you can see the facial expression of a baseball pitcher precisely at the moment when he is going to throw the ball, and in the lower photo the maximum tension has already passed. The ball has been thrown. It can still just be seen and so ensures that there is a field of tension in the picture. The difference in expression in these two photos is very great, and it's up to the photographer to capture such moments. The shutter speed for both these shots was 1/2000th second. The film was Kodachrome 64 and it was necessary to work at full aperture. This again shows the importance of a telephoto lens of good quality which can provide optimum results at large apertures. This applies particularly if the photos, as in my case, have to be enlarged for exhibition purposes. In this photo I used the Canon FD 400mm lens, a fairly light lens ideal for this form of photography. Baseball does not lend itself so much to blurring and I have not yet succeeded in mastering it properly. It could, however, be very creative. Just think of the finish in athletic competitions when the expression on the face is much more important there than a possible blurring. One would expect problems of reprocity failure to arise with these extremely short times

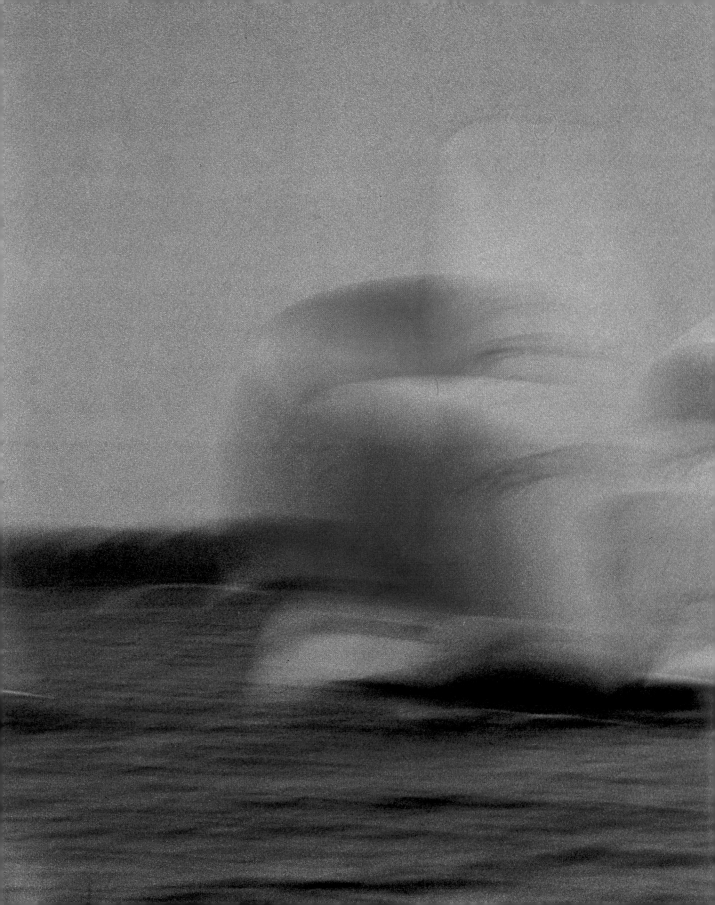

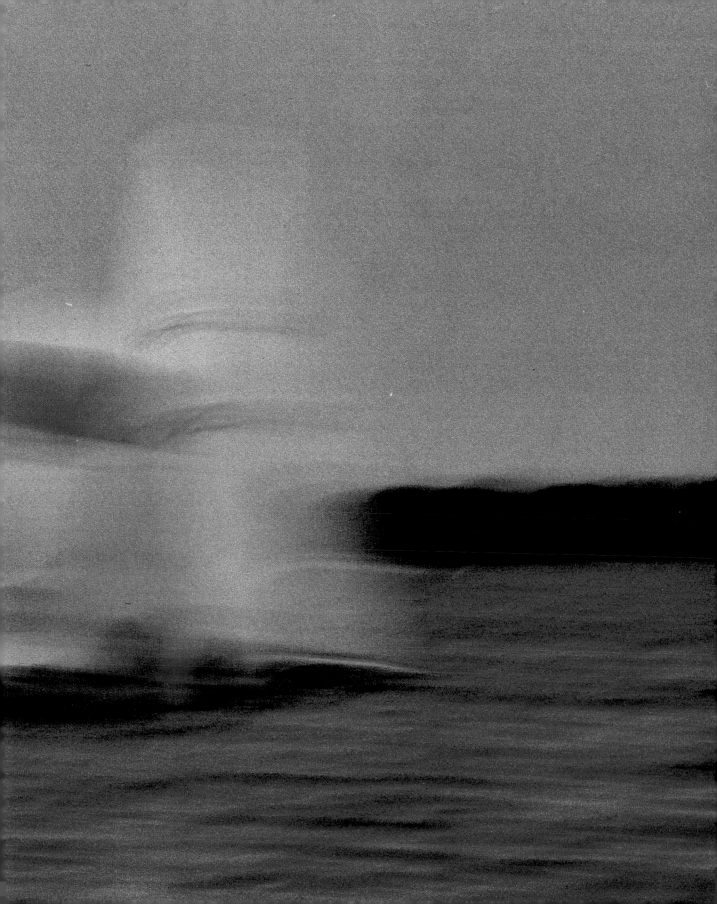

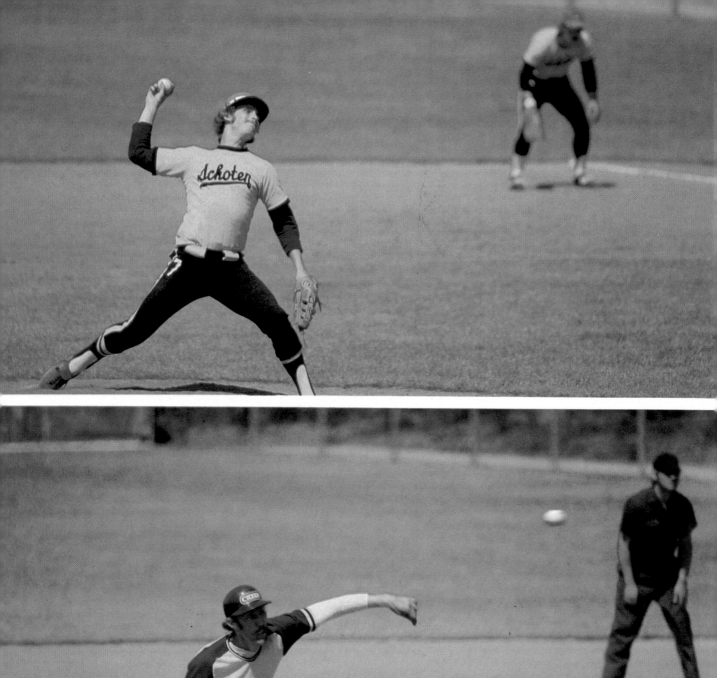
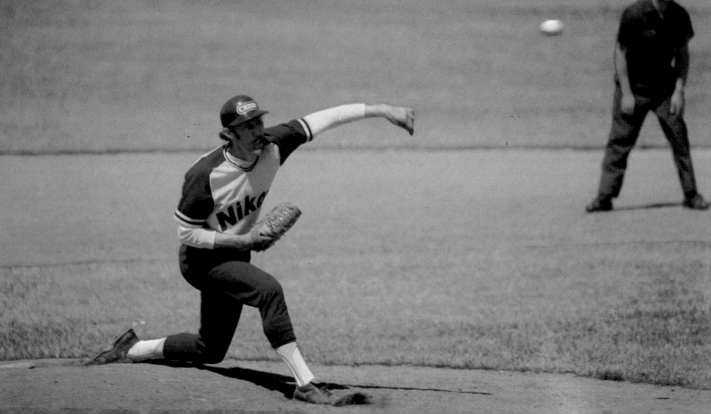

but in fact there is little if anything to be seen of this in these pictures. It can however be connected with the colours in the subject – there is a marked difference to be seen if, for example, a grey wall occurs in the photo. If shutter speeds of 1/4 and 1/1000 second respectively are used, then with the long shutter time the grey tends towards yellow and with a short shutter time somewhat towards blue. In this case however the difference is minimal. The third photo of this series shows a tennis-player, once again in a typical attitude, expressing the natural tension of the game.

We now come to a branch of sport which lends itself particularly well to both sharp reproduction of movement and to blurring as a result of lack of sharpness caused by movement. I refer to motor cycling.

The photo on p.129 is a sharp reproduction. The tension of the race is apparent from the attitude of the man in the side-car. Some people think there ought to be more motor cycle combinations in the picture at the same time in order to express that tension, but I would not always agree. The mood is reproduced here by the marked isolation resulting from a high viewpoint with the 400mm lens. It is important for such a shot that one can photograph with a hand-held camera and a long focus lens. Since the subject was coming towards the camera, a shutter time of 1/500 second was adequate.

The photograph on p.130, taken at the start of a race, is completely blurred and a shutter time of 1/15 second was used. The technique employed has already been described, i.e. movement of the

camera against the direction of movement. In this way a start can even be 'created' while the drivers are still stationary. Here, however, the photo was taken just as they leapt away, resulting in a dynamic impression of the cacophony which accompanies such a start. Another way of photographing the start of a race is to pan the camera with a long shutter time. A neutral density filter may be necessary, even if you are using Kodachrome 25, if there is glaring sunlight. It is very important to determine the correct moment for pressing the shutter release. A fraction too early or a little too late can result in a disturbance of the image and the photo loses a lot.

The photo on p.131 was taken using a technique I seldom employ but which – providing it is carried out well and sparingly – can be very selective. I made a partial enlargement on coarse-grained film of a blurred photo of a bike rider, and then a number of negatives of this copy were made on ortho material. These negatives were then coloured using Tetenal Multitoner. I then chose the one which was coloured steel blue. This was placed behind the original and displaced slightly to give a sandwich with a bas-relief effect. In order to get the grain even coarser, I copied the sandwich once again, and this resulted in the photo shown here. It is a fairly complicated technique, but one which can nevertheless be effective. Even so, it is not one to be used too often.

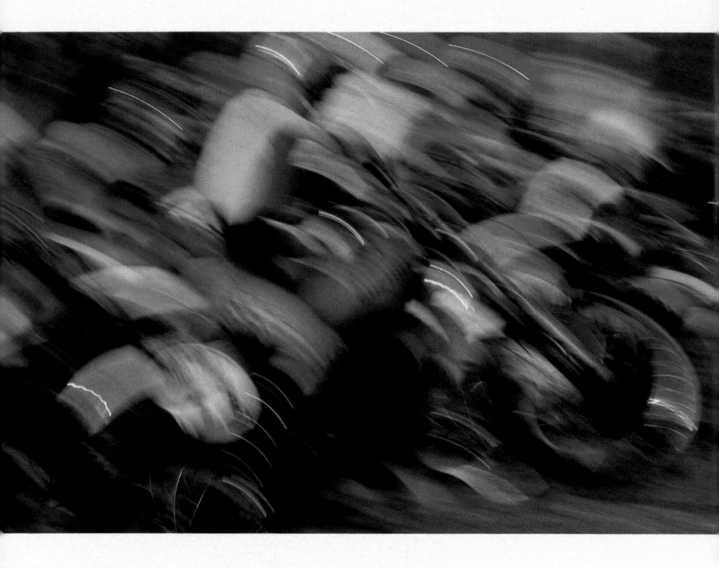

Zoom techniques in sport

I mentioned earlier that zoom techniques would come into their own in this chapter. A sport which is highly suitable for these techniques is cycle racing but before starting on it read the chapter on zoom techniques again and master the methods described there.

One of the problems in sport is that one has to work as a rule with a hand-held camera. In the zooming examples previously described in Chapter 3 a tripod was said to be essential. It cannot be used in most cases here so the alternative, mainly when using a heavy zoom lens, is a chestpod or a monopod. I must say here that the latter more or less impedes mobility, but hand holding when starting these techniques is not to be recommended. I am showing four examples taken using the zoom technique. Two were made with a chestpod and two with a hand-held camera. These last two (page 137) were made only after

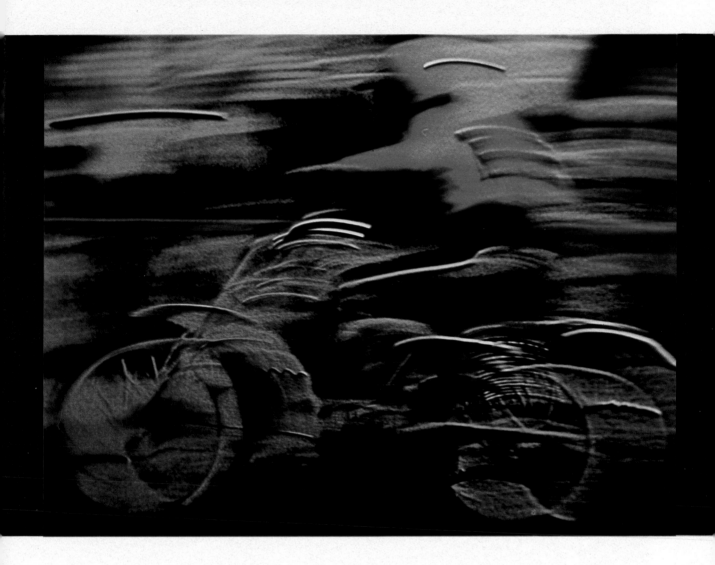

I had fully mastered the technique with the chestpod. I willingly admit that photos made with the hand-held camera have a certain charm caused by the irregular course of the streaks resulting from zooming.

One of the first things to remember in all these techniques is that there is a great difference, when zooming moving objects which are approaching the photographer, between going from maximum to minimum and from minimum to maximum. The latter almost always gives rise to total deformation of the image while, if zooming is from a long focal length to a shorter one, a certain recognizability is preserved, particularly if the object is kept to the same size in the viewfinder by adapting the zoom movement to the speed at which the object is approaching. This implies that with a photo of a cyclist it is not necessary to zoom as quickly as in a photo of a racing car. It is best to practise this technique thoroughly without a film in the camera and once it is fully mastered, one can deviate from it in order to obtain specific

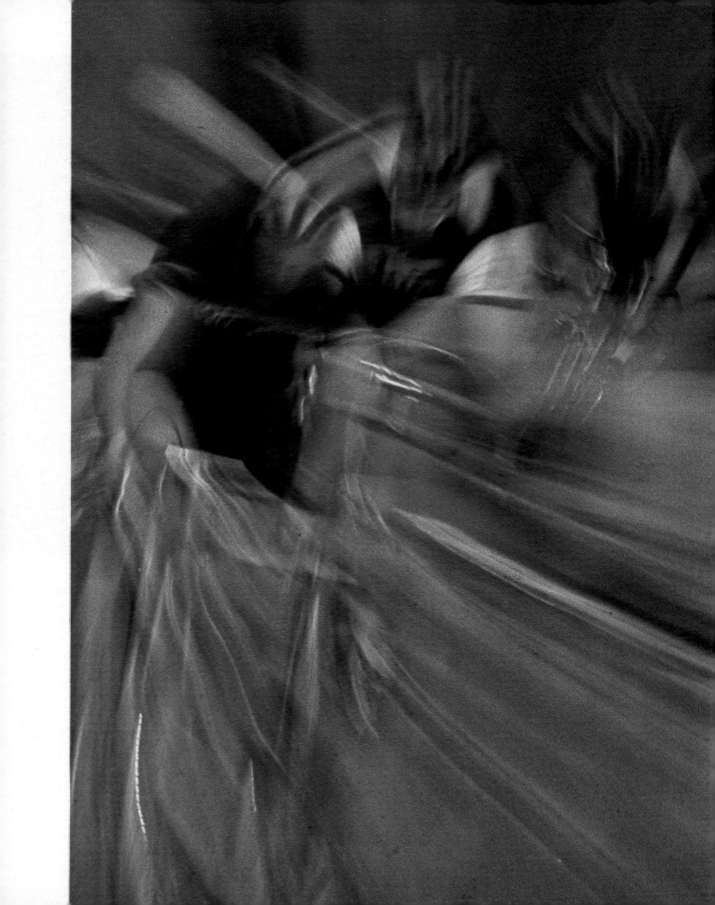

effects; for example, by zooming in somewhat more slowly or quickly than the actual movement. Each of these methods results in a different effect. It does not take long in practice to notice whether zooming has been too slow or too rapid. In the latter case the image is almost completely deformed.

When describing the zoom technique in Chapter 3, we proceeded from the fact that the sharpness lay in the middle of the image. We have seen in the meantime that by photographing from an oblique angle the sharp image can be placed anywhere in the photo. A striking example of this is the photo of the cyclists on page 136. I often take such photos at cycling events in a small town, taking up a position from which I can see the cyclists approaching around a bend. First I go to have a good look and, once I have chosen my position, I focus sharply on a point at which I foresee a specific situation. For this photo I stood at an angle to the cyclist whose handlebars are reproduced sharply. By following him in the viewfinder and paying particular attention to the handlebars when zooming in, I obtained this impression. The cyclist who was closer is reproduced in totally blurred form because of his relatively greater speed in relation to the camera, further intensifying the zoom effect. The shutter speed was 1/15 second. Again, a good result is not obtained with a single shot and you have to accept many disappointments before reasonable results are obtained.

The photograph on pages 134/135 arose in the same way, but in this case from a completely different position, this time at the inside of the curve. I expected a total blurring of everything in the foreground, with some sharpness at the back of the bend. There is no genuine sharpness, but through the relationship between sharpness/lack of sharpness, there is a hint of focus about the cyclist at the back. It is, however, an optical illusion. I zoomed from maximum focal length to minimum, but the speed of the cyclists in the foreground is greater than that of the cyclist coming around the bend on whom I focused sharply. A speed of 1/30 second was used and the lens zoomed in very quickly.

The photos on p.137 were both taken with a hand-held camera. In the first I concentrated on a single cyclist. He always came through the curve in the same way and thus I could – after observing for a time – take this photo with almost 100% certainty. I nevertheless took it ten times with, as a result, one first-rate and a few second-rate transparencies.

Two techniques were combined in the lower picture, panning and, at the same time, zooming in, and what is more from a short focal length to the longest. The camera was also panned a little faster than the speed of the cyclists.

Although cycling is pre-eminently suitable for the zoom technique, there are many other sports where it is possible to work just as effectively. In fact I am inclined to consider all sports suitable for it. Its employment can be particularly suitable for activities where there is a lot of tension, for example in rugby. The photo on pages 138/139 shows a scrum, an event with much tension and yet little movement. In order to intensify this the scrum can be zoomed out, but the centre kept sharp. This greatly accentuates the action.

The photo on the following two pages was taken during a very hard attack. The camera was panned during the fairly long shutter speed of 1/8th second so that attention falls very much on the player in possession of the ball and the other player storming down on him. The action is reproduced here in a completely different way from the previous photo and the correct moment in the blurring is of decisive importance.

In the photo on p.142 a breast stroke swimmer is reproduced sharply in a characteristic attitude. The photo was taken during regional competitions and is by no means inferior to one taken at national competitions. After all, it's not the name of the swimmer that makes an artistic photo, but the interpretation the photographer puts on it.

The next two photos involve movement. The upper picture on p.143 was taken with a combination of two techniques: panning the camera and using a slow shutter speed.

The shutter speed was 1/15 second and the panning (at the same speed as that of the swimmer) was concentrated on the swimmer himself. The movement of the arm was somewhat faster than that of the body, resulting in an extra movement

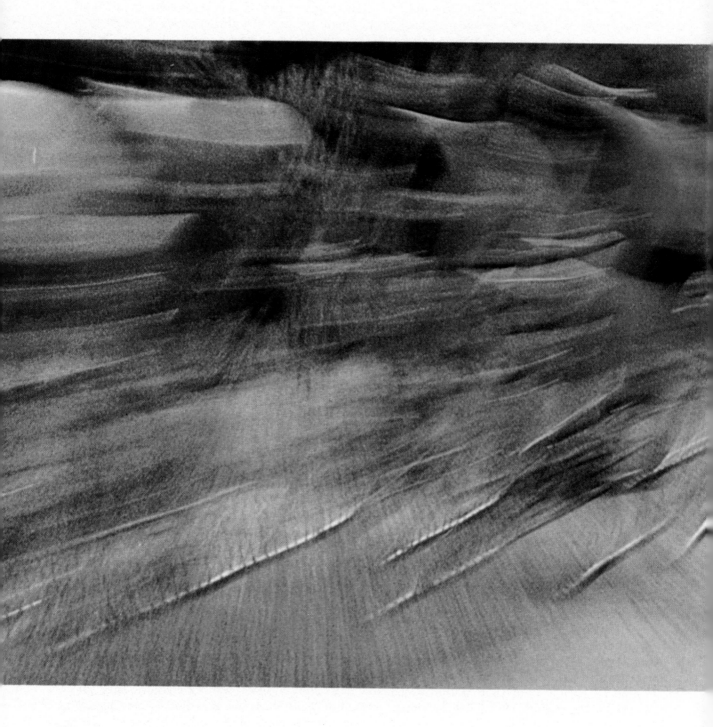

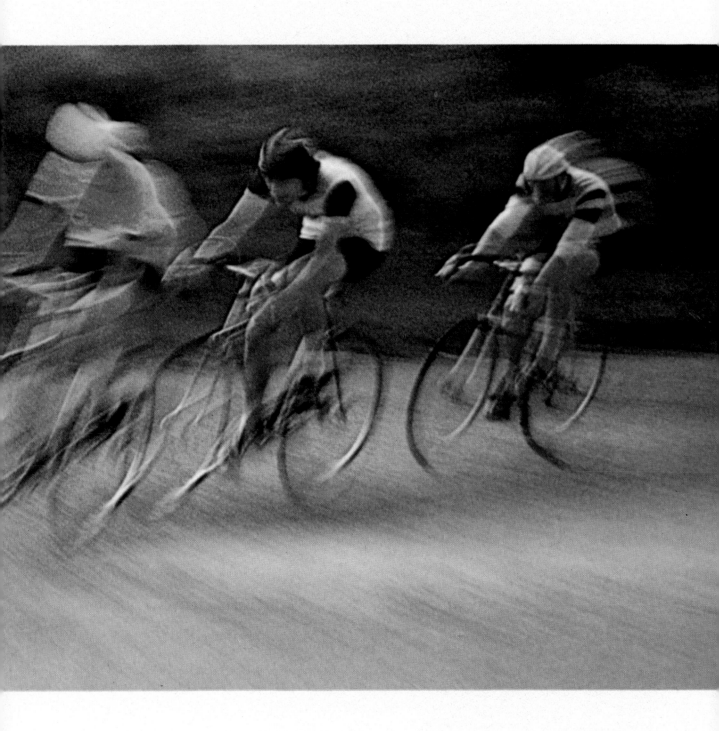

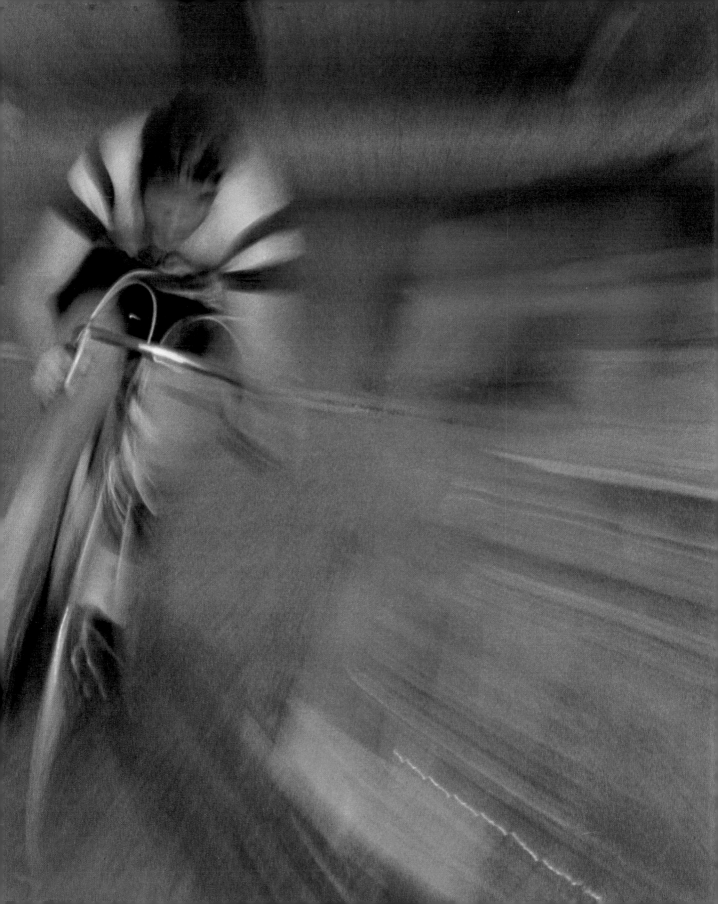

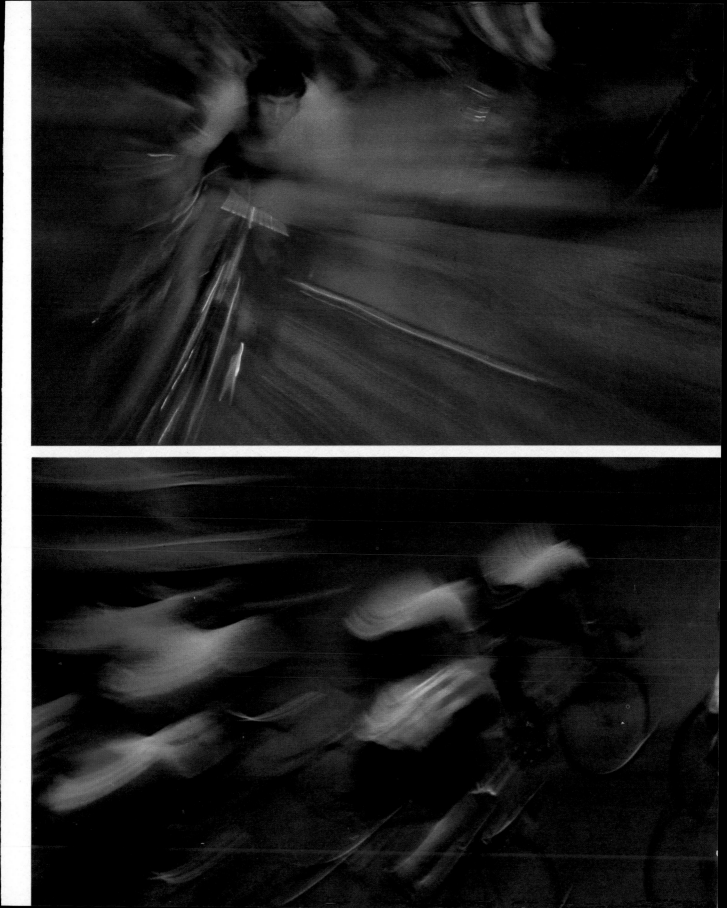

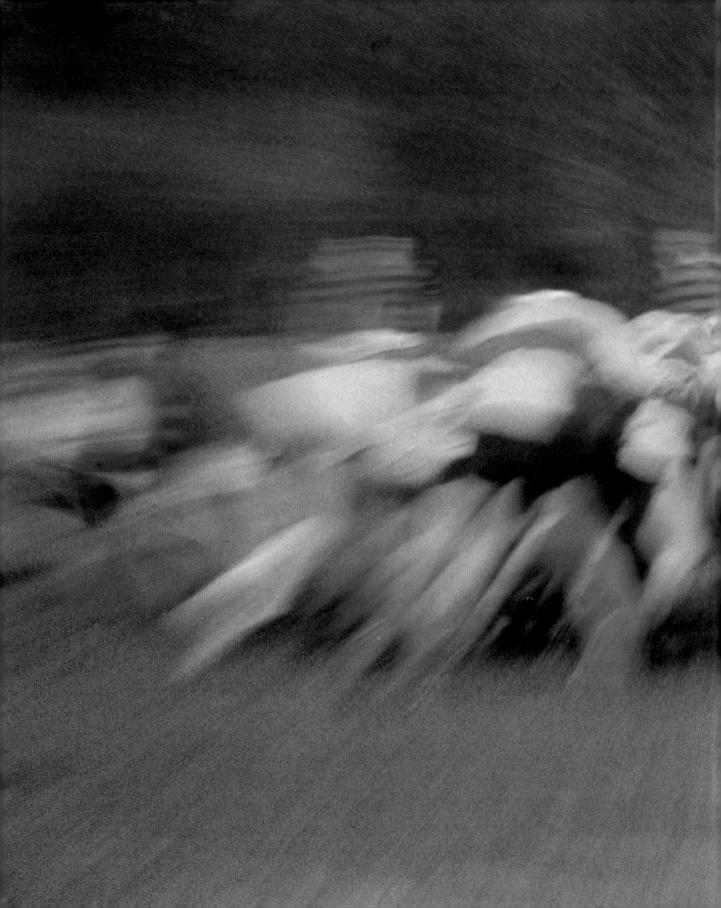

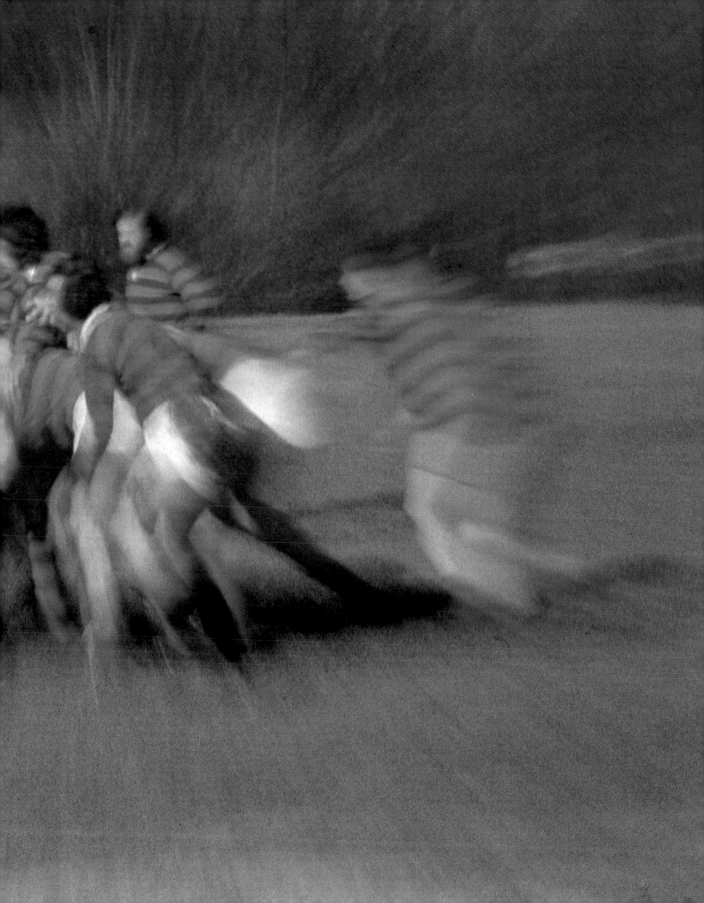

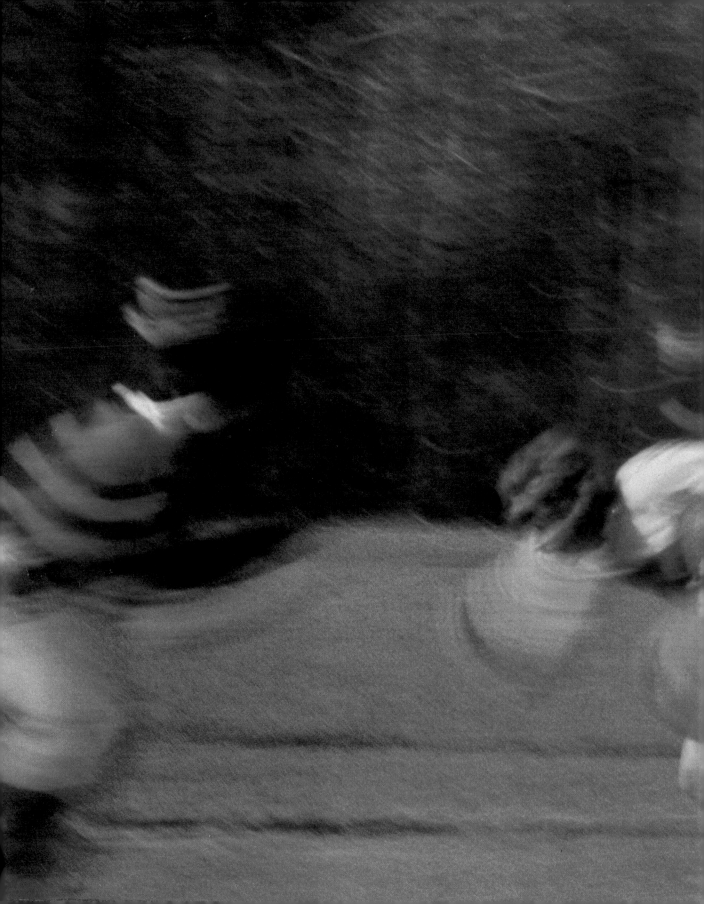

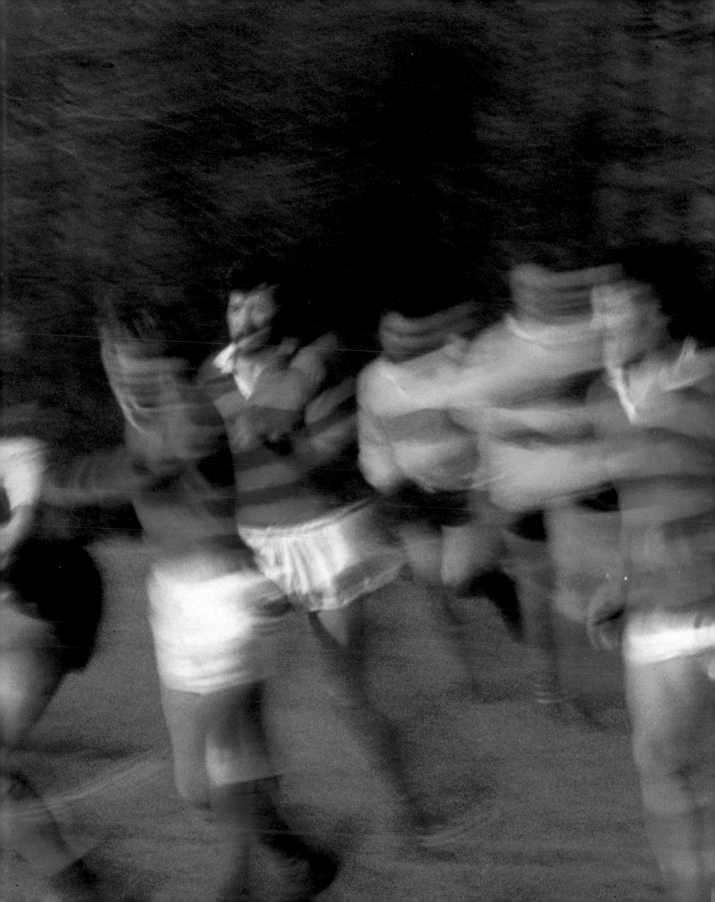

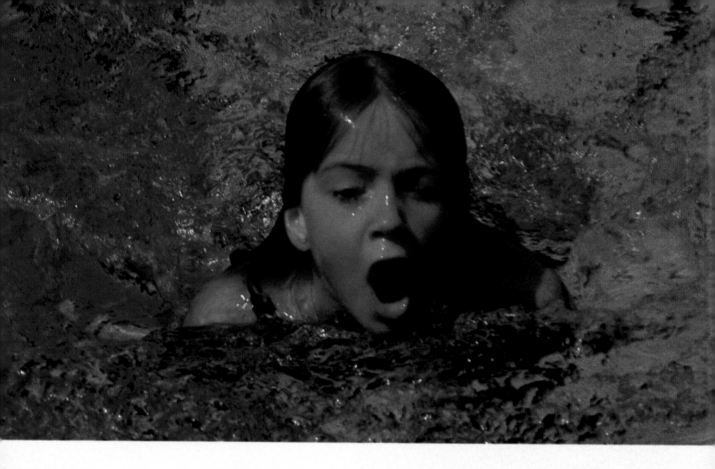

factor being added to the overall impression. I took account of this extra movement beforehand, although it was particularly difficult to get it in the correct place in the picture.

How does one get the idea of making a photo so that that arm plays a part in the total? The answer is simple: experience! I had once been asked to take some photos of swimming and as I had no experience of this sport, I first went along to study what I should capture. I was struck by the constantly repeated movement of that arm. As if automatically, I conceived the idea of making that arm the strongest point of the photo. Once such an idea has come, there is its translation into practice and that is always more difficult than you think (and also takes much more film

than you think). The lower photo on this page really arose from the same philosophy. It would be wrong just to allow the winder or motor drive to run on such occasions and to await the result. Each photo has to be made in a well thought-out way and for that it is necessary to see the right moment approaching.

The photos were taken from different positions, the upper was taken with frontal light and the second against the light. Both types of lighting have their own character. It is important to consider one's position all the time. When I took these pictures, I first stood for an hour on one side of the pool in order not to disturb the competition officials too much, adapting the lighting which was indicated by the camera's

142

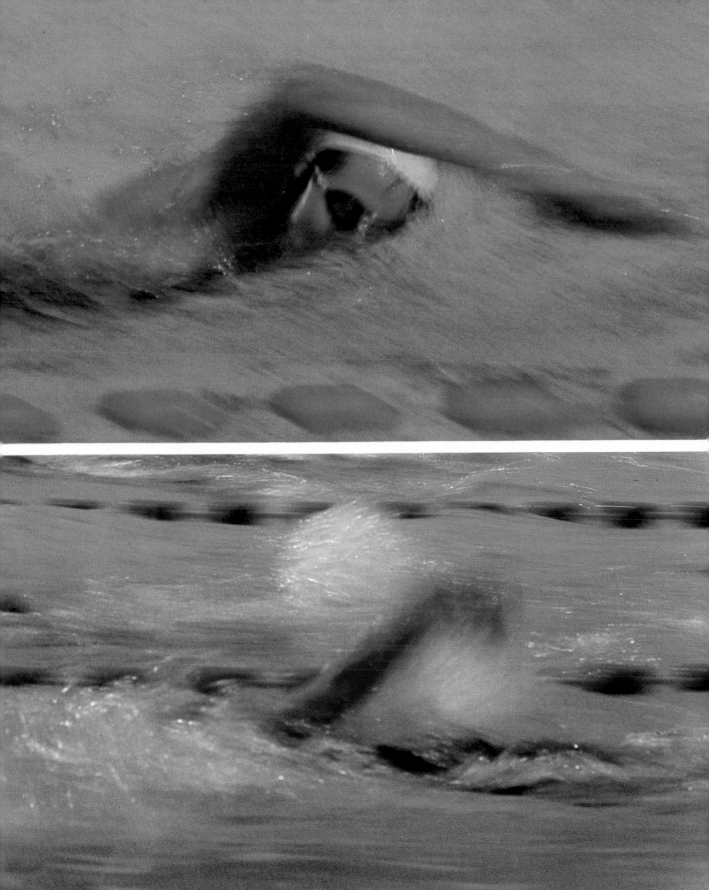

built-in exposure meter. Then I spent an hour at the other side of the pool shooting against the light. A whole stop over-exposure was given in order to accentuate the fine atmosphere and the shutter speed was in this case the primary factor.

Athletics is also a sport in which very photogenic things happen and where one can often get close. The photo of the start of a race on p.144 took much brain-racking. It is not the result of working for a single afternoon, but for several days. I had already taken photos of starts on many occasions, but I wanted to take one in which one head would appear sharp between the others and so heighten the tension in the photo. This gave rise to many problems and I had to visit many competitions but one gets no good results without effort. Finally, I was struck by the fact that in various starts the head of the girl so

clearly visible almost always went down at the crack of the starter pistol, but without causing a false start. On a subsequent occasion, when I recognized her, I took a shot with the result you see here. It was taken with a shutter speed of 1/8th second, and the camera was also moved slightly with the action. A start can also be photographed with the camera on a tripod, using a slow shutter speed. The background and the ground itself are then reproduced sharply. I prefer to move the camera along during the exposure, as a result of which everything moves but I would still advise working from a tripod at the beginning if this is at all possible. If the camera is moved too quickly at this shutter speed, total blurring results, and this is not the intention. The movement can be captured by the slight blurring of the starting-line caused by panning somewhat faster than the movement.

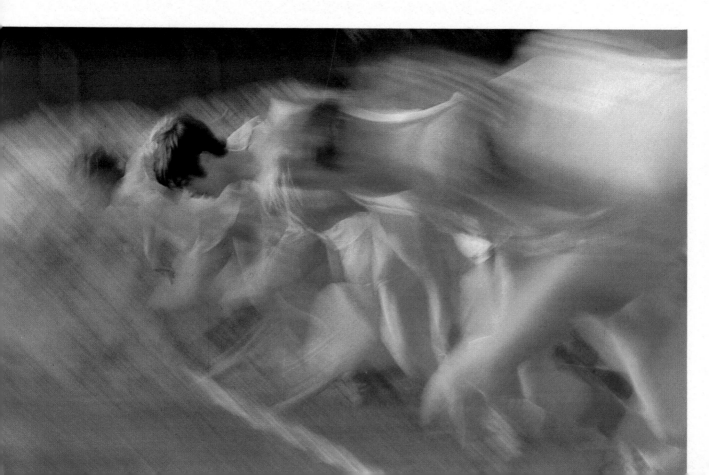

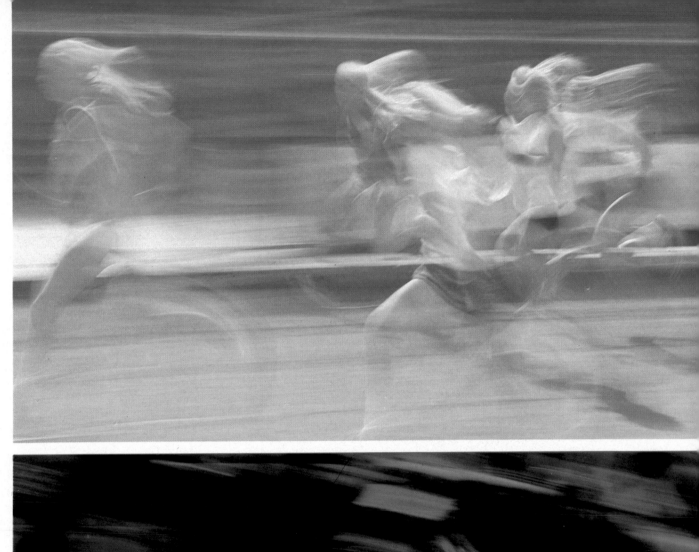

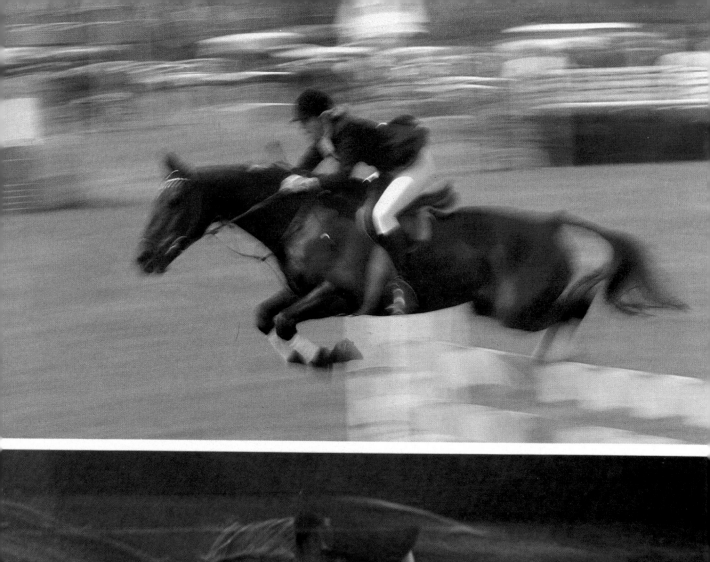
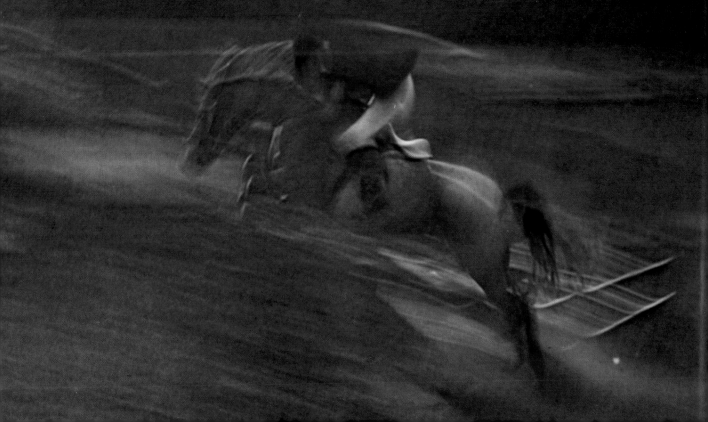

The photo of the sprinters on page 145 (upper) is permeated by movement. Here a speed of 1/4 second was used, as a result of which both the ground and the background are blurred. The flowing hair of the girls is what really makes the photo and it is no accident that they all have long flowing blond hair – it is the result of long observation at such events. It is, for me, a typical example of the fact that good results need not occur only amongst top athletes, and it's not only a question of the winner, but of the artistic element in the photo. The hard counter-light shines magnificently through the hair. Such photos of movement can only really be made against the light with such a slow shutter speed and by so doing the movement appears in a three-dimensional way. It is even possible to work in rainy weather. I like to use Kodachrome 25 in bad weather when the neutral density filter will not be needed. As a result of the good inherent contrast of this film I often obtain striking results but if everything has to be sharp under bad weather conditions, I use 200ASA Kodak Professional film. This doesn't mean that other films would not be good or could not be used for this purpose, but my personal preference, based on long experience, is for the films mentioned here. It is important to know how a film reacts to long exposures. One must also be aware of the fact that focusing has to be carried out with great care. Lack of optical sharpness due to camera shake or careless focusing can give rise to a particularly unpleasant effect. Very occasionally, it can intensify the image but that is the exception and, as far as I know, I have only once had an acceptable result in this way. *Total* lack of optical sharpness as a pictorial element can sometimes lead to striking results and the chapter on impressionism in photography bears this out. In the lower athletics photo on p.145 the background dominates, resulting in an intensification of the suggestion of speed, the vital feature for success in such a photo. The shot was taken with a shutter speed of 1/15 second from the inside of the track. A 400mm lens and a position somewhat further away ensured that the background would become one with the movement of the running girls. You can see from this that mastering perspective is not only important in landscape photography, but also in subjects showing action.

The last branch of sport I want to mention in this book is that involving horses. Movement is essential here since the graceful element of horses can only be expressed by it. One must of course be selective. A wrong position of a horse's leg can cause total disturbance of the movement in the photo. Care must be taken in jumping competitions not to break the concentration of the rider and horse, especially if one is close to them but that danger is not so great in racing or trotting because one is kept at a reasonable distance away by the barrier. If you want to work in colour and fill the picture area, it is best to use fairly long focus lenses. I use a 400mm or a 85 to 300mm zoom lens, but it is just possible to manage with a somewhat shorter zoom as well. A 135mm lens is rather on the short side, but one can manage with a 200mm lens. When photographing movement it is also possible, as an alternative, to use a converter with a 135mm lens. However the amount of light reaching the film is reduced. You will make a 270mm lens of a 135mm lens with a 2X converter but the exposure has to be doubled. Those who decide a converter should ensure that they use a good one and not a bottle bottom costing about £6! You just cannot obtain good definition with this and no amount of stopping down makes a good converter out of a bad one. If it is true anywhere that one has to be familiar with the sport, then it certainly applies to photographing equestrian sports, particularly jumping events. It is best first of all to walk around the course and seek out the most favourable position, preferably a place where one is not hindered by too many bystanders. Occasionally I take the highest place on a stand, but it is also possible to get good shots from a low viewpoint. It is advisable not to start photographing immediately, but first to let all the participants pass in review. Those with any feeling for things will immediately see whether a rider or horse passes elegantly over the obstacles or wallows and jerks like a tank. The latter won't happen so much at national competitions, but it is not unusual at small regional competitions. Many people will have to rely on these, and that is when it is wise to make a choice and to

follow this rider or those riders consistently. Photographing obstacles which have been knocked down disturbs the picture. It is also better not to include any course builders in the picture or the exposures have to be so long that even with panning they become totally blurred. That is successful in any case only with speeds of 1/4 second. It is not recommended because, among other reasons, the camera has to be panned straight although the horse is jumping up. (This only applies to beginners.) Panning in the movement of the horse, in other words obliquely upwards, gives a rather special effect. I can already hear the easy-going saying, "What a lot of effort just for a photo!" and the stickler will score a point here. Don't forget, either, the spectators who come to enjoy the sport; they must not be hindered by a "tiresome photographer" who gets in everyone's way.

In the upper photo on p.146 the camera was panned in the ordinary way with a shutter speed of 1/30 second. The horse and rider are not completely sharp, but are somewhat drawn into the lack of sharpness due to movement by the relatively long exposure. The camera was panned horizontally here, as can be seen from the course of the streaks in the background. In the lower photo on p.146 a speed of 1/4 second was used and the upward movement of the horse was followed completely. It took a whole afternoon to take this photo, not photographing for the whole afternoon, but waiting! The obstacle here was tarred wood which was lit by sunlight but would be better still with the setting sun which I was waiting for. My hopes were confirmed, and the warm evening light began to shine on the wood. It was very dry weather, so the course was rather dusty, giving ideal conditions. By panning with the movement of the horse and a slow shutter speed the photo creates the impression of a golden diagonal running through it. In such circumstances I do not of course take only a single shot. I continued shooting until I had exploited the situation to the full, in this case a whole film, and the best one in my opinion is shown here. Very many factors contributed to the success

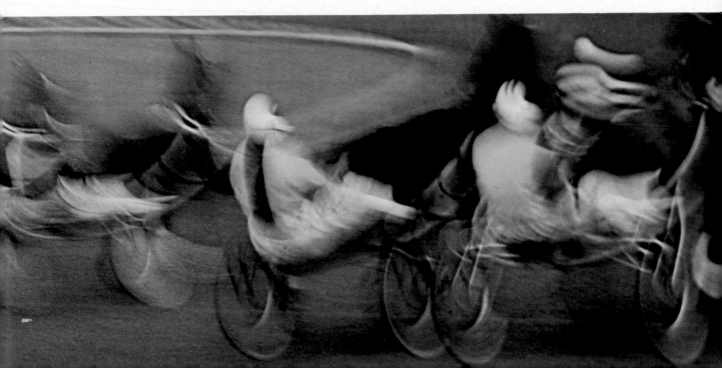

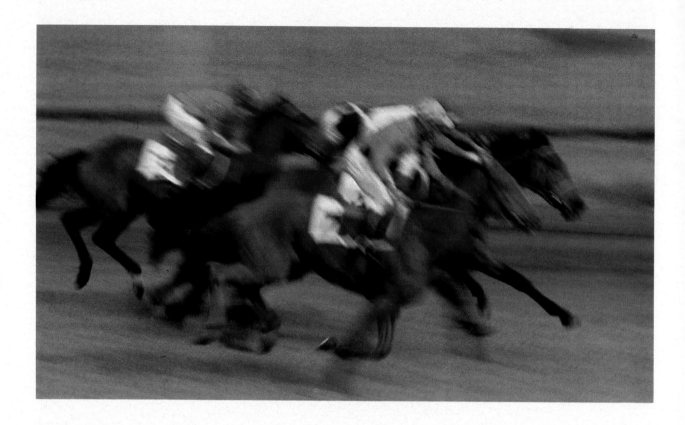

of this photo: a dusty terrain, late evening light, the construction of the obstacle and choice of viewpoint. It was taken with a 400mm lens using a neutral density filter in order to get the proper reduction of light.

The photo on p.148 also shows a rider approaching an obstacle. It was made with a speed of 1/8 second in magnificent evening light and the camera was panned.

The upper photo on p.149 was taken using the normal zoom technique so that everything remains sharp in the centre. The photo was taken from a high position with an exposure of 1/15 second. The shutter was released while changing the focal length. It was not taken during a competition, but while the trainers were busy giving the horses a bit of practice beforehand.

The fact that a lens with a long focal length is not necessary under all circumstances is proved by the lower picture on p.149. It, too, was made with a panned camera with a shutter speed of 1/8 second. The course was as dry as a bone and it was in the middle of summer. Spraying had been carried out, but it did not really help because of the terribly dry weather. The lens used was a 100mm f/2.8, combined with a good converter I wanted to try out. I was behind the glass of a restaurant high above the course and neither the use of the converter nor photographing through the glass had any adverse effect on the overall impression which was largely determined by the atmosphere of the dust blowing up to blur the horses with their trainers. If a totally sharp photo had to be made in this way, it would have been quite different and in such conditions I couldn't have hoped for good results. Expensive equip-

ment is obviously not *always* the decisive factor for success. The last photo in this chapter is one of horse-racing which is considerably faster than trotting, so account must be taken of this when photographing. The shutter speed was 1/60 second during which the camera was panned with the subject. It is particularly important in these photos that no horse's leg be moving in the wrong direction. That is something difficult to foresee so that here, too, many photos had to be taken, in fact ten to twenty.

But isn't a good photo worth it?

7. Something about films, retouching and finishing photos

In this chapter I want to tell you something about the films I use. There are three kinds of film I use regularly, namely Kodachrome 25, Kodachrome 64 and Kodak Professional film 200ASA. These three types are particularly suitable for printing on Kodak 14RC reversal paper. They show hardly any differences as far as filtering is concerned because the manufacturer has already taken this into account when making the film. Although these three films resemble one another very closely in relation to filtering, it is nevertheless recommended – at least in the beginning – to restrict oneself to one type. It is necessary to get used to it completely so that you get to know all its characteristics. It is essential to know how a film reacts to long and short shutter times. The above-mentioned films are characterized in that they show virtually no deviations at extremely varying times. The influence of the Schwarzschild (reciprococity failure) effect with slow shutter speeds and ultra-short exposures is scarcely perceptible. What is the best film to begin with? In my opinion the somewhat more sensitive Kodachrome 64. If you want to show a lot of movement, then you move on to Kodachrome 25 which is a little less sensitive. This lesser sensitivity has the advantage of a very good reproduction of contrast and an extremely fine grain. I have had partial enlargements made of miniature Kodachrome 25 transparencies measuring 1 m × 2.85 m (3′3″ × 9′4″). The result was staggering. It is almost unbelievable that a miniature transparency can produce such results. If very big enlargements have to be made, then I

would recommend Kodachrome 25. For zoom techniques 25ASA film is particularly suitable because of its strong contrast. You will see that I choose a specific film for the different subjects I am photographing and for subjects which require high shutter speeds I used until recently Kodak High Speed Ektachrome, but after the introduction of the new Ektachrome 200ASA film I switched to that. It is an enormous improvement and even with forced development the skin tint still reproduces very well, while there is hardly any difference in colour compared with normal development. On pages 154 and 155 you can see two sports photos taken with this film during the world rowing championships in Amsterdam. The 200ASA film was up-valued here to 400ASA. The photos were taken with a Canon 400mm lens

at full aperture with an exposure time of 1/2000 second which might have easily produced discolouration of the skin tints, but nothing can be seen of this. The virtues of this film are such that I always have it in stock and always in my camera bag. I make a habit of keeping all reversal films in the refrigerator and this is specially recommended by Kodak for this film. Once a film has been exposed it should be developed immediately. It should not remain for months in the camera as this could give rise to considerable colour change. A film which is kept in the refrigerator should be removed in good time before it is used in order to reach ambient temperature. Use a film in one go (if possible) and then send it straightaway to be developed. Do not wind the film completely back in the cassette and fold the

projecting tongue over once or twice, so that it can be recognized as an exposed film. It is a very nasty experience to expose a film twice!

Finally, I should mention Kodak slide duplicating film. This film was originally supplied only in large packs, but is now also available in miniature cassettes and the amateur can make very good duplicates of his transparencies with it. The film has a very low sensitivity and has to be exposed by a light source with a colour temperature of 3200 K(elvin) so it is an artificial light film.

It would be going too far to include all the data for the films used in this book. I merely wanted to list my own experiences and preferences.

Finishing techniques

I mentioned earlier that I would be returning to a few special aspects of enlarging transparencies on Kodak Ektachrome 14RC paper. It is not my intention to consider in detail the technique of enlarging; there are already various publications on this and it does not come within the framework of this book. I should nevertheless like to remove a few misapprehensions. It is definitely feasible for an amateur photographer with a darkroom to work solely according to the 14RC process or any other process for making colour prints from transparencies. Other standards of course apply to the professional photographer who may need colour negatives in order to make a number of prints. The argument often heard that it is so terribly expensive does not really hold water unless one sets to work in a slovenly way and does not adhere fully to the instructions provided by the manufacturer.

The opinion is likewise often voiced that only transparencies very low in contrast are suitable for making prints. This is not entirely true either, as will appear from consideration of the special techniques for processing transparencies rich in contrast. An alternative to 14RC paper is in

the Cibachrome-A process which is extremely easy but rather more expensive. It is unsuitable for contrasty transparencies unless masking is employed.

Cost aspect

A colour enlargement is naturally more expensive than one in black-and-white. However, if we compare the black-and-white amateur of twenty years ago and the colour amateur of today, in a period of greatly increased welfare and considerably more free time, then I do not think this is particularly relevant. One can nevertheless save some money by using the chemicals for developing two or three times. A first requirement is to work very accurately and cleanly, thus saving considerably on developing costs. The chemicals used are collected and used for a second time, replenishing the liquid remaining with fresh liquid to give the original amount. This can be done two or three times. The method is referred to as replenishing. Obviously this reduces the cost of colour enlarging considerably. Economical kits of chemicals such as Photochrome R are now available and represent a considerable saving both in time and cost.

Printing transparencies which are rich in contrast

Although the range of contrast of Ektachrome 14RC paper is staggering, it can happen that transparencies which are particularly strong in contrast do not come out well. An example is the plate of the Piazza in Eindhoven on page 157. Even the sun is in the picture, and there is a lot of contrast. If a straight print is made the result is still definitely worth while but if it is desired to

reduce the contrast, then there is a method for this which is used in copying transparencies, namely masking.

The masking process is certainly somewhat more laborious than direct printing from a transparency, but it can be worth doing. After all, nothing is too much trouble to ensure a good result. We begin by making a negative of the transparency by contact and sandwiching it with the original. The resulting print is considerably softer through this combination but it is obvious that the transparency and negative must coincide exactly because, if not, a relief effect will result. For this reason the mask is often made unsharp by inserting a sheet of clear plastic between transparency and the negative film before exposure.

The exact register of the negative is obviously important with this method or a bas-relief effect may result. When enlarging a combination of a transparency and a negative it is of course necessary to increase the exposure time. We call the negative a high-lit mask – it is obvious how this name arose. It is a question of suppressing the high lights to give a softer result.

There are also copying machines on the market which reduce the contrast by slightly fogging the film at the same time as the exposure is made. The degree of contrast reduction is variable and can be closely controlled.

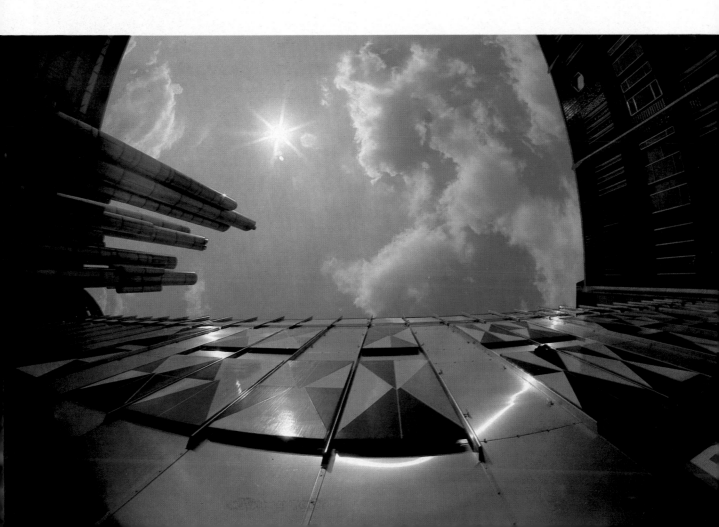

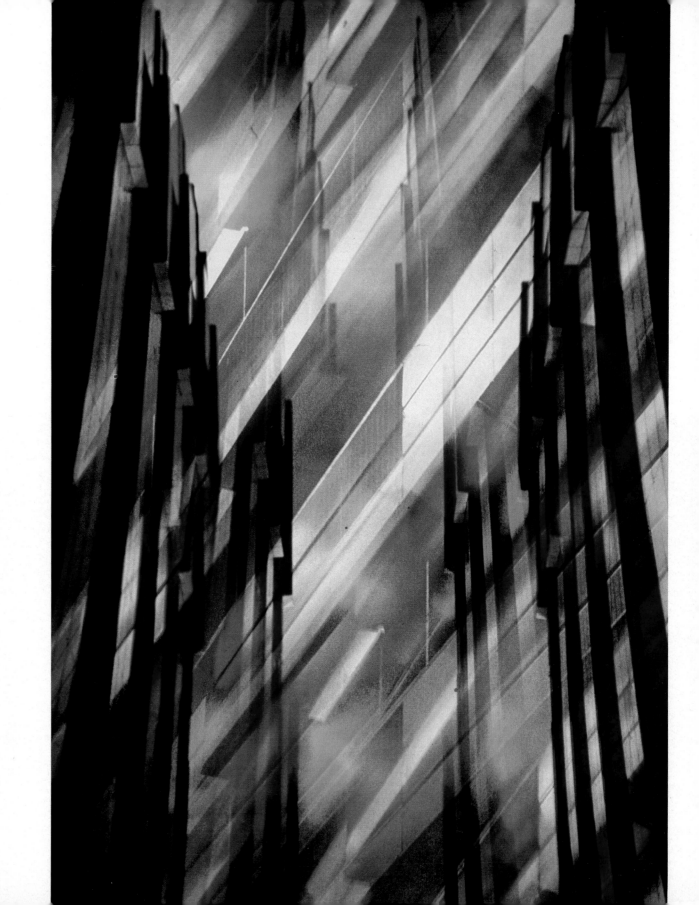

A few special tips

It can happen that one has transparencies which are subdued in colour, often in the case of landscape photography. If one wishes to intensify such a photo in the same colour there is a strong possibility that the colour will switch to the complementary colour. So a rule of thumb in intensifying colour is that one must never additionally filter more than the density of the colour, otherwise the so-called "switching" effect occurs, i.e. the colour switches to the complementary colour.

We find on p.158 an example of an enlargement of a threefold sandwich and it required a very long printing exposure. Filtering is also a very important element here. The film used required a 15 magenta filter in order to arrive at the correct colour. With a combination of three transparencies the basic filtering has to be increased by three so that in this case the filtering was 45 magenta. The format on which the enlargement was made, i.e. 40×50 cm, contributed to a very long exposure time in the enlarger. Reciprocity failure begins to play a part here. By making the exposure time extremely long and partly by using a neutral density filter and anticipating the switching process this print was obtained. It is obvious that such experiments cannot begin until one has mastered the basic techniques completely. The basic photo was taken with a spectral star filter and then combined with two shots of the flats taken against the light, each mounted on one side against the transparency.

It is important in such experiments always to write down exactly what was done so that the data can be referred to later.

Retouching

I attach much value to the proper finishing of a colour photo. It says something about the photographer's mentality and photos in exhibitions which are not finished properly lose their attraction for me, however good they may be. There are modern photographers who say they are not interested but all forms of craft or art require a finishing touch and for me this is retouching. It requires much patience when working with colour and at the beginning I could not manage it until I had set aside three days in order to practise it thoroughly. That proved worthwhile.

There are two ways of retouching, the dry and the wet method. I shall describe the techniques here on the basis of Kodak retouching colours but other colours, such as the Photocolor acrylic colours are used in the same way. A set of them is not cheap, but lasts for years. The set can be used for both the dry and the wet method, but you must bear in mind that once you have dipped a wet brush into the dye it can no longer be used for the dry method. It follows from this that if you wish to use the wet method you must take small amounts of colour from the pots and apply them to, for example, a glass plate or palette for use. Those who do not do this and still want to use both methods will have to get two sets, which can sometimes be expensive.

The dry method. This is particularly suitable for retouching larger areas of pictures. Thus shadow sections which are too blue can be corrected, tints of clothing and the skin can be built up and large areas can be made warmer or cooler. An important advantage of this method is that it is only permanent once the desired result has been achieved. A little colour is taken on to a wad of cottonwool, breathed on, and applied with circular polishing movements to the part to be treated. In this way colour can be added as well as removed. If the desired effect is not obtained, one can go on with another colour combination until the desired result is obtained. Small areas can be treated in the same way, but with a pointed stick tipped with cottonwool. If too much has been applied, the excess can be removed with a dry wad of cottonwool, likewise with a circular polishing movement. The density can be further reduced with retouching colour reducer and the method of working is the same as that with retouching colours. All the retouching applied

can be removed, if necessary, with weakener or alcohol. In order to make the retouching permanent, it can be treated carefully for a few seconds with steam. Once the waxy nature of the colour has disappeared the retouching is permanent. The enlargement must be properly dried before retouching is started.

The wet method. This is particularly suitable for removing small blemishes. As I have already said, it is best to take small drops of colour from the pots and to mix them on a palette as an artist does. A retouching brush is dipped in a 1:1 solution of stabilizer in water, after which a little retouching colour is taken on the brush. You must remember not to put the retouching brush in your mouth unthinkingly as used to be quite customary in the past with black-and-white. The enlargement is now spotted by using mixed colours or by reducing colours which are too bright by the use of grey. Before placing the brush on the enlargement touch it on a piece of blotting-paper so that not too much is placed on the paper resulting in a blob. If too much wet retouching colour has been applied it must be removed straightaway with a piece of blotting-paper. In the case of severe damage, in which the photo is scratched right through to the bottom layer, the method is somewhat more cumbersome, but can work out well. Begin by laying the photo on a good flat base, after which the dent, that is the upright edge of the damage, is pressed down with the back of the retouching brush. We now fill up the crack with a mixture of white and black retouching colour. Depending on the final colour, the mixture should be made lighter or darker. Filling up should take place layer by layer, waiting in each case until the bottom layer is dry. Then the final colour is applied with the brush using the spotting method and the art is to do this to make a perfect match with the surrounding colours. Large areas are always built up by spotting. After retouching, the photo is sprayed with matt aerosol varnish so that all retouched parts are covered and do not show up.

In the case of glossy paper things can be a bit more complicated, but it is not necessary to use glossy retouching colours. Mix the dyes on a piece of adhesive tape and the gum will make them glossy. With small unevennesses retouching can be carried out virtually invisibly by the spotting method. If, in spite of these precautions, the retouching still remains visible, there is nothing to do but spray the whole photograph with matt or treat it with glossy lacquer.